GRAPHIC DESIGN FOR THE ELECTRONIC AGE

D0691091

These scribes at work come from a woodcut in
Petrarch's *Glückbuch*, published in 1539 in
Augsburg, Germany. The tradition of handwritten
books was still very much alive at the time, even
though the art of printing from movable type was
already three generations old.

The point to keep in mind is that all the new
technical developments are merely events in a
long chain, stretching back to humanity's earliest
cultures. The many old woodcuts illustrating this
book have been chosen as reminders of this proud
heritage. Today's wonderful technologies promise
improvements—but what they deliver depends on
the way people use them.

GRAPHIC DESIGN FOR THE ELECTRONIC AGE

Jan V. White

A XEROX PRESS BOOK
WATSON-GUPTILL PUBLICATIONS / NEW YORK

Copyright © 1988 Jan V. White

First published in 1988 in New York
by Watson-Guptill Publications,
a division of Billboard Publications, Inc.,
1515 Broadway, New York, N.Y. 10036,
in conjunction with Xerox Press,
an imprint of Xerox Corporation.

Library of Congress Cataloging-in-Publication Data

White, Jan V., 1928–
 Graphic design for the electronic age / Jan V. White.
 p. cm.
 "A Xerox Press book."
 Includes index.
 ISBN 0-8230-2121-1 ISBN 0-8230-2122-X (pbk.)
 1. Desktop publishing. 2. Graphic arts—Data processing.
 3. Printing, Practical—Layout—Data processing. 4. Electronic
publishing. I. Title.
Z286.D47W5 1988
686.2'2—dc19 88-37
 CIP

Distributed in the United Kingdom by Phaidon Press Ltd., Littlegate
House, Ebbe's St., Oxford

Manufactured in the United States of America

First printing, 1988

7 8 9 10 11/98 97 96 95 94

CONTENTS

Preface ix

Using type 1

Type is for reading (and understanding) the message 2

 1 Think about what you are trying to say, then say it clearly 2

 2 Consider type as a pliant, malleable material 3

 3 Use common sense and your own experience as a reader to determine what will work 3

 4 Assume that readers know nothing about what you are telling them 3

 5 Realize that you are making an object 4

Type and common sense 5

 1 Type size is related to the way the object is handled 6

 2 Different readers respond to different kinds of type 6

 3 What is useful depends on the use 7

 4 The typeface, paper, and character interrelate 7

 5 Typography defines the weightiness of your publication 7

 6 Form naturally follows function 8

 7 Stop worrying: each problem carries its own natural solution 9

Type options: Practical pointers 11

Serif or sans serif? 12

Justified or ragged? 18

 Ragged-right reads better 19

 Ragged-right can add the "unexpected" 22

 Ragged setting helps captions adhere to pictures 23

How long a line? 24

Capitals or lowercase? 30

 Nomenclature 30

 Problems with all-caps 31

 When to use all-caps 34

 Up-and-Down Style versus downstyle 34

Roman or italic? 36

Type on backgrounds? — 39

White on black — 40

Black on color — 41

Black or white type on a mottled background — 41

Type facts

Type facts — 43

Typographic variety — 44

Technicalities — 51

Spacing and kerning — 51

Muts, nuts, ems, ens, quads — 52

Quadding — 53

Pitch — 54

Punctuation — 55

Symbols, pi characters, and rules — 60

Numbers in type — 62

Equations and other difficulties — 63

Metric system — 64

Roman numerals — 66

Abbreviations — 67

Foreign languages and "accents" — 69

Greek alphabet — 70

Cyrillic (Russian) alphabet — 71

Proofreaders' marks — 72

Page ingredients

Page ingredients — 75

Text or body copy — 76

Questions to ask — 77

Picking a typeface — 80

Using the space on the page — 81

Relating the type to the column — 83

Handling runarounds — 86

Incorporating lists — 88

Titles, headlines, headings, heads — 93

Writing for attention — 94

Styling heads for type — 95

	Placing heads on the page	97
	Considering the many kinds of heads	99
	Having fun with heads	104
Initial letters		107
	Weaving initials into text	108
	Using several initials	110
Decks, blurbs, and other prelims		111
Pull quotes or breakouts		116
	Setting off the quote	117
	Placing the quote on the page	118
Bylines and bios		121
Captions, legends, cutlines		124
	Writing the content	125
	Dealing with typographic technicalities	126
	Observing the picture/caption relationship	127
	Refining caption placement	128
	Titling the caption	133
	Handling technical material	134
Credits		135
	Deciding on placement	136
Footnotes, references, and endnotes		137
	Styling the notes	138
	Setting and placing footnotes	138
	Variations for endnotes	140
Tables		141
	Seeing tables as "pictures"	143
	Horizontal tracking, or reading across the table	143
	Understanding the five main parts of a table	145
	Deciding on the type	148
	Placing the headings	149

Constructing publications

Constructing publications		**151**
The outer package		152
	Dust jacket	152
	Paperback covers	153
	Magazine and journal covers	153
	Comment card	154

The insides | 155

Traditional customs (which you cannot ignore) | 155

Front matter | 157

Text | 159

Back matter | 160

Appendices 163

Paper | 164

Desktop systems | 164

Traditional sizes | 164

Metric sizes | 165

Envelopes | 167

Binding | 170

Multipage sheets | 171

Single sheets | 172

Checklist of criteria | 174

Measuring equivalents | 175

Converting fractions to decimals of an inch | 176

Converting inches to millimeters | 177

Converting feet to meters | 177

Converting millimeters to inches | 177

Converting meters to feet | 178

Converting U.S. points to inches | 178

Converting inches to U.S. points | 178

Converting U.S. points to millimeters | 179

Converting millimeters to Didot points | 179

Converting Didot points to millimeters | 179

Converting Didot points to inches | 180

Converting Didot points to U.S. points | 180

Converting U.S. points to Didot points | 180

Converting inches to spots-per-inch | 181

Converting millimeters to spots-per-inch | 181

Glossary | 182

Communication timeline | 191

Hexalingual nomenclator | 205

Index | 210

It was somewhere around 1958, if memory serves. I think it was just after we had moved from the old Time and Life Building overlooking Rockefeller Plaza to the new building on Sixth Avenue (the avenue no self-respecting New Yorker calls Avenue of the Americas). Rumor had it that an incredible new machine had been installed. It was said to make instant copies by magic—without ink, developer, or even drying time, and on regular paper. So help me, they ran formally scheduled, guided tours to watch this wonder at work. The Xerox, of course.

I have just checked some old photos of the art department to see whether there were dispensers around. Yes, there were, so we must have had Scotch tape by then. But it was the shiny kind, not the "Magic" one. And we didn't use it with abandon. It was expensive. The news editor of the magazine insisted on doing everything the newspaper way. He used straight pins to attach the galleys to the layout sheet. But he admitted to being a bit eccentric. He wore a green eyeshade and plastic cuffs to protect his shirtsleeves.

There was no Letraset yet. To dummy a headline, we traced over alphabets printed on orange cards we got from ATF (American Type Founders). They were about 10½ inches wide and showed the full alphabets of handset type in all the available sizes. (I must refinish the box they came in . . . it is beautiful.)

Then Time, Inc., bought us a new marvel, called a ProType. With it, you could do headlines photographically by exposing each letter from a film negative onto photosensitive paper with a short burst of light from a blinding gadget that burned your fingers. Then you developed the paper in liquids, which smelled if the chemistry wasn't just right (we had to clean out a closet in which to quarantine it). Management justified the investment by claiming we could control our own final product. At last we were in charge of our own destinies . . . we could make changes up to the last minute. Alas, nobody foresaw that now the editors would have more time to be late. Besides, the nuisance gadget was time-consuming and interrupted the normal flow of work. The new and obviously useful tool was an aberration for the magazine. Technology doesn't necessarily bring universal progress.

Nowadays the world is abuzz with activity. Every day new technologies or improvements on older ones are introduced with hype and drumbeat. Obsolescence terrifies. Are we old-fashioned? Will progress pass us by? Will we miss that all-encompassing wonder-program that will not only shield us from mistakes but guide us to the Promised Land? Nonsense.

Let's remember the fundamental truth: it is not the technology that matters, but the message. No matter how the message is produced or transmitted, it is its content that makes it useful and worthy. Recipients of communication couldn't care less about how or where the piece was produced. All they want is information, and they want it fast, to the point, easy to understand, easy to absorb, easy to use. To them, its technological provenance is immaterial.

Let's also remember that the latest, undoubtedly fascinating developments are merely one event in the long and proud history of human communication. They are just the newest link in a very long chain. That is why there is a timeline in the back of this book. That is also why the illustrations scattered throughout were chosen. They are all reminders that we are part of a developing continuum. Technology may have influenced it and changed its direction, but the stream flows on. It will absorb electronic publishing. It will absorb desktop publish-

ing. It will absorb WYSIWYG. They are improvements because they can make communication faster and easier and perhaps even cheaper. They will certainly make more of it. But they will only be welcome improvements if they help make communication better.

Making communication in print better was the reason this book was assembled. It started three years ago at Xerox. The company's electronic publishing products are accompanied by an immense array of technical documentation for its customers, managers, users, teachers, trainees, and service people. Manuals of all shapes, sizes, and purposes needed coordinating for unity's sake, not just because a coordinated look would enhance the corporate image, but because if diverse machinery is to blend into a system, so must the manuals that control it. Several years of effort by the office of documentation headed by Richard M. Lunde resulted in the publication of *Xerox Publishing Standards,* which are beginning to prove their efficacy within the company. To be useful, they had to cover the entire spectrum of concerns, from management to writing style, from organization to design.

It was an exciting and challenging project, making us go right back to the fundamentals in our search for an underlying logic. We had to produce guidelines that would make sense to the full gamut of users, yet be practical within the constraints as well as the opportunities of the technology. It was a joy to be a member of a small team who understood each other and pooled their souls—Carla Jean Jeffords, Paul Doebler, Melinda Broaders, Brenda Peterson, and Helen Choy-Whang. It was also fun.

While working on the manual on manuals, we slowly came to the realization that there was a hole in the system that had to be filled. If we had done our thinking about manuals correctly, then certainly the customers would become experts at using the equipment. Yes, but what would they be using it for?

We realized that Xerox would be doing a great service to its customers were it to give them a modest and concise manual on typography. Actually, Geoffrey Nicolaysen, president of Computer Software Services, a division of Xerox Corporation, first pointed to the need for such a manual when we were working together way back in 1983. Over time the scope of this manual grew, and as it broadened, the more obvious it became that we should perhaps offer the information to a broader public. Not because we were so arrogant as to think the presentation was so wonderful or all-encompassing (though we hope that it will prove useful), but because there are so many people out there who need basic information on typography and design.

That brings us full circle to the technological revolution. More important than the wonders of the new equipment is the parallel opening up of the communication-making process to a whole new group of nonprofessional communicators. By bringing the technology of mass communication to the desktop, a new group of people is suddenly faced with making decisions about printing. But there is a problem if you do not feel trained in this area. You may be confused by it, even daunted. You do, however, know something about printed communication because of the traditions and patterns of our culture. You already have knowledge and insights based on common sense. But you may not trust these instincts and may look for authoritarian rules, searching for the "correct" solution. What you need to do is build on the knowledge you already have.

Frustration with the printed page is nothing new. This late-nineteenth-century engraving shows unmistakably how illegible typography and inconsiderate page makeup were resented even then.

The equipment is programmed to help, of course. It prompts or directs with its built-in systems. But there are also traditions of communication as an intellectual, even emotional, endeavor that have evolved and flowered over the centuries. The value of these traditions does not lie in the fact that they are traditional. It lies in the way that these techniques propel understanding. They are shared signals, and their subtle nuances are vitally important in interpretation.

In using today's equipment, you have to understand both "forward" and "backward" to do your job well. You must master the technology of the ultra-modern machines. You must also understand the techniques of communication in print proven by use.

Communication performs a service. It is a conduit that links speaker and listener, producer and recipient, writer and looker/reader. It is a universal need and is not machine-specific. It has no restricting rules, only principles. Its options are as wide as the capabilities of your equipment. Its possibilities are only limited by your ideas.

How the little black marks are composed on the paper is known as *typography*. Typography is not an esoteric art form; it is a tool to be used to make information accessible. Information is neutral material. It is a data base, lying fallow. It has to be accessed and used. Only when it is transformed into knowledge does it have value. Typography, layout, and design help to do that. Is there anything more valuable to our culture?

Additional acknowledgments

In addition to the Xerox Standards team and Geoffrey Nicolaysen, mentioned above, I wish to thank Allan Ayars for his active encouragement. My thanks also to my editor, Sue Heinemann, at Watson-Guptill Publications, for her clear thinking, her searching questions, and her organizational ability. Julia Moore, senior editor at Watson-Guptill Publications, was another invaluable guide.

Lastly, my thanks to all the editors, art directors, technical editors, writers, designers—communicators all—who have attended my seminars over the years. They are the troops who do the work in the front lines. They know what the realities are and where the problems lie. Veterans or novices, working in traditional or ultra-modern contexts, they share the same concerns. They articulated their worries in their questions and showed me what they needed. While I was working, I constantly imagined what they would say and how they would react. This is their book. I just assembled it for them. It is to them, therefore, that this book is dedicated.

Westport, Connecticut
April 1988

USING TYPE

This printer comes from Jost Amman's *Stände-buch*, published in Nuremberg in 1568. Even that early the true value of printed communication was understood. "Through this procedure, many arts are given the light of day, and they are easy to come by," say two lines of Hans Sachs's accompanying verse.

Painters use insight, judgment, colors, brushes, and all sorts of other paraphernalia—even scaffolding if they have to get up to work on the ceiling of the Sistine Chapel. They enjoy what they do. Some are happy setting their skills to covering the walls. Others use them to express their souls. Both are essential to society. Who is to say which is "better" or "more useful"?

Typography is like painting: it can produce pieces worthy of gallery exhibition, or it can just be the plain, unnoticed background. This chapter concentrates on the workaday, house-painting level. It makes no pretense at treating typography as the art form it undoubtedly can be in the hands of masters. Instead, its purpose is to make you just skilled enough to feel comfortable and confident. It is about common sense, coupled with a few well-established principles—techniques that work—developed over the centuries.

Today's ever-changing electronic technology with its miraculous speed, accuracy, and flexibility, as well as its apparently limitless typographic options, can be daunting. Daunting? No, that is an understatement. The proper word is *terrifying*. Terrifying, that is, to anyone but the technician or expert. That's why we must go back to the basics, because the wonders of technology are nothing more than tools for us to use for the same old purpose of human communication. That will remain constant, no matter what wonder-machine produces it.

The unexpected factor that the new technology has introduced is not mechanical but human. The new equipment is so clever and so easy to use that anyone can be taught its techniques in a few hours. As a result, people who have no training in typesetting, production, graphic arts, design, journalism, or any of the other skills slowly developed over the centuries in the traditional printed media are being thrown into positions of responsibility. To make matters worse, more often than not they are alone with only their machines to talk to and work with. Of course they are daunted by decisions they do not feel competent to make. They know which program to insert and which buttons to press—but how can they know their results will be "right"? And what is "right" anyway? Had they had the benefit of traditional training, they'd know there ain't no such thing as "right": it's all a compromise based on guesswork based on experience. Unfortunately the precision of today's technology doesn't encourage flying by the seat of one's pants. High-tech engineering presupposes that there is The One, True, Correct, and Only Answer to everything. It just isn't so. Typography, like all the other arts, is a malleable, flexible discipline, which is responsive to the needs and purposes of its user. So, lesson number 1: relax. Figure out what needs to be done, then do what feels sensible. Chances are that it'll be acceptable. Will it be "good" or "right"? If you're lucky, it may turn out that way.

This book is intended to help. It presents the basic, standard, accepted ways of doing things. Nothing in it is sacrosanct. Everything in it is sensible and has proven workable. Use it as a foundation, building on its principles. Depart from it whenever such departure seems appropriate. Don't misuse it as an excuse not to think or, worse, not to be inventive. Don't ever say, "This book says to do thus-and-so, therefore we can't do such-and-such."

The new, limitless technology is waiting to be exploited in ways nobody has yet thought of. If it is applied with logic—so that the message is lucidly presented—and the velocity of its communication matches that of its mechanical production, we stand at the threshold of the most stimulating development in information exchange.

An English gentleman enjoys the pleasures of reading in his library. The classically sneering bust is doubtless a portrait of the author. He looked down at the book over the reader's shoulder, noticed the typography, and despaired. The action was caught by Thomas Bewick around 1778.

Type is for reading (and understanding) the message

Functional typography is invisible because it goes unnoticed. The aim is to create a visual medium that is so attractive, so inviting, and so appropriate to its material, that the process of reading (which most people dislike as work) becomes a pleasure. Type should never stand between the reader and the message: the act of reading should be made so easy that the reader concentrates on the substance, unconscious of the intellectual energy expended in absorbing it. Ideally, it should be so inviting that the reader is sorry when the end of the piece is reached (although the subject matter may have something to do with that, too).

1 Think about what you are trying to say, then say it clearly

Typography is a means of transmitting thoughts in words to someone else. Obviously, you have to understand what the words mean before you can translate them into visible symbols that make sense. Avoid thinking of typography as anything but what it is: a mechanical means to an end (i.e., the clear communication of some sort of information). And remember that the end is the only thing that matters.

Don't be self-conscious about typography as an art. Stop worrying about fashion that just leads to affectation and pretense. Don't always strive for originality: often it is impossible to invent new wheels, especially when the existing ones are still perfectly serviceable. Most of all, forget the folk wisdoms that displace analytical thought with axioms and proverbs about the way typography is supposed to be done. Figure out the specifics of each problem and solve them in their own context. Every problem carries within itself the seeds of its own solution.

Unfortunately, deducing what is needed to get the product to that lucid state is often a roundabout process. What usually happens is that you are first led to wrong conclusions by some wild ideas, inspired by something you came across somewhere. Or you may be guided by

rigid rules, instilled by "correct" high school reports. Everybody falls in love with silly ideas, and everybody lugs around the baggage of unquestioned assumptions. Why should you be different from anyone else? It is only after ruthless self-editing and brutal cutting that the worthwhile ideas remain. They are the ones that expose the material most effectively, fit the chosen medium most efficiently, and strike the targeted audience most directly.

2 Consider type as a pliant, malleable material

There's nothing hard-and-fast about type. It is so easy to shape that you can make it do whatever you want. You can even turn typography into crystallized speech, making it look as though someone were speaking.

Think of the hard work in listening to a droning speaker, when you have to concentrate to dig out the nuggets of wisdom. Such a monotonous speech translates visually into column after column of small, hard-to-read, pale gray type. In contrast, a lively speaker brings attention to those nuggets by varying the loudness and pitch of the voice. An increase in loudness can be represented by an increase in type size, while pitch can be suggested by the boldness or lightness of the type. The nugget-content may be identical in both versions of the speech (monotonous or lively), but it's obvious which will spark more enthusiasm.

This capacity for expressiveness makes typography a useful tool in editing, since the fundamental function of editing is to expose what is significant and make it as accessible as possible. What is important deserves emphasis and what is unimportant should be clearly differentiated from it. The result is clearer, more readily understandable communication.

3 Use common sense and your own experience as a reader to determine what will work

Exploit habits and expectations. People look at pages expecting to find them arranged in a certain way. Consider, for instance, the page number, which is usually placed on an outside corner. Common sense suggests putting it there in your new piece, because page numbers are essential reference points and people get annoyed if they can't find them right away or are forced to figure out some strange new pattern. It may, however, make sense to put them elsewhere because _____ (fill in your special reason). In that case, by all means do something different. But expect to pay a price in creating some misunderstanding, confusion, or just plain discomfort for your reader. It may be worth it, or it may not. A case in point: despite the horrors of the illegible typography in which legal briefs are normally presented, judges expect to see them that way. It would be folly for a lawyer or litigant to break precedent, lest the judge be so startled by improved legibility as to jeopardize the fairness of the trial.

4 Assume that readers know nothing about what you are telling them

Readers have to understand the form and absorb the substance of your printed piece at the same time. That is no small task, especially if the information is complex. Keep in mind that few people examine a printed piece before starting to read; they do not try to figure out its format, the structure of its presentation, or how the headings fit into a hierarchy. They do check how long it is, in order to gauge the time and effort to be invested. Some begin at the beginning and stay with it to the end. Some start at the beginning, then jump to the next point that catches their interest and hop and skip around, pecking at the piece in

random fashion. Others may become intrigued by a detail somewhere in the piece, be hooked into reading that snippet, and then go back to the start. Every potential reader is enticed differently.

It is wise not to make the piece look too intellectually intimidating. People will naturally shy away from the visual complexity of five levels of headings and three levels of indention with subparagraphs, quotations, footnotes, and extracts. Wouldn't you? The simpler the visual arrangement, the greater the likelihood of the audience bothering to pay attention. Too many minor variations are self-defeating. If it is necessary to provide instructions on "how to use this book" up front, you had better do some re-examining.

Keeping it simple pays off, as long as you don't go overboard and oversimplify. That is as dangerous as making things too complicated. The happy medium is where the piece looks "easy," yet everything that needs to stand out does so. Remember that the capacity of typography to be helpful to the user is one of its most valuable properties. Always think of your publication from the user's point of view and make it reader-friendly by giving visual clues to the way the piece is constructed and organized. Use typography to show readers where they are, how the elements fit, which items are dominant and which ones matter less. In other words, help readers save time and energy by suggesting where they can skim and skip. With your cunning visual clues, they won't have to figure it out for themselves. Ideas will catapult off the page into their minds effortlessly. They'll reward you by *liking* your publication and saying that it is *easy to read*. They won't ever know how much work and thought went into getting it that way.

5 Realize that you are making an object

Every document—from a single page to a multivolume set—is a crafted object. Think of it that way, plan it that way, and control it that way. It will force you to keep it simple.

Simplicity grows out of consistency. Minor variations—whether on a page or within a larger piece—may be interpreted as incoherence and disorder. Such apparent disorder can affect the credibility of the publication: "Anything as messy as this can't be any good—I won't bother with it."

Be consistent in the way you apply typographic detail. Whenever something recurs—be it an important element, a signal, a text component of some sort, or even empty ("white") space—it should be repeated exactly the same way. Not only does such rhythmic echoing make the meaning easier to decipher, but it also creates familiarity. Furthermore, it fosters easy recognition of the publication in relation to its competition, often a valuable advantage. Always make the user feel comfortable and confident.

Yes, but what about *variety*? You've probably heard that variety keeps the reader interested. And it does. But you can put in too much spice and spoil the stew. How do you know that there is too much? When all that clever variety creates confusion.

It is better to have a document whose unified character gives it its own dignity and presence than to have a pile of visual odds and ends, each calling attention to itself in a deafening babel of competing typographic voices. Besides, the subject matter ought not to depend on visual cosmetics to fascinate the reader.

The simplest method is usually the most effective. If it works, it is probably right. This gentleman is gathering information in the most reliable way: checking it out for himself. He was drawn by Ludwig Richter in an 1860 German storybook.

Type and common sense

There are no "correct" ways of doing anything in type. Whenever you are using type, you have to blend a number of practical factors into a decision that makes sense for that particular piece. Unfortunately there are a lot of them. But don't worry: you don't have to think about all of them all the time, because not every typographic product has to take each one into account. Besides, once you realize what they are, you'll discover that they are pure common sense and totally obvious. (But, like most things that are obvious, we don't bother to think about them, and so we make unnecessary mistakes.)

1 Type size is related to the way the object is handled

· What a relief it is to see one of those wonderful gas-station signs when your gauge registers empty. There it is, poking confidently up above the trees on its enormous pole, signaling relief only a few hundred yards away—you'll just make it with a bit of judicious coasting. Wasn't it helpful of the gasoline company to make it so nice and large? (True, with a full tank, you don't view such intrusive advertising quite as positively, which only proves that you can't please all of the people all of the time.) If you want your type legible at 420 feet, make it 12 inches high. That will probably work, even in fog.

· Well-fed, comfy-cozy, and ready for an evening of television, you bring your program guide in your chubby hand close to your face because your elbow is so gently cushioned by the pillow . . . aaah, how nice. How big does the type need to be here: 12 inches high? Of course not. The scale is different because the point of use is different.

· Is your final product one of those discouraging monster-documents bound in a three-ring binder? Only fanatic bodybuilders could hold it in their hands for any length of time. Instead it will be read lying on a desktop, so you had better respond to the physical demands and make the type large enough for easy reading at that distance.

Commonsense conclusion: **Make the type larger the farther away it is from the reader's eye.**

2 Different readers respond to different kinds of type

· Ever since childhood, the librarians who are the audience for your publication have been avid readers. They wallow in type just like hippopotamuses in warm water. And they'll read anything—the smaller the better. Just take a look at the catalogs of books-in-print that they have to use every day!

· Here is a group of young kids who have just learned to read. You hope that they are going to make you so rich and famous that your next Great American Children's Book will be dictated between sips of rum punch while you float in your palm-shaded pool on the beach on your Caribbean island. The text had better be set good and large or you'll continue riding the subway.

· Have you noticed how the pages of the book you're reading seem to shrink in the evening (just as the laundry shrinks your shirt collars after vacation)? The type seems so much harder to read. Does it really look smaller than it did in the morning? Yes, because you are tired. Furthermore it dwindles as you grow older and bifocals join the support hose, dental bridges, and lower-back pain. The prospect is depressing but inevitable.

Commonsense conclusion: **Fit the nature and size of the type to the nature and age of your audience.**

3　What is useful depends on the use

- The manuals service people bring with them when your technology breaks down and you need wizardry to bring it back on line had better be usable or they'll "forget" them in the car. They must be compact enough to fit into the tool kit. They must be clearly organized, concise, and efficient. A typographic format needs to be devised to fulfill such specialized requirements.

- The *Oxford English Dictionary,* which fills more than twenty outsized volumes, has been photographically reduced to two without cutting a word. The box that protects them is equipped with a little drawer containing a magnifying glass. Perfect for the scholar who wants to find that the first known use of the word *typography* was in _____.

Commonsense conclusion: **Configure the type to the needs of the user.**

4　The typeface, paper, and character interrelate

- Why can't newspapers use ink that won't come off? Just look at your hands when you get off the bus and no longer need your newspaper to anesthetize you to the hassle. Of course you read it quite easily, even going over those potholes. Its unassuming, functional typography worked well on newsprint. Yet, despite the valuable information you gleaned from it, you'll happily throw it away. Its materials and shape are perceived as cheap and temporary, however useful they might be.

- What gratifying illusions of grandeur blind you when you unwrap that sleek annual report. How startling is this year's typeface on such impressive stock. Marvel at the lightness and precision of the strokes. That bespeaks quality. This is your company (never mind that you hold only forty shares). It feels good to have arrived. You'll keep it right there, on your shelf of honor.

Commonsense conclusion: **Choose type that not only prints well on the paper, but also fits it in character.**

5　Typography defines the weightiness of your publication

- The report took twelve months to assemble. It is the definitive study of an esoteric subject that is unlikely ever to get such funding again. Nothing the team of tenured academics could think of has been left out. Everything there is to know about it is included, fully packed page after fully packed page. That solid density is its dominant visual characteristic. It condenses a lot of information in little space.

- Another report is handled somewhat differently: the material is subdivided into components, each displayed separately on the page and lightened with its own little illustration. This loose format seems to demand less determination on the reader's part to tackle the task of reading. Alas, that is precisely what makes the report literally harder to pick up, for it uses much more paper.

Commonsense conclusion: **Make muchness a positive attribute by crowding or promote looseness by opening up.**

6 Form naturally follows function

There is a pile of printed pieces in front of you. Each one is written in a different way, and therefore looks different from the others. None is "right" or "wrong." Each is an appropriate expression of its subject matter.

· The contract is forty-three (count 'em) pages of hereinabouts, notwithstandings, and parties of the first part. Each one needs initialing with witnesses countersigning the last page. Thank goodness only your lawyer needs to read all that stuff. He is used to all that boilerplate and knows what to skip. Besides, his eyesight is still good. Is that where the phrase "legal eagle" comes from?

· Page after page the narrative runs on, written in flowing fashion, with the only visible breaks at chapter starts. It looks just like a novel— which is not surprising, since that's exactly what it is. The format identifies it at first glance. It will be read for pleasure, not for speed. The type can be all the same size and weight, since no visual clues are necessary.

· An eight-page magazine article is organized into a fast-scanning, two-level proposition-support format. Each major point is made with a headline and opening paragraph in large type (the important proposition), followed by smaller type set in narrower columns (the supporting background information). The fast reader who just wants the main points can scan the big stuff and skip the small (two-level readership). The typography gives the visual clues to the reading pattern, because it reflects the structure of the piece.

· The assembly instructions for your boy's new bike are easy to follow: the steps are clearly numbered. The words are set in large type that you can read without having to pick the document up (dropping the wrench and losing the nuts). The illustrations are close to the words that refer to them, the labels are clear, and they even use the same names as the text. Your mechanical engineering degree doesn't hurt either.

· The words are carefully arranged on the page: the type lines are broken by the sense of the words, each separate line representing a self-contained idea. This presentation sets up a rhythm and becomes an integral part of the poetic expression.

· The list of employee promotions (with all the names picked out in **boldface**) in this issue of the company newsletter looks quite different from the chemical engineering treatise (with its wide columns of type to make room for the formulas).

I could go on describing different formats and the functions that make them look the way they do till the details blinded you to the most important commonsense conclusion of all:

Commonsense conclusion: **Figure out what you are trying to accomplish in the printed piece; then the typography will fall into place naturally.**

Albrecht Dürer never actually saw a rhinoceros; none had been brought to Europe by 1515. He had to rely on someone's sketch and verbal description. He got the idea of armor right, except he made it look very much like the armor human knights wore. The function was fulfilled; just the form was a bit off. Fearsome beast, nonetheless.

The more self-conscious about Design (with a capital D) you are, the more pretentious and unsatisfactory the result will be. The less you think about all that aesthetic stuff and concentrate on getting the job done as simply as possible, the clearer (and more effective) your publication will be. That paradox is what makes type so fascinating and satisfying.

Commonsense conclusion: **Don't think about design; it will happen by itself as you solve the problem.**

Was St. Jerome worried when the lion came for help for that painful thorn in his foot? Not a bit. (He just looks that way in this woodcut by Albrecht Dürer from the *Epistolae beati Hieronymi*, printed by Nicolas Kessler in Basel in 1492.) First he checked his thorn-removing manuals, of which he happened to have three: one in Greek, one in Latin, and one in Hebrew. Then he operated with a sharpish needle. The situation didn't leave him much choice, so he just did what had to be done as best he could.

TYPE OPTIONS: PRACTICAL POINTERS

Here we have in-house communications, nineteenth-century style. Data storage is in double-toggle springback binders arrayed in Chippendale cabinet. Data retrieval is by Uriah Heep, the obsequious mustachioed clerk with the pencil ready at his ear. Data target is the whiskered Mr. Upper Management, whose pince-nez has to be a status symbol, as there is no corner office.

To dispel any fears you might have about type and to show how easy it is to arrive at good, working typography, this chapter presents some generally accepted techniques. Stick with them, and you won't go wrong; they are based on experience. But don't feel restricted by these techniques. If you need to do something else to breathe life into a piece, by all means follow your instincts. Typography is nothing more than the means to an end, so exploit it.

The most common stumbling blocks in the typographic decision-making process involve choices about:

- serif or sans serif type

- justified or ragged edges

- line length

- capitals or lowercase

- roman or italic type

- type over backgrounds

This chapter contains down-to-earth criteria on which to base your decisions.

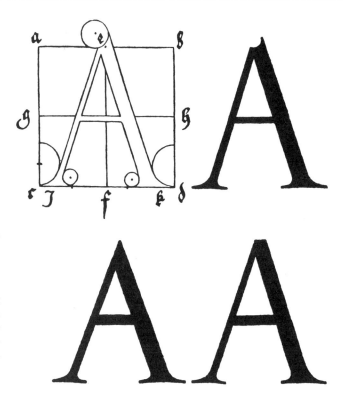

Like many artists of the Renaissance, Albrecht Dürer explored the mathematics and proportions of the alphabet. In a book published in 1535 he analyzed each letter, basing its shape on sub-divisions of a square. Yet, after establishing a structure that conformed to his principles, he still suggested three subtly different alternatives.

Serif or sans serif?

Serifs are one characteristic of type that almost everyone has heard about. (They are like the Doric, Ionic, and Corinthian orders that everyone learns about in architecture—and just as unimportant in practical terms.) If you don't know what serifs are or where to look for them, here's a simple guide:

Serifs originated from chisel marks made while cutting letters into marble monuments in Rome two thousand years ago. Similar-looking marks were left by the quills of medieval scribes, lettering on parchment. If you are a violent partisan of sans serif, you could even say that serifs are the untidy mistakes of poor workmanship petrified into a traditional form!

Sans serif came later—at least in printed form—and is described as more "contemporary" in character. It is perceived as symbolic of new, machine-age high-tech precision. Yet what would old William Caslon IV have thought about that when he introduced his first sans serif face back in 1816? He called it *Doric,* because it was derived from lettering on Greek vases. (Greece was much in the news then, as the sculptures from the Parthenon had just been brought to the British Museum.) *Gothic* was a misnomer given to more condensed sans serif typefaces because their shapes were reminiscent of the shapes of true gothic, or medieval, letters. The term was extended to include all faces without serifs and today *sans serif* and *gothic* are synonymous.

Over the years partisan camps have arisen around serif versus sans serif type. One of the most common clichés about type is that "sans serif is harder to read." That would be an oversimplification, even if it were true, which is questionable. Readability is the product of a complicated mix of factors, and the presence or absence of serifs is just one of them. "Readability is likely to be the result of good design and adequate production, not of type, but of *text.* Not 'Times Roman is readable or unreadable' but 'A newspaper or a book is readable or unreadable,'" according to Gerrit Noordzij, a Dutch professor of typography and design.

If you're worried about legibility, consider:

• what you do with the type and how you dispose it on the page

• how big the type is

• how long the lines are

• how much space there is between them

• how big the page is

• how shiny or slick the paper is

• how light or dark the paper is

• how shiny the ink or toner is

• how the type relates to the paper, ink, and page size

• how the type arrangement reflects the content

• how much type there is to take in

• how difficult the language is

• how the text is broken into component segments

• how the information is organized

All these (and many more technical minutiae) affect the ease of reading, resultant comprehension, and subsequent retention. Yet it is the poor little serif that is singled out as the main culprit. It isn't fair, is it?

The argument about serifs cannot be resolved: both pro- and anti-serif partisans are right. The decision depends on what you need. Here are a few facts to help you make your choice.

The typefaces we learned to read with are the ones we are used to and that we therefore find most congenial and comfortable. In the United States those happen to be the faces with serifs (Century, Primer, Times Roman, and so on). In Europe sans serif is the rule rather than the exception. Choose what makes most sense.

Our eyes skip and stop during the reading process. Researchers call the jerky movements *saccadic jumps* and the pauses that follow *fixations*. The information from the text is gleaned during the moment of fixation. The jumps traverse the groups of letters and recognize them as the words that they are. In other words, we don't read letter by letter

INDIVIDUAL CHARACTERS

in rows line by line like an Optical Character Recognition (OCR) machine. Instead, we read letter-group by letter-group. Since serifs are horizontal extensions of the vertical ends of the lines in the letters, they

This shows exaggerated letter - grouping

emphasize horizontality and that helps to bind the individual letters into those all-important letter-groups. That is an undeniable advantage of serifs.

horizontality Serifs help to blend letters together horizontally

horizontality Serifs have been chopped off here: each letter stands alone as an individual vertical unit

As we read, our eyes travel along the line of words from left to right, then by "return sweep" (in researcher parlance) they come back to the start of the next line down. Keeping the eyes on this horizontal track is aided by the horizontal direction created by the serifs. That doesn't

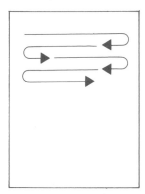

mean serifs have to be there. You can achieve the same legibility by adding extra space between the lines. But if you use serifs, you can crowd more lines onto the page, because you don't have to "open up" between the lines. Again: advantage, serifs.

Another advantage of serif faces is that there is a much larger variety of designs to choose from than with sans serif. The type designers have more to work with: the little end strokes are a rich field for creating subtle variations.

But this brings us to a distinct disadvantage of serif faces: their vulnerability in the reproduction process. By their very nature, serifs are usually delicate, and the thin strokes tend to disappear in the printing process. Faces with light serifs often have other lines of equal delicacy. Unless great care is taken, they can fall apart and become hard to read, let alone ugly.

abcdefghijklmnopqrstuvwxyz abcdefghijklm

The thin strokes need careful attention in reproduction ...they can disintegrate and make letters illegible

Sans serif faces tend to have strokes of more equal weight, with less contrast of fat-to-thin in their lines, making their reproduction easier and less demanding. But that, of course, is a generalization. Obviously

Serif types tend to have greater contrast between thick and thin strokes... ...sans serif faces have strokes of more even thickness

there are sans serif faces whose success depends on subtle craftsmanship just as much as some serif faces.

Before going on to a few more points, let's look at some common technical terms:

STEM ASCENDER
CAP LINE
COUNTER
MEAN LINE OR X-LINE
X-HEIGHT
BOWL
BASELINE
DESCENDER LINE
DESCENDER

Obviously it's important for both serif and sans serif face designs to respond to contemporary requirements of reproduction and economy. We've already looked at the problem of reproducing overly thin lines. There is also a problem if the counters are very small, as they can easily fill up with ink or toner, resulting in a blob. Most of the new

Counters clog up with ink or toner if they are too small

faces, as well as updated versions of old faces, are being developed with larger counters because their x-height is larger in proportion to the overall size of the face.

A greater x-height makes the type easier to read because it looks larger, although it does not occupy any more vertical space on the page. The x-height has just transferred some of the "wasted space" from between the ascenders and descenders to the main body of the letters, giving

X-HEIGHT abcdefghijklmn abcdefghijklmn X-HEIGHT

Both faces are the same "size" but the difference in x-heights makes Avant Garde (*right*) look larger than Bernhard Modern

them that enlarged and easier-to-read look. You could, therefore, use a smaller type size without making it harder to read (going down from 10-point to 9-point,* perhaps). That way you could squeeze more lines on the page, which may be a definite advantage. Unfortunately it is only a minor help in solving the serif or sans serif puzzle, since such large x-height type is available in both serif and sans serif.

The same text set in identical size in three different faces: Bembo (*top*) has the smallest x-height; therefore looks smallest and takes the least space. Dominante (*center*) and the sans serif Helvetica (*bottom*) both have very large x-heights.

We hold these truths to be self-evident, that all men are created equal, that they are endowed by their Creator with certain unalienable Rights, that among these are Life, Liberty and the pursuit of Happiness. That to secure these rights, Governments are instituted among Men, deriving their just powers from the consent of the governed. That whenever any Form of Government becomes destructive to these ends, it is the Right of the People to alter or abolish it . . .

We hold these truths to be self-evident, that all men are created equal, that they are endowed by their Creator with certain unalienable Rights, that among these are Life, Liberty and the pursuit of Happiness. That to secure these rights, Governments are instituted among Men, deriving their just powers from the consent of the governed. That whenever any Form of Government becomes destructive of these ends, it is the Right of the People to alter or abolish it...

We hold these truths to be self-evident, that all men are created equal, that they are endowed by their Creator with certain unalienable Rights, that among these are Life, Liberty and the pursuit of Happiness. That to secure these rights, Governments are instituted among Men, deriving their just powers from the consent of the governed. That whenever any Form of Government becomes destructive to these ends, it is the Right of the People to alter or abolish it . . .

On a final note, sans serif is useful for technical material: it looks right for it. It is useful as a contrast to separate subsidiary (sidebar or boxed) material from running text or to use as display type for headings. Some publications choose it for picture captions. And it is the type of choice for tabular matter.

*For more on type sizes, see page 46.

Yet it is impossible to make a clear-cut list contrasting the advantages and disadvantages of serif and sans serif. You must follow your preference, basing your decision on an understanding of the purpose, objectives, materials, desired personality, and image of the piece in question, as well as the character of the audience. It is all a question of interpretation. And remember: serifs are only one factor. Perhaps it might be a good idea to consider the others and then return to this one.

Nouem. 7. 1622. Numb. 6.

A Coranto.

RELATING

DIVERS PARTICV-
LARS CONCERNING
THE NEWES OVT OF *ITALY*,
Spaine , *Turkey* , *Perfia* , *Bohemia* , *Sweden* ,
Poland , *Auftria* , the *Pallasinates* , the *Grifons* , and
diuers places of the Higher and Lower
GERMANIE.

Printed for *Nathaniel Butter* , *Nicholas Bourne* ,
and *William Sbefford* , 1622.

Perhaps life was indeed easier in the olden days. At least they didn't have so many typefaces to choose from. Here is a London newsletter from November 1922. Pamphlets were known as *corantos* then. That it is dated and numbered shows that its journalistic intent was different from that of a book, though the shape and size of the piece resemble a normal book of the period. Only one typeface was used because that is probably all there was to work with. No problem of serif versus sans serif to deal with in those days.

This printing press was "drawn" with type and other typographic elements by Georg Woffger of Graz, Austria, in 1670. It proves that you can do anything with type: stretch it, squeeze it, align it —even if each element is a piece of hard metal. Such tours de force were much admired as advertisements and promotion pieces. There was a lot of humor hidden in them, too. The inscription on the sign hanging on the hook at the top right says: "Since writing and paper need dampness for their very existence, it follows that printers are justified in enjoying their wine and beer."

Justified or ragged?

The phrase *justified setting* means that all lines in a column of type are set to the same length, so that you have a neat right-hand margin as well as a neat left-hand margin. *Ragged setting* means having lines of varied lengths, so the margins are not neat but look—well—ragged.

We hold these truths to be self-evident, that all men are created equal, that they are endowed by their Creator with certain unalienable Rights, that among these are Life, Liberty and the pursuit of Happiness. That to secure these rights, Governments are instituted among Men, deriving their just powers from the consent of the governed. That whenever any Form of Government becomes destructive to these ends, it is the Right of the People to alter or abolish it...

Copy set justified: all the lines are forced to fill out the space between the two edges of the column. Only the last line of a paragraph does not have to fill out the available space.

We hold these truths to be self-evident, that all men are created equal, that they are endowed by their Creator with certain unalienable Rights, that among these are Life, Liberty and the pursuit of Happiness. That to secure these rights, Governments are instituted among Men, deriving their just powers from the consent of the governed. That whenever any Form of Government becomes destructive to these ends, it is the Right of the People to alter or abolish it...

Copy set flush-left and ragged-right. The left-hand edge of the column is straight. The right-hand edge is determined by the way the words fall, within a specified maximum.

Ragged-right is what is usually implied when text is set ragged, because ragged-left is seldom used except in special situations, such as picture captions. The reason for the rarity of ragged-left is simply the difficulty of reading it in bulk. You can get away with any peculiarity when you are handling just a short piece: half a dozen lines, perhaps. Anyone can decipher the way through that, always assuming the information is worth the effort. But even the most fascinating subject will remain unread if the reader is expected to fight ragged-left setting.

We hold these truths to be self-evident, that all men are created equal, that they are endowed by their Creator with certain unalienable Rights, that among these are Life, Liberty and the pursuit of Happiness. That to secure these rights, Governments are instituted among Men, deriving their just powers from the consent of the governed. That whenever any Form of Government becomes destructive to these ends, it is the Right of the People to alter or abolish it . . .

Copy set flush-right and ragged-left. The right-hand edge of the column is straight. The left-hand edge is random, determined by the way the words happen to fall.

We hold these truths to be self-evident, that all men are created equal, that they are endowed by their Creator with certain unalienable Rights, that among these are Life, Liberty and the pursuit of Happiness. That to secure these rights, Governments are instituted among Men, deriving their just powers from the consent of the governed. That whenever any Form of Government becomes destructive to these ends, it is the Right of the People to alter or abolish it . . .

Copy set ragged-center. Both margins are ragged and type lines centered between them. Spaces between words are of equal width. A self-conscious format that should be reserved for very special situations.

Why? Because a neat left-hand margin is an easier reference point for finding the start of the next line. The eye always returns to the left edge of the column. It is tiring to have to look for the next line's start, and annoying and confusing to make an error that requires re-reading. Flush-left setting bypasses any such problems.

A disorderly right-hand edge, however, creates no such difficulties. On the contrary, a random right-hand margin brings several advantages.

Ragged-right reads better

We recognize words as groups of letters combined into a single visual image rather than as a series of individual letters (see page 14). How the individual letters combine into their groups, then, is vitally important for legibility. Obviously, the shapes of the individual letters must be clear and conform to the traditional forms for easy recognition. It isn't, however, only the shapes of the letters themselves that matter, but also the relationships of the letters to each other. The negative spaces (spaces between the letters within the word and between the letter-groups) are equally vital for legibility.

decipherable u nd eci p hera ble

Normal spacing between letters Abnormal or irregular letterspacing

In setting justified copy, the typesetter (whether a person or a programmed machine) often has to spread out the spaces between words and sometimes even between the characters to make those lines come out the same length. This spacing becomes increasingly problematic as the column becomes narrower because—to state the obvious—in narrow columns you have short lines. Long lines have lots of words, with lots of spaces between them, but short lines have fewer words and spaces to manipulate. Since words vary widely in length as well as breakability at line ends, you may have to insert huge gaps

between them to justify the line. The resulting uneven spacing affects the visual rhythm of each line and disturbs reading: it makes the eye stumble, as it tries to compensate for these imbalances. That is tiring work.

When copy is specified to be set justified, it is necessary to insert extra space between words and sometimes even between characters, in order to fill out the lines to the precise edges that justification demands. Certainly, the product looks neater that way, and the technique poses few problems where the columns are wide enough to allow about eight or ten words per line.

In particularly narrow columns like this exaggerated example, justification forces disturbingly artificial word spacing, which results in "rivers" of white space flowing inside the column. Gaps inhibit smooth reading.

In particularly narrow columns like this exaggerated example, justification forces disturbingly artificial word spacing, which results in "rivers" of white space flowing inside the column. Gaps inhibit smooth reading.

If you turn this sample upside down and half-close your eyes, you can see the "rivers" of white between the words most vividly.

In particularly narrow columns like this exaggerated example, justification forces disturbingly artificial word spacing, which results in "rivers" of white space flowing inside the column. Gaps inhibit smooth reading.

In particularly narrow columns like this exaggerated example, justification forces disturbingly artificial word spacing, which results in "rivers" of white space flowing inside the column. Gaps inhibit smooth reading.

In this version the typesetter was trying to mask an impossible situation by letterspacing between characters and opening up between words.

Here the lines were arbitrarily lengthened, allowing opening up throughout. Though the column appears "neater," the type's texture has been destroyed: two wrongs can't make a right.

Ragged-right overcomes the problem of artificial spacing by simply doing away with the necessity for it. Type appears the way it is supposed to: naturally spaced. It looks and reads best that way.

Ragged-right setting avoids the problem of bad word spacing by removing its cause: no artificial right-hand edge is called for, so spacing can be natural and in correct proportion.

There is, however, more to this than meets the eye. You can control the degree of raggedness—the untidiness—that you are willing to accept and specify your preference. It all depends on hyphenation and word breaks at the ends of the lines.

If you specify "no hyphenation," you'll get maximum raggedness, which can look very untidy indeed when set to a narrow measure (short lines, narrow columns). The style—known as a *rough rag*—is the result of setting the lines as the copy comes; if there is not enough space to accommodate the last word in full, it will be forced to the next line, since no hyphenation is allowed. Here's an exaggerated example to make the point vivid:

> This is
> an example
> of ragged-rightness
> producing
> an extraordinarily
> varied
> right-hand
> edge. No
> word breaks
> are allowed.

Now let's look at an example of tight rag, which allows some word breaks. Where do you draw the line between hyphenation and no hyphenation? You simply decide that you don't want indents at the right-hand edge deeper than _____ (say, 24 points, 2 picas, 8.5mm, or 18 spots—depending on how you do your measuring). Whenever the setting equipment arrives at an indent that would exceed such a dimension, the next word is broken.

> This is an example
> of ragged-right-
> ness producing a
> less startlingly
> varied right-hand
> margin than the
> extraordinarily pe-
> culiar-looking one
> in the previous
> example. Word
> breaks allowed.

The minimal rag, yielding the least disturbing image of messiness, allows hyphenation for word breaks in the same way as justified copy, but skips the last step in the justified-setting process—pushing the button that opens up between words or characters to justify the line measure. (True, the software doesn't actually do any button-pushing, but you get the general idea.)

There is one option that gives you complete control over the raggedness of the setting: doing it yourself. No matter what kind of word-processing equipment you may be using, you can type the wording line for line, the way you want it reproduced in type. This is an essential technique if you want to break for sense, rather than using arbitrary breaks to get the stuff to fit a given line length.

Ragged-right can add the "unexpected"

Differentness may or may not be an advantage. The medieval scribes invented justification of lines to create perfection, thus fulfilling the religious purpose of their work. They knew how difficult justification is, even using such flexible materials as quill-drawn marks on parchment, and they invented all sorts of techniques with which to accomplish it, including running letters into each other (ligatures),

æ as ct et fr sp ll ta tt us is nt gy

Examples of ligatures

shortening words (abbreviations), and combining letters above each other (as with the exclamation point and question mark, see pages 56, 57). A hard right-hand edge was the ultimate high-tech of their time.

When Johann Gutenberg invented the system that used movable type in a printing press and switched from handmade books to machine production, he had to reach the same perfection as the scribes, using mechanical means. His patrons expected that what they bought from him would look as good as the handmade product they were used to. That is why his alphabet contained dozens of space-saving ligatures. The typesetter needed the flexibility they gave. Just inserting space between the words would have been cause for rejection as second-rate, shoddy goods. Also note that in Gutenberg's Bible the hyphens were placed outside the rectangle of type—as "hanging" punctuation—to avoid little bays of white space, which would have disrupted the perfect edge.

The collection of letters Gutenberg had to cut in order to achieve the precise justification of the text column in his 42-line Bible, printed in Mainz around 1455. Notice the number and variety of ligatures (two characters joined into one). The precision of the right-hand edge is also perfected by placing the hyphens outside the rectangle: "hanging punctuation" is still called for in high-quality typesetting today.

Standards may be lower today. Printed matter is not as unique or as valuable as it was in the 1450s. But the expectation of "perfect" column edges is with us still.

The disadvantage of using normal, justified columns is precisely that they are so ordinary and expected. Their very familiarity makes them unremarkable. Ragged-right has an "edge" there. Its peculiarity is its greatest asset: whether used throughout a document or in parts to contrast against the rigid rectangularity of its surroundings, it can add personality, brightness, visibility—or just visual interest.

It can be particularly useful in setting off major pronouncements (such as messages from the CEO or introductions to a document), which might be set in larger type at a wider measure. Or it may help distinguish segments within running copy, such as comments on the side or answers to questions. Or it can signal display items deserving recognition and visibility, such as a sentence that explains or qualifies a headline, or quotations inserted into the body of a text piece.

Ragged setting helps captions adhere to pictures

One of the greatest values of ragged setting is in its use for captions to pictures. The normal look of a printed piece tends to be rigid and geometric. Even the illustrations are usually rectangular in outline. Captions set ragged-right or ragged-left bring a touch of unexpected informality to the page, in the feather-edged sliver of white space along their ragged side. Besides, there is a magic "stickiness," which can be exploited to attach the caption to its picture. When the straight edge flanks the illustration, the elements become joined; reverse the arrangement, and they look separate. (For more on the placement and alignment of captions, see pages 128-133.)

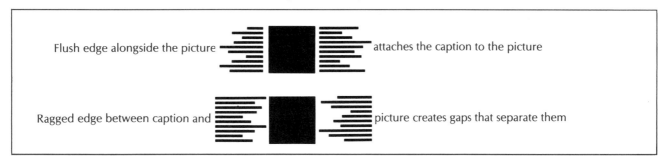

Flush edge alongside the picture — attaches the caption to the picture

Ragged edge between caption and — picture creates gaps that separate them

Reader reaction is worrisome. Will they like what I've done? Will they find it easy to read? Will the type be large enough? Handing the finished report to the client has always been a traumatic experience. Witness this scene of the apprehensive author presenting his book to Philip the Good. Is it respect or weakness of knee that forces him to kneel? Is the boat waiting to push him over the edge of the world if Philip hates it because the lines are too long to read comfortably? *The History of Jason*, published in Haarlem, in the Netherlands, around 1485, fails to inform us.

How long a line?

There are a number of factors you need to consider before making a decision about line length. It should come as no surprise that these factors are similar to the ones affecting your choice of serif or sans serif type, set justified or ragged. They are all intertwined.

• What typeface are you using? Since some are more legible than others, you can take greater risks with them and set lines a bit wider.

- What size type are you using? The bigger it is, the more legible it is likely to be, till you reach a point of diminishing returns. Don't forget that x-height affects the apparent size of a typeface. Look at what you are dealing with and trust your visual instincts; don't go by mathematical size specifications. (The old truism that body copy should be set in 10-point type may be a falsism!)

- How much spacing between lines—or *leading* (pronounced "ledding")—are you using? The more spacing there is between the lines, the longer the lines can be. (More detail about this later.)

- What color paper and ink or toner are you using? Too much or too little contrast can affect your reader's reaction and cause fatigue.

- Is the paper and ink or toner shiny or matte? Shininess creates annoying highlights that tire the eyes, but you may want to use it because it produces the brightest color reproduction.

- How big is the page and how many pages are there? How daunting does the total mass of the document look? What you do on a page or two may be perfectly acceptable there, but it may well become wearisome or troubling when multiplied by a hundred. A specimen tree is one entity, a forest another; in both cases we're dealing with trees, but there's no such thing as a forest made of specimen trees.

- How much text will appear on the page? The greater the apparent mass, the greater the need to make it less threatening. You help to make it inviting and easy to read by keeping lines short. You can get away with all sorts of typographic experiments in short pieces.

- What kind of text are you presenting? Is it technical matter that requires concentration (which you must make easy to read), or is it smooth, easily flowing narrative (which can be handled more courageously)?

- How much typographic breakup is there? How many stopping points or changes in subject are signaled by subheads, initials, or the like, so that each block of type appears short and easy to enter?

All these factors must be taken into account when you think of line length. But are there no rules to go by? No. There is no answer that can apply to every situation, no foolproof formula. There are only rules of thumb that have evolved over the years. Here are three:

—Figure one-and-a-half alphabets (39 characters, or 8 words) per line.

—Or 60 to 70 characters (commonly and successfully used in books).

—Or 10 words of average length (50 characters) if you use serif type, 8 or 9 words if you use sans serif.

What is the problem with lines that are <u>too short</u> (four or five words)? With justified setting, they force poor word spacing and cause too much annoying hyphenation at line ends. Although ragged-right setting avoids these problems, too-short lines are still annoying because they disrupt the normal horizontal rhythm of reading.

What is the problem in lines that are <u>too long</u>? The longer the lines, the more difficult it is to follow a line of words from left to right without being distracted by words in the line above or below. Worse, the longer the lines are, the greater the difficulty of returning to the left-hand edge of the column and finding the next line to read. The reader quickly tires of the concentration required, and becomes irritated with the confusing skips and the need to re-read. You have to have a clear connection between the end of one line at the right and the start of the next line at the left, or else.

How do you overcome the problem? By helping the reader's eye travel along the path smoothly, easily, confidently. That is done by creating tracks for it to move along: tracks of nothing but space. A sliver of space added between lines—called *interline spacing* or *leading*—is all that is needed.* The longer the lines, the more space you need to insert.

What is the problem in lines that are too long? The longer the lines, the more difficult it is to follow a line of words from left to right without being distracted by the words in the line above or below.

Tiny type can be set in one line of
any length without becoming illegible.

What is the problem in lines that are too long? The longer the lines, the more difficult it is to follow a line of words from left to right without being distracted by the words in the line above or below. Worse, the longer the lines are, the greater the difficulty of returning to the left-hand edge of the column and finding the next line to read. The reader quickly tires of the concentration required, and becomes irritated with the confusing skips and the need to re-read. You have to have a clear connection between the end of the line at the right and the start of the next line at the left.

Tiny type set without additional leading
(interline spacing) becomes hard
to read.

What is the problem in lines that are too long? The longer the lines, the more difficult it is to follow a line of words from left to right without being distracted by the words in the line above or below.

Worse, the longer the lines are, the greater the difficulty of returning to the left-hand edge of the column and finding the next line to read. The reader quickly tires of the concentration required, and

becomes irritated with the confusing skips and the need to re-read. You have to have a clear connection between the end of the line at the right and the start of the next line at the left.

Tiny type set in very long lines but with
generous interline spacing is readable.
The eye can travel from side to side and
line to line fairly easily.

What is the problem in lines that are too long? The longer the lines, the more difficult it is to follow a line of words from left to right without being distracted by the words in the line above or below. Worse, the longer the lines are, the greater the difficulty of returning to the left-hand edge of the column and finding the next line to read. The reader quickly tires of the concentration required, and becomes irritated with the confusing skips and the need to re-read. You have to have a clear connection between the end of the line at the right and the start of the next line at the left.

Bigger type makes the same line lengths
perfectly acceptable.

If you are using a serif typeface, you'll need a little less leading than if you are using sans serif, because the serifs do help the eye to travel along the line. But watch that x-height proportion: if your typeface has a very small x-height, there is a lot of white above and beneath it in the spaces between the ascenders and descenders. That space is added visually to the space between the lines, so you need less extra space to help the eye to travel along.

*In the days of hot metal, when type was hand-set character by character or machine-cast by the line, each line was a separate entity. Slivers of metal were inserted between the lines to separate them or "open up." The metal in printshops was referred to as *lead*, even though the slivers were made of copper or brass. And *leading* has remained the trade word for interline space, even though we have lost its metallic origins. Leading used to be measured in increments of one point (12 to the pica, or 72 to the inch). In today's technology, much smaller increments are possible. It's also easy to work with negative leading or tightened spacing, where less space than normal is used, so that lines overlap a little.

Face with small x-height: The space enclosed above, between the ascenders, and below, between the descenders, flows into the space between the lines, so the lines appear sufficiently separated from each other. Little additional leading is needed for legibility.

We hold these truths to be self-evident, that all men are created equal, that they are endowed by their Creator with certain unalienable Rights, that among these are Life, Liberty and the pursuit of Happiness. That to secure these rights, Governments are instituted among Men, deriving their just powers from the consent of the governed. That whenever any Form of Government becomes destructive to these ends, it is the Right of the People to alter or abolish it . . .

On the other hand, faces with a large x-height require more interline spacing, because the space above and beneath has been pre-empted by the body of the type itself. Also note that dark, bold faces benefit more from generous leading than do light ones.

Face with large x-height: These lines appear to have been placed closer together. Since the x-height is larger, there is less space between ascenders and descenders to be added to the space between the lines, so extra spacing between lines is required for legibility.

We hold these truths to be self-evident, that all men are created equal, that they are endowed by their Creator with certain unalienable Rights, that among these are Life, Liberty and the pursuit of Happiness. That to secure these rights, Governments are instituted among Men, deriving their just powers from the consent of the governed. That whenever any Form of Government becomes destructive of these ends, it is the Right of the People to alter or abolish it...

We hold these truths to be self-evident, that all men are created equal, that they are endowed by their Creator with certain unalienable Rights, that among these are Life, Liberty and the pursuit of Happiness. That to secure these rights, Governments are instituted among Men, deriving their just powers from the consent of the governed. That whenever any Form of Government becomes destructive of these ends, it is the Right of the People to alter or abolish it...

Let's look at the helpfulness of extra leading by comparing the same type in the same size but at varying line lengths. The line lengths (merely another way of saying "column widths") are derived from the common practice of subdividing the space on a standard 8½ x 11-inch page into two or three sections.

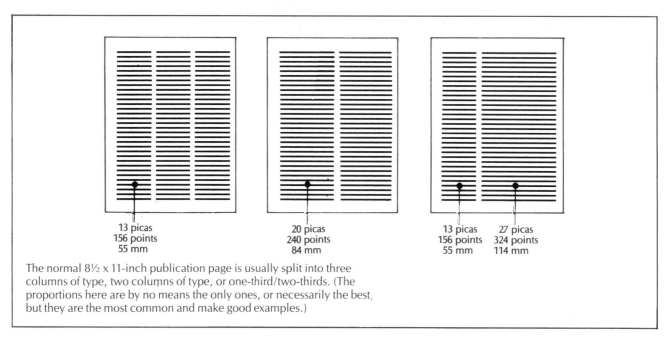

13 picas
156 points
55 mm

20 picas
240 points
84 mm

13 picas
156 points
55 mm

27 picas
324 points
114 mm

The normal 8½ x 11-inch publication page is usually split into three columns of type, two columns of type, or one-third/two-thirds. (The proportions here are by no means the only ones, or necessarily the best, but they are the most common and make good examples.)

The examples opposite show the type set solid (without additional leading between the lines), with two points, and with four points added, in each of the three measures (or column widths). The tightest setting is fine for the narrowest column, but very reader-unfriendly in the widest column. Yet, while the version of the widest column that has the most space is certainly the most legible, that same looseness disintegrates the narrow column.

13 picas
156 points
55 mm

We hold these truths to be self-evident, that all men are created equal, that they are endowed by their Creator with certain un-alienable Rights, that among these are Life, Liberty and the pursuit of Happiness. That to secure these rights, Governments are **A** instituted among Men, deriving their just

We hold these truths to be self-evident, that all men are created equal, that they are endowed by their Creator with certain un-alienable Rights, that among these are Life, Liberty and the pursuit of Happiness. That to secure these rights, Governments are **B** instituted among Men, deriving their just

We hold these truths to be self-evident, that all men are created equal, that they are endowed by their Creator with certain un-alienable Rights, that among these are Life, Liberty and the pursuit of Happiness. That to secure these rights, Governments are **C** instituted among Men, deriving their just

20 picas
240 points
84 mm

We hold these truths to be self-evident, that all men are created equal, that they are endowed by their Creator with certain un-alienable Rights, that among these are Life, Liberty and the pur-suit of Happiness. That to secure these rights, Governments are instituted among Men, deriving their just powers from the consent of the governed. That whenever any Form of Government be-**D** comes destructive of these ends, it is the Right of the People to

We hold these truths to be self-evident, that all men are created equal, that they are endowed by their Creator with certain un-alienable Rights, that among these are Life, Liberty and the pur-suit of Happiness. That to secure these rights, Governments are instituted among Men, deriving their just powers from the consent of the governed. That whenever any Form of Government be-**E** comes destructive of these ends, it is the Right of the People to

We hold these truths to be self-evident, that all men are created equal, that they are endowed by their Creator with certain un-alienable Rights, that among these are Life, Liberty and the pur-suit of Happiness. That to secure these rights, Governments are instituted among Men, deriving their just powers from the consent of the governed. That whenever any Form of Government be-**F** comes destructive of these ends, it is the Right of the People to

27 picas
324 points
114 mm

We hold these truths to be self-evident, that all men are created equal, that they are endowed by their Creator with certain unalienable Rights, that among these are Life, Liberty and the pursuit of Happiness. That to secure these rights, Governments are instituted among Men, deriving their just powers from the consent of the governed. That whenever any Form of Government becomes destructive of these ends, it is the Right of the People to alter or abolish it, and to institute new Government, laying its foundation on such principles and organizing its powers in such form, as to them shall **G**

set solid with no leading

We hold these truths to be self-evident, that all men are created equal, that they are endowed by their Creator with certain unalienable Rights, that among these are Life, Liberty and the pursuit of Happiness. That to secure these rights, Governments are instituted among Men, deriving their just powers from the consent of the governed. That whenever any Form of Government becomes destructive of these ends, it is the Right of the People to alter or abolish it, and to institute new Government, laying its foundation on such principles and organizing its powers in such form, as to them shall **H**

leaded with 2 points

We hold these truths to be self-evident, that all men are created equal, that they are endowed by their Creator with certain unalienable Rights, that among these are Life, Liberty and the pursuit of Happiness. That to secure these rights, Governments are instituted among Men, deriving their just powers from the consent of the governed. That whenever any Form of Government becomes destructive of these ends, it is the Right of the People to alter or abolish it, and to institute new Government, laying its foundation on such principles and organizing its powers in such form, as to them shall **I**

leaded with 4 points

All these examples are set in the same typeface (Times Roman) in the same size (9-point). The size is perhaps smaller than ideal legibility might demand. But here it dramatically illustrates the comparative need for inter-line spacing. The principle: *The longer the line, the greater the leading.*

For greatest legibility:
In the narrow column, A (tight).
In the medium column, E (opened up).
In the wide column, I (very open).

Note how impossible G is to follow. On the other hand, C is much too cut up.

The California typecase, developed by Octavius A. Dearing, was first introduced in San Francisco in 1867. Its sales literature described it as "the only case made that will hold an ordinary font of job letters larger than a pica, without overrunning the boxes." The box sizes varied according to the number of characters they had to contain. Notice that the lowercase "e"—the most commonly used letter in English—has the largest box. Nowadays these typecases are used to display knickknacks.

Capitals or lowercase?

When words are set in capital letters, our culture interprets them as being more important—more worthy of attention. Think of street signs, product names, or instructives like WARNING! This unquestioned importance is something to keep in mind. But also note that all tests show that reading matter set in all-caps is harder to read. Understanding why this is so is a help in resolving the paradox of when and how to use capitals.

Nomenclature

The terms *capital, majuscule,* and *uppercase* all mean the same thing. When writing first appeared, all letterforms were capitals. Medieval scribes developed faster-to-write shapes, and their amendments to the capitals (which they called *majuscules*) became standardized and known as *minuscules.* "Big letters" and "small letters."

When metal type displaced handwritten type, both sets of letters were cut and cast. Printers stored the majuscules in one big drawer, or case, and the minuscules in a companion case beneath it. Hence *uppercase* and *lowercase.*

Capitals in the upper case

Minuscules in the lower case

If you want type set in capitals, specify it as "all-caps" or "uc" or underscore the words with three lines.

Set the following words in all-caps

ALL-CAPS

Problems with all-caps

We do not read character by character, but rather word by word (character-group by character-group). Word recognition depends on the relationship of the little black marks as much as on their shape. The silhouette or outline of the word's shape is an especially important factor. When a word is set in all-caps, the outline is a rectangle, since all the letters align at the top and bottom.

THIS SHOWS THE **RECTANGULARITY** OF WORD SHAPES

Type set in all-caps requires concentrated attention and is slow to decipher. By contrast, the ascenders on the lowercase letters "b, d, f, h, k, l, t" and the descenders on "g, j, p, q, y" prevent the monotony of the rectangular outlines of words.

This shows the **bumpy** shapes of the words when set in lowercase

Each word's shape varies from its neighbor, making recognition faster and easier. You may notice that the shapes and proportions of the ascenders and descenders vary from typeface to typeface: some have short ones, others long ones. In some the ascender of the lowercase "t" is shorter than other ascenders, or the descender of the lowercase "p" may be shorter than other descenders. In many faces the ascenders are taller than the capital letters. But these are all idiosyncratic characteristics and need cause you no concern. The important factor is the irregular silhouette they produce.*

Another problem is that all-caps take more space (about 30 percent), because they are bigger and wider. Lowercase packs better; it is more economical of space. The larger size also demands more "fixations" for the eyes to take in all the wording, thus slowing reading speed. The need for more space is made even worse if you have to add extra space between the lines of all-caps to improve legibility.

*By the way, did you ever wonder where the little dot over the lowercase "i" came from? It was added by scribes to help distinguish the "i" from the "m," "n," and "v," which all had jagged tops when handwritten. Something had to be done to improve the legibility of a word like:

WE HOLD THESE TRUTHS TO BE SELF-EVIDENT, THAT ALL MEN ARE CREATED EQUAL, THAT THEY ARE ENDOWED BY THEIR CREATOR WITH CERTAIN UNALIENABLE RIGHTS, THAT AMONG THESE ARE LIFE, LIBERTY AND THE PURSUIT OF HAPPINESS. THAT TO SECURE THESE RIGHTS, GOVERNMENTS ARE INSTITUTED AMONG MEN, DERIVING THEIR JUST POWERS FROM THE CONSENT OF THE GOVERNED. THAT WHENEVER ANY FORM OF GOVERNMENT BECOMES DESTRUCTIVE OF THESE ENDS, IT IS THE RIGHT OF THE PEOPLE TO ALTER OR ABOLISH IT, AND TO

We hold these truths to be self-evident, that all men are created equal, that they are endowed by their Creator with certain unalienable Rights, that among these are Life, Liberty and the pursuit of Happiness. That to secure these rights, Governments are instituted among Men, deriving their just powers from the consent of the governed. That whenever any Form of Government becomes destructive of these ends, it is the Right of the People to alter or abolish it, and to institute new Government, laying its foundation on such principles and organizing its powers in such form, as to them shall seem most likely to effect their Safety and Happiness. Prudence, indeed, will dictate that Governments

Text set in all-caps is much harder to read than the same text set in lowercase. Also notice how many more words in lowercase fit the same area.

WE HOLD THESE TRUTHS TO BE SELF-EVIDENT, THAT ALL MEN ARE CREATED EQUAL, THAT THEY ARE ENDOWED BY THEIR CREATOR WITH CERTAIN UNALIENABLE RIGHTS, THAT AMONG THESE ARE LIFE, LIBERTY AND THE PURSUIT OF HAPPINESS. THAT TO SECURE THESE RIGHTS, GOVERNMENTS ARE INSTITUTED AMONG MEN, DERIVING THEIR JUST POWERS FROM THE CONSENT OF THE GOVERNED. THAT WHENEVER ANY FORM OF GOVERNMENT BECOMES DESTRUCTIVE OF THESE ENDS, IT IS THE RIGHT OF THE PEOPLE TO ALTER OR ABOLISH IT, AND TO

The all-cap setting can be helped by generous addition of leading. It does read a little less badly; it also appears somewhat stuffily dignified.

WE HOLD THESE TRUTHS TO BE SELF-EVIDENT, THAT ALL MEN ARE CREATED EQUAL, THAT THEY ARE ENDOWED BY THEIR CREATOR WITH CERTAIN UNALIENABLE RIGHTS, THAT AMONG THESE ARE LIFE, LIBERTY AND THE PURSUIT OF HAPPINESS. THAT TO SECURE THESE RIGHTS, GOVERNMENTS ARE INSTITUTED AMONG MEN, DERIVING THEIR JUST POWERS FROM THE CONSENT OF THE GOVERNED. THAT WHENEVER ANY FORM OF GOVERNMENT BECOMES DESTRUCTIVE OF THESE ENDS, IT IS THE RIGHT OF THE PEOPLE TO ALTER OR ABOLISH IT, AND TO

All-cap words in copy look huge in contrast to the surrounding lowercase. It is wise to drop down one size when setting an acronym or similar material, to prevent it from overwhelming its surroundings. But find out whether "small caps" are available before specifying dropping down to a smaller point size. Some typefaces have a third alphabet specifically designed for such contingencies. These small caps are shaped like capital letters, but they are only about as high as the x-height. Their color and line weight is appropriate to the type size they are part of, and therefore they seem to belong. By contrast, the

capitals of a smaller point size are drawn with slightly lighter strokes, appropriate to that size, and as a result they appear paler than they should when surrounded by lowercase type.

ABCDEFGHIJKLMNOPQRSTUVWXYZ1234567890

abcdefghijklmnopqrstuvwxyzABCDEFGHIJKLMNOPQRSTUVWXYZ1234567890

Small caps in ITC Novarese typeface. Specified as "small caps" or "s.c." and underscored with a double line below the words on the manuscript.

There are two kinds of numerals or figures:

Those aligning with capitals (lining, ranging, or modern).

Those with ascenders and descenders and aligning with small caps (nonlining, nonranging, or old style).

The spacing between some capital characters can be unsatisfactory. The shape of the letters makes the spacing between LA or TYVW, for instance, look huge, whereas the spacing between the first three letters of the word MINIMUM looks very tight. Unless you do some tinkering,

LATYVW MINIMUM

the result can be visually uncomfortable, especially in large sizes, when such anomalies become noticeable. Depending on the equipment and circumstances, you can:

—use wider spacing than normal to help equalize the spaces visually. But this may result in "loose" setting, which is not altogether desirable.

—use optical letterspacing, examining and properly balancing each combination of letters. This is obviously a custom-made (and therefore expensive) process.

LATYVW MINIMUM

Compare the letterspacing here to the previous example.

—use ligatures (see page 22) if they are available. They combine or overlap letters to reduce the space between them. You can also squeeze characters more tightly together on the more sophisticated film-set or electronically digitized equipment—a process called *kerning* (see page 52).

33

Yet another problem is that the vertical alignment of letters at the left can look peculiar in all-caps, especially in larger sizes. Where excellence in visual presentation is an important factor, optical alignment needs to be done. Allowing parts of the letters to overlap the vertical edge, however, requires line-by-line design.

```
OH          OH          OH          OH
YES,        YES,        WOW,        WOW,
THIS        THIS        THIS        THIS
VERTICAL    VERTICAL    VERTICAL    VERTICAL
EDGE        EDGE        EDGE        EDGE
ALIGNS      ALIGNS      IS          IS
WELL,       WELL,       OPTICALLY   OPTICALLY
BUT IT      BUT IT      ADJUSTED    ADJUSTED
LOOKS       LOOKS       TO LOOK     TO LOOK
AWFUL       AWFUL       BETTER      BETTER
```

When to use all-caps

Seldom: only when you really must.

In small amounts, restricted to a few words.

To achieve what they are suited for: startling attention-getting.

For logos, trademarks, labels, titles.

For text that must simulate telegrams or computer printouts.

For matter that needs an aura of dignity or specialness.

For tombstones and other such depressing things.

Up-and-Down Style versus downstyle

A subset of the capitals-and-lowercase problem is the decree that the first letters (initials) of important words in headlines be capitalized. This practice evolved in U.S. newspapers in the last century for technical reasons: they ran out of capital letters for headlines and had to invent some alternative means to distinguish headlines from text. With today's technology, such shortages cannot happen; besides, we now use much larger and bolder type to make headlines noticeable, so we don't need capitals to bring attention to the change in typographic texture.

Nonetheless, this outmoded typographic habit continues in un-questioned use (although only in the United States). It is perpetuated not only by force of convention, but also by the continued functional necessity of differentiating headings from text in typescript or word-processor output. There the all-cap headings are, indeed, a useful variant. However, it is unnecessary to translate it into typeset type, especially when you realize how confusing it is to read.

Our eyes recognize words as letter-groups by scanning the upper part of the word.

You can easily decipher these words by seeing only their tops...

You can easily decipher these words by seeing only their tops...

...but it is much harder to recognize the words by their bottoms

...but it is much harder to recognize the words by their bottoms

Capital Initials Impede and Retard Reading Speed Because They Disturb the Natural Patterns and Relationships of Letters to Each Other. tHIS iS jUST aS sILLY, bUT fORTUNATELY wE dON'T sEE iT tOO oFTEN.

This Visual Hiccuping Serves No Purpose Other Than Tradition

This Visual Hiccuping Serves No Purpose Other Than Tradition

To make matters worse, an Up-and-Down Style prevents the reader from noticing proper names and acronyms, both of which use capital letters as distinguishing characteristics. Instead of being visible as the vital references they are, their presence is camouflaged by neighboring words that receive the identical typographic treatment without deserving it.

The Quick Brown Fox Jumps Over TLD, That Lazy Dog!

The quick brown fox jumps over TLD, That Lazy Dog!

Setting the acronym letters TLD and the explanatory initials in capitals helps make these words tower over their neighbors. That makes them look "different" and distinguishes them as clues to speedy comprehension of the information.

If you want your product to read smoothly, look contemporary, and be logically crafted, become aware of the dead hand of tradition and get rid of the Up-and-Down Style. Instead, start your headlines with a capital letter and continue in lowercase (downstyle), as if it were a normal sentence that happened to be important and therefore deserved a bigger and bolder setting.

iſſima, ſed quòd omniũ litera=
lium protractiónum te=
nuiſsimę proxima.
Eminuero quę per c b angulos
commeat propríum hoc ſibi no=
men habet ✓

This is an example of cursive handwriting or chancery script, on which italic type design is based. It comes from a page of Gerardus Mercator's *Literarum latinarum* published in Louvain, Belgium, in 1540. Mercator was not merely a calligrapher, but also an engraver, maker of scientific instruments and globes, and the cartographer responsible for the Mercator projection, the most familiar version of the map of the world.

Roman or italic?

Most typefaces made for setting text (those that are not specially designed for display in headlines) come in two versions: roman and italic.

Roman

The roman has a vertical emphasis

Italic

The italic is slanted

True italics, however, are more than mere variations in posture. They are separate faces, designed to accompany, match, and complement the roman versions. The shapes of the characters are often very different. The so-called italic versions of roman produced by photographic distortion or digitized typesetting technology take the roman letters and slant them some 12 degrees to the right. The results are merely oblique versions of roman forms, not true italics.

Italics originated in Venice, where, according to legend, Aldus Manutius needed a typeface that would crowd more characters onto a page than the round roman faces available in his time (around 1500). He based the new, tight design on the cursive handwriting then in use at the papal chancery. Hence its original names: cursive, or chancery. (*Cursive*, meaning "running"—so, by implication, "writing fast.") To this day, many non-English-speaking countries call the form *cursive* rather than *italic*. It was never easy to read and never caught on as a basic text face, especially since narrower and tighter-setting roman faces were also developed at about the same time.

The Milanese monk and author Paolo Attavanti is shown writing in his library (published in 1479 in his *Breviarium totius juris canonici*). The letters stand for Magister Paulus Florentinus Ordinis Sancti Spiritus.

Newspaper-printing convention has used italics to emphasize important elements in the text. I believe that is a functional misuse, since the design of italics is much more delicate and paler, and the slanted posture makes them harder to read than the roman version of the face they accompany. They are also deliberately gentler, less assertive, more picturesque, more decorative. In my opinion, italics should not be used for crude attention-getting but rather for creating subtler contrast. They can enrich the page or make a particular element special. Furthermore, they should never be used in bulk for reading matter because they slow down velocity of reading considerably.

Congress shall make no law respecting an establishment of religion, or prohibiting the free exercise thereof; or abridging the freedom of speech, or of the press; or the right of the people peaceably to assemble, and to petition the government for a redress of grievances.

Congress shall make no law respecting an establishment of religion, or prohibiting the free exercise thereof; or abridging the freedom of speech, or of the press; or the right of the people peaceably to assemble, and to petition the government for a redress of grievances.

Because traditional italics set tighter, they are more difficult to read in bulk than roman.

There are many different options for creating emphasis:

· Substitute **boldface** for italics. But take care: use boldface in moderation. Like italics, too much of it tires the reader's eye.

· Underline (underscore) the important word, phrase, or whole sentence. But reserve this for material that really deserves to be called to the viewer's attention. Not only does overdoing it make the product look spotty and therefore less attractive, but it devalues the technique you are using. Stress must be used with restraint. Use too much of it, and your pages will look frenetic.

· Increase the type size.

· Set the important parts to a different measure, changing the line length.

· Go ragged-right if the surroundings are set justified, or vice versa.

· Choose another typeface.

· Run the stressed elements in another color, if that's available.

You don't need to force italics in the wrong direction. You can let them be their characteristic selves. To make the most of their gentle informality, use them as two or three free-floating lines on the page, or perhaps as blurbs or quotes or extracts, a few lines at a time. They are ideal as informal visual contrast to the surrounding hard-edged makeup of a page.

And, of course, use them for the various copy elements traditionally distinguished by italics such as:

—titles of books, periodicals, plays, films, works of art

—names of vehicles such as ships, airplanes, and trains

—references to words as words

—foreign words in text

—scientific names

—mathematical unknowns

—names of legal cases

—stage directions

If you are working with traditionally produced type, specify the words to be set in italics in a manuscript by a single-line underscore. The word *italics* is often abbreviated to *ital*, or in newspaper circles to *ltlx* or even just *X*.

Superimposing words on backgrounds is nothing new. This woodcut is from a textbook on music (*Theorica musicae*) by Franchinus Gafurius, printed in Milan in 1492 by Philippus de Mantegatiis. It shows the organist at the keyboard below his pipes, each of which bears callouts and annotations. A clear diagram.

Type on backgrounds?

We are used to reading black type on white paper. This format evolved as the most effective in terms of the materials and technology available, as well as the easiest to read. There is some concern whether the maximal contrast of pitch-black ink on the brightest white paper may be detrimental to legibility—and perhaps it is. But we need not be overly worried, because the general run of printed matter is really in dark gray on a stock that is anything but white.

White type on black (called *reverse* or *dropout* type), black type on a colored background, or black or white type on a mottled background (surprinted on, stripped into, or dropped out from a picture) can be quite another matter. Here legibility may indeed be jeopardized. That does not mean such trickery ought never to be used. It merely means that the danger must be understood, and disaster avoided by compensating for the problems ahead of time.

White on black

Two factors must be understood in using white type on a black background. The first is that tests have proved that white on black is harder to read than the same text set the same way in black on white. The difference becomes serious with a lot of text. A few words, even a sentence or two, are not particularly serious. But a whole column of type is quite another matter: it may even be skipped because it looks too difficult and uninviting to bother with.

A second problem is that in the printing process the strokes of the letters can easily clog up with ink or toner, making them thinner than they should be. To make matters worse, if the face uses contrasty thick-and-thins to start with, parts of the letters can easily disappear altogether. Both conditions are seriously detrimental to ease of reading.

To solve both problems you need to use:

• a face that has a fairly even stroke thickness

• a face that has heavy serifs or, better, none at all

• a face of medium weight—bolder than the body copy

• a size larger than the body copy

• shorter than normal lines

• more generous interline spacing

Most of all, you need to use white type on black as little as possible.

Instant communication, vintage 1902, courtesy of Sears Roebuck catalog. Note how clearly the word *BATTERY* reads in black on white. The words *MANUAL OF TELEGRAPHY* read well also, though not as punchily. And note that the word *TELEGRAPHY* is more effective than *MANUAL* because it is a trifle larger. Dropping type out from a background successfully is a subtle art.

Black on color

In printing black on color, much depends on the color background. If it is light in tone and yields good contrast to the ink or toner, then it matters little if it is powder blue, pea green, or toast brown. If, however, the blue is dark, then some compensation will be required to make up for the diminished contrast. The type will have to be bigger and blacker, to make it noticeable and legible. Use the criteria outlined for white on black.

Black or white type on a mottled background

Black type printed over a picture is surprinted or stripped in. White type printed over a picture is dropped out. Common sense suggests that black type be used when the background is pale and white type when it is dark. However, both conditions decrease ease of reading for the same reasons given for white on black or black on color. Again, the suggestions for white on black apply, but even more urgently.

The problem is far more serious when the background is not a reasonably smooth pale or dark, but mottled. It is very difficult to make any type legible against such visual competition. It is wiser not to tempt fate and to avoid it altogether.

TYPE FACTS

Publishing has always been considered a risky
occupation. Here, in the first known rendering of
a printing press, the subject is Death and the
Printer. It is a woodcut from *La Grand Danse
macabre* published by Matthies Huss in Lyons,
France, in 1499.

Composing a page looks so complicated. No wonder assembling a whole multipaged publication is terrifying. There are so many daunting dont's to remember . . . so many misleading conventional wisdoms to bear in mind . . . so many "supposed-to" axioms to recall.

Forget the rules. Forget the prejudices and supposed-to's. Use common sense. There is no such thing as the only right solution. There is only the effective solution. If it works, then it is indeed right.

What is essential is to analyze the project first. Define its purpose, its audience, its special characteristics. If you look hard enough, you will discover that each problem carries within itself the seeds of its own solution. Find them, and the problem resolves itself. It designs itself. You only get into difficulties when you try to impose a pat solution on a set of circumstances that do not fit.

Once you realize that a page or even a whole book is merely pieced together out of small units, the overwhelming, monolithic problem disintegrates into small-scale decisions, each of which is easy to handle. You can master them individually, control them collectively.

To succeed, you have to have confidence in your own judgment. No one can help you decide on the policy you think is right for any particular publication. It grows out of your own analysis of the problem. But you must also have confidence in your technical knowledge. That, too, is mostly common sense—general knowledge based on experience.

To help you establish that confidence and put the bits of technical knowledge you need in perspective, here is a collection of basics. They have been assembled in logical groups. You may want to scan the pages to familiarize yourself with what they include. But it's not unusual to postpone reading it all in detail until such time when you really need the knowledge. At least you'll know where to look it up.

Decoration and graphic delight are affected by the tides of fashion. In 1568, when Jost Amman published his *Ständebuch* in Nuremberg, the illuminator was an important member of the publishing fraternity. It was his job to color and gild the illustrations by hand. A method using stencils and patterns had been devised, but such mass-produced work was held in lower esteem and therefore commanded lower fees.

Typographic variety

Type is a remarkably varied material. The variations are in subtle, minute details, adding up to major differences that can influence the success of your publication. It is not merely a matter of aesthetics to create something pleasing, but of down-to-earth practicality, for it affects whether your document will be noticed, read, understood, and ultimately lead to action.

To get an idea of the riches at your disposal, consider that we are taught to read two distinctly different alphabets in type.

ABCDEFGHIJKLMNOPQRSTUVWXYZ CAPITALS
abcdefghijklmnopqrstuvwxyz LOWERCASE

The cursive (handwritten or script) typeface is another variant.

ABCDEFGHIJKLMNOPQRSTUVWXYZ CAPITALS
abcdefghijklmnopqrstuvwxyz LOWERCASE

Next reflect on the two basic posture variations available in most typefaces.

ABCDEFGHIJKLMNOPQRSTUVWXYZ ROMAN (VERTICAL)

ABCDEFGHIJKLMNOPQRSTUVWXYZ ITALIC (OBLIQUE)

Now add the basic variations of weight.

ABCDEFGHIJKLMNOPQRSTUVWXYZ REGULAR

ABCDEFGHIJKLMNOPQRSTUVWXYZ BOLDFACE

Don't forget the many variations of boldness that are available.

Hairline Thin Extra Light Light Book Regular Medium
Demi Bold Semi Bold Heavy Black Ultra

Watch out for these names, though: they are not standardized and what they describe can vary in visual effect from one face to another. Always determine your choice by what is produced on your equipment or by the sample from your supplier.

Think about the basic variations in width.

ABCDEFGHIJKLMNOPQRSTUVWXYZ REGULAR

ABCDEFGHIJKLMNOPQRSTUVWXYZ CONDENSED

ABCDEFGHIJKLMNOPQRSTUVWXYZ EXPANDED

Plus these additional variations.

Extra Condensed **Ultra Compressed** **Extra Compressed** **Compressed**
Narrow Extended **Expanded** **Wide**

Condensing and expanding can be produced in a variety of ways. The traditional method, in which each variation is specifically designed, yields the finest results. In phototypesetting, however, the existing patterns can be manipulated by lenses, and digitized typesetting can

narrow or widen letterforms by removing or adding raster lines to each character. The range of increments is just about infinite, bounded only by common sense. In the illustration here, the possibilities are shown in large (3 percent) increments to convey the idea without wasting too much space.

CONDENSED Excellence in typography is the result 85%
Excellence in typography is the result 88%
Excellence in typography is the result 91%
Excellence in typography is the result 94%
Excellence in typography is the result 97%

NORMAL Excellence in typography is the result 100%

EXPANDED Excellence in typography is the result 103%
Excellence in typography is the result 106%
Excellence in typography is the result 109%
Excellence in typography is the result 112%
Excellence in typography is the result 115%

Type is usually specified in standard sizes, which evolved from the tradition of hot-metal type. Anything up to 12-point type is considered *text* type. Type over that size is considered *display* type.

ABCDEFGHIJKLMNOPQRSTUVWXYZ 6 POINT
ABCDEFGHIJKLMNOPQRSTUVWXYZ 7
ABCDEFGHIJKLMNOPQRSTUVWXYZ 8
ABCDEFGHIJKLMNOPQRSTUVWXYZ 9
ABCDEFGHIJKLMNOPQRSTUVWXYZ 10
ABCDEFGHIJKLMNOPQRSTUVWXYZ 12
ABCDEFGHIJKLMNOPQRSTUVWXYZ 14
ABCDEFGHIJKLMNOPQRSTUVWXYZ 18
ABCDEFGHIJKLMNOPQRSTUVWXYZ 24

The traditional range of display type sizes is shown on top of page 47. The stepped sizes are not accidental. They were developed through trial and error over the years to fill specific needs. They work: the deliberate dissimilarities in proportion are noticeable to the untrained eye. They can thus be applied to rank ideas in order of importance and their classification will be universally understood. It is wise to be conservative and stay with them unless specific needs demand otherwise.

E E E E E E E E E E E E
14 18 24 30 36 42 48 60 72 84 96 144 points

Phototypesetting as well as electronically digitized equipment can produce an infinite range of sizes in increments as small as one-tenth of a point. The examples here are in half-point increments.

Xx	Xx	Xx	Xx	Xx	Xx	Xx	Xx	Xx	Xx	Xx	Xx	Xx
5	5.5	6	6.5	7	7.5	8	8.5	9	9.5	10	10.5	11

Xx	Xx	Xx	Xx	Xx	Xx	Xx	Xx	Xx	Xx	Xx	Xx
11.5	12	12.5	13	13.5	14	14.5	15	15.5	16	16.5	17

Xx	Xx	Xx	Xx	Xx	Xx	Xx	Xx	Xx	Xx	Xx
17.5	18	18.5	19	19.5	20	20.5	21	21.5	22	22.5

Xx	Xx	Xx	Xx	Xx	Xx	Xx	Xx	Xx	Xx
23	23.5	24	24.5	25	25.5	26	26.5	27	27.5 POINT

All the variety discussed so far must be multiplied by the incredible number of typefaces available. There are thousands, each with its own set of variants. Nevertheless, only some 25 faces account for 90 percent of all type set nowadays. (Newspapers have their own groups of special text faces.) Some of the most widely used, all set in 14-point to make the differences clear, are shown on page 48.

Each face has a certain personality. There are light, delicate, "feminine" faces, and there are bulky, aggressive, "masculine" ones. There are those that bespeak high-tech, others that bring an image of antiquity. These interpretations are subjective and arguable. Furthermore, the effects they create are subliminal: few readers are aware of typefaces as such. Yet they undoubtedly respond to the atmosphere type helps to create, and they either like the result or don't. The point to remember is that the form and the content must relate: the typeface should be congenial to the words.

Pickaxe and shovel **PICKAXE AND SHOVEL** Pretty lace **PRETTY LACE**

The main purpose of letters is the practical one of making thoughts visible
Baskerville

The main purpose of letters is the practical one of making thoughts visible
Bembo

The main purpose of letters is the practical one of making thoughts visible
Bodoni

The main purpose of letters is the practical one of making thoughts visible
Bookman

The main purpose of letters is the practical one of making thoughts visible
Caledonia

The main purpose of letters is the practical one of making thoughts visible
Caslon

The main purpose of letters is the practical one of making thoughts visible
Century Expanded

The main purpose of letters is the practical one of making thoughts visible
Century Schoolbook

The main purpose of letters is the practical one of making thoughts visible
Cheltenham

The main purpose of letters is the practical one of making thoughts visible
Garamond

The main purpose of letters is the practical one of making thoughts visible
Goudy

The main purpose of letters is the practical one of making thoughts visible
Helvetica

The main purpose of letters is the practical one of making thoughts visible
Janson

The main purpose of letters is the practical one of making thoughts visible
Korinna

The main purpose of letters is the practical one of making thoughts visible
Lubalin Graph

The main purpose of letters is the practical one of making thoughts visible
Melior

The main purpose of letters is the practical one of making thoughts visible
Novarese

The main purpose of letters is the practical one of making thoughts visible
Optima

The main purpose of letters is the practical one of making thoughts visible
Palatino

The main purpose of letters is the practical one of making thoughts visible
Souvenir

The main purpose of letters is the practical one of making thoughts visible
Spartan (Futura)

The main purpose of letters is the practical one of making thoughts visible
Times Roman

The main purpose of letters is the practical one of making thoughts visible
Univers

To complicate the problem even more, there are special variations of faces, including open letters:

OUTLINE INLINE LINED Hi-Lite Contour

Dimensioned letters with shadows:

Shaded Raised Shadow DROP SHADOW RELIEF

Alternative characters:

AABCDEFGGHIJKLMMMNOPQRSTUVVVWXYZ
abcdeefghijklmnopqrsttuvvvwwwxyyz

And ornamental or swash characters:

AAAAAAA BBCDDDEEEFFGGHHH

For each typeface there is what is called a *font*, embracing a collection of characters.

ROMAN CAPITALS AND LOWERCASE	ABCDEFGHIJKLMNOPQRSTUVWXYZ abcdefghijklmnopqrstuvwxyz	
ITALIC CAPITALS AND LOWERCASE	*ABCDEFGHIJKLMNOPQRSTUVWXYZ abcdefghijklmnopqrstuvwxyz*	
SMALL CAPITALS	ABCDEFGHIJKLMNOPQRSTUVWXYZ	
LIGATURES	ÆŒæœ Æ Œ fiflffffiffl *fiflffffiffl*	
LINING FIGURES	1234567890 *1234567890*	
OLD STYLE FIGURES	1234567890	
FRACTIONS	⅛ ¼ ⅜ ½ ⅝ ¾ ⅞ ⅛ ¼ ⅜ ½ ⅝ ¾ ⅞	
SPECIAL CHARACTERS	@ ℔ & £ & @ ℔ & £	
PUNCTUATION MARKS	[] * †	‡ ‖ § ¶ - — , . - ; ' : ' ! ? () , . - ; ' : ' ! ? ()

A separate font is needed for boldface versions. In hot metal, each size also required a separate font. In phototypesetting, however, the font is replaced by one or two master negatives (a small and a large one), from which the required size is created by lenses. In digital typesetting, the font is replaced by a bitmap, which defines the outlines of the shapes of the letters that are then filled in at the required size electronically.

In addition to the range of characters available in the normal font, many electronically produced typefaces also include underscored and strike-through type.

| Underscored type | A B C D E F a b c d e f |
| Strike-through type | A B C D E F a b c d e f |

Standard character sets have been assembled to allow setting of Afrikaans, Dutch, British and American English, French (including Canadian French), German, Italian, Portuguese, the Scandinavian languages, and Spanish. They are usually designated with the suffix *iso* (for International Standards Organization) following the font name. They include special characters and all the requisite floating accents.

abcdefghijklmnopqrstuvwxyzABCDEFGHI
JKLMNOPQRSTUVWXYZ 0123456789 ¼ ½ ⅛ ¾ ⅜ ⅝ ⅞
.,:;!¡?¿' " ' ' " "★ &/\| _ @¤¢£$¥¤%#°
←↑→↓ +−±=<>÷×~ ·§¶#®©™¹·²·³ ()[]{}«»
ÆÐHIJL·ŁØŒÞŦŊ æđħijl·ŧøœþŧŋ ∫– µΩκðªºß'nŋ

Character set of Xerox Letter Gothic 12 iso

Data-processing (DP) character sets contain the characters needed to match the most widely used data-processing applications.

ABCDEFGHIJKLMNOPQRSTUVWXYZ
αεορω ∩∪⊃⊂ ∨∧ →←↓↑ ∇∆⊥⊤
0123456789 $¢∘ +−×÷=≠<>≤≥~
.,:;?'★¨ ()[]{} /\|_¯ ⌈⌊⌋¬→↦◇▢

Xerox APL-A 10 data-processing font

The purpose of this "showing" of type possibilities is not to worry or upset you, but to suggest the vast range of forms that make typography such a flexible medium. Note that not all these variations are available in all faces, on all equipment, everywhere, and at all times. Do not be frustrated by that: nobody needs the full range of possibilities. Besides, it is not a good idea to use them all. The simpler and more restrained the typography, the better the final result. Use the minimum means for the maximum illumination of the information.

Letters and blank spaces were cast as individual pieces of metal. Their interchangeability and possible reuse was the great invention of Johann Gutenberg in the mid-fifteenth century. They are shown here in an illustration from Diderot's *Encyclopedia*, first published in Paris in 1751. Each line's worth of characters was first arranged in a "stick," then the lines were gathered in a "galley." If more blank space was needed between the lines, extra shims of metal ("lead") were inserted—hence the term *leading*.

Technicalities

You may not want to become a professional typographer. You may have other interests and ambitions. But you may have to discuss your project with professionals. That is why it is a good idea to have some inkling of specialized knowledge—if only to be able to use the jargon. It is a lot of fun to throw a few impressive-sounding words around.

Yet there is a deeper need: you have to know the words to understand the concepts they represent. So, beyond just enlarging your vocabulary, here are some necessary technicalities.

Spacing and kerning

In the old days, when each letter was the top part of a piece of metal, the space between letters was just about immutable. You could insert a sliver of spacing material between the characters, if they were not too small. You could do that a bit more easily if the setting was produced by linecasting machines such as linotype. But it was not possible to squeeze the letters together by reducing the space between them. In film and digital typesetting, however, intercharacter spacing is completely flexible. Still, normal spacing should be adhered to, unless you have good reason to depart from it.

NEGATIVE SPACING (tighter)	Spacing between the characters – 2 units
	Spacing between the characters – 1 unit
	Spacing between the characters – 0.5 unit
NORMAL	Spacing between the characters Standard
POSITIVE SPACING (looser)	Spacing between the characters + 0.5 unit
	Spacing between the characters + 1 unit
	Spacing between the characters + 2 units

The universal letterspacing (negative or positive) just described must not be confused with individual negative letterspacing, more commonly known as *kerning*. Many letters need to be placed closer together to look right. One part of the letter needs to be tucked under its neighbor to prevent jarring gaps. The most common character combinations that require this special treatment are:

T|o T|o

To Tr Ta Yo Ya Wo Wa P. TA PA yo we

Muts, nuts, ems, ens, quads

These are old-fashioned terms, redolent of hand-set type, when metal character after metal character was carefully positioned in a stick, the type assembled line by line, and then the whole construction locked in a chase (a kind of frame) and tied up with string. It was a craft. Rules of thumb and practical shortcuts dominated the handcrafted labor. Some vestiges remain because they continue making sense, even though we assemble type electronically. Take, for example, muts and nuts.

A square of the type size (or quad) was and continues to be a useful proportion. In most typefaces the capital M is shaped more or less like a square. That is why the square of the type size was nicknamed an "M." To avoid visual confusion, the "M" is spelled out as *em*. In the noise and bustle of the workshop, the apprentice could easily misunderstand being asked for an "M," even if it was spelled *em*, so for clarity it was called *mutton* (just as "Alpha, Bravo, Charlie" stood for "a, b, c"). The long word *mutton* was quickly cut to *mut*, and there we are.

Not quite. The simplest things tend to be complicated in typography. The capital M does indeed resemble a square, but the em measures a little larger than the M. It is the square of the type size: that measurement must include the descenders of the lowercase letters. In some faces the ascenders tower above the capital letters, so they, too, must be included in the overall em's size.

One-half of an em is also a useful typographic measurement. For some reason, lost in the mists of antiquity, it was called an "N," though the N measures more than one-half the width of an M. The "N" was spelled *en* and nicknamed *nut*. To compound the felony, although a quad is strictly a square, the hunk of metal that represented a nut was also called a *quad*. So we now have such a thing as a "half-square square" commonly known as a *nut quad*!

So far so easy. Here is the hard part. Type comes in all sorts of different sizes. The em and the en are always related to the type's own size. They do not exist on their own as a measurement like inches, centimeters, or even picas and points. They are ratios of the point size. The em always measures sideways whatever the type height happens to be. For instance, in 18-point type, the em measures 18 points. The en, being half its width, measures 9 points. On the other hand, in 10-point type, the em measures 10 points wide; the en 5 points wide.

The issue is confused even further because the word *em* is often substituted for the word *pica* when printing professionals talk shop. The basic measurement for type used to be the 12-point pica. Logically the 12-point em—being a horizontal measurement—was used to describe the length of the line. A 14-pica-long line would be known as a 14-em line, and everyone would know from the sense in which it was used that that is what was meant.

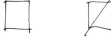

In the United Kingdom the term *em* (meaning a pica or 12 points) is still used as widely as ever. In the United States the term *em* is usually restricted to describing the depth of paragraph indents, since the normal is a one-em indent. (In 10-point type, the paragraph indent usually measures 10 points.)

Quadding

In the United Kingdom and several other places, the term *quadding* is still commonly used. *Quad-left* means the same as "placed at far left" or "flush-left," and *quad-right* the same as "placed at far right" or "flush-right."

Quad-left

Quad-right

Quad-center

Where does this term come from? In the days when type was made of metal and each character was set by hand, the quad was a square area of blank metal, lower than type-high, so that it did not print. The white, nonprinting areas of the page were filled in with such blanks.

Pitch

Line printers and old-fashioned typewriters use monospaced typefaces —faces in which each letter uses the same space as all the others, regardless of how wide it ought to be. The lowercase "i" or "l" is very narrow. The lowercase "m" or capital "W" is extremely wide compared with the "i" and the "l." Yet the "i" and "l" are extended (fattened), and the "m" and "W" are condensed (narrowed) to make them fit a standardized character width.

```
These characters are monospaced: the i and the m are of equal width
THESE CHARACTERS ARE MONOSPACED: THE I AND THE M ARE OF EQUAL WIDTH
THESE CHARACTERS ARE MONOSPACED: THE I AND THE M ARE OF EQUAL WIDTH
These characters are monospaced: the i and the m are of equal width
These characters are monospaced: the i and the m are of equal width
THESE CHARACTERS ARE MONOSPACED: THE I AND THE M ARE OF EQUAL WIDTH
```

There are two basic proportions:

· 10-pitch, which fits 10 characters into each inch

· 12-pitch, which fits 12 characters to the inch

You've probably heard 10-pitch referred to as *pica* type and 12-pitch called *elite* type. Obviously the 12-pitch type looks smaller, since two more characters are squeezed into the same space.

```
          First line
          Second line
   1"     Third line
          Fourth line
          Fifth line
          Sixth line
```

Both 10-pitch and 12-pitch typewriters have the same vertical spacing up and down the page. Both yield six lines to the inch.

"Executive" typewriters have variable pitch, with the spacing varying according to the natural shape of each letter.

Film-set type is designed to fit each letter into a certain number of vertical slivers of space or units. The narrower the units, the finer the resulting letter shapes and the way they fit together. Systems using as few as 18 and as many as 72 units have been devised. (Once the letters have been successfully fitted into the system, the same proportions of units-per-character are retained, no matter the size of the type.)

abcdefghijklmnopqrstuvwxyz

Electronic, digitized type is designed to fit a grid or raster of dots. The finer the dots—the more there are to a given area—the finer the resolution, and thus the resultant letterforms.

Typing was considered much too technical for women to learn when typewriters appeared in the late nineteenth century. Electric machines like the telegraph were also men's perogative, too dangerous for women to handle. Not till the beginning of the twentieth century did women become secretaries. This genteel illustration from a typewriter ad was daring in the 1890s.

Punctuation

imaginewhatajobitwouldbetodecipherletalonetounderstanda
paragraphwithoutpunctuationhopelessyousaywhysoitis
evenifthewordsarewellknownliketobeornotthatisthequestion
williamshakespeare 15641616

no punctuation, no word spacing, no capitalization

Imaginewhatajobitwouldbetodecipherletalonetounderstanda
paragraphwithoutpunctuationHopelessyousayWhysoitis
evenifthewordsarewellknownlikeTobeornotthatisthequestion
WilliamShakespeare 15641616

no punctuation, no word spacing, just capitalization

Imagine what a job it would be to decipher let alone to understand a paragraph without it Hopeless you say Why so it is even if the words are well known like To be or not that is the question William Shakespeare 1564 1616

no punctuation, just word spacing and capitalization

Imagine what a job it would be to decipher, let alone to understand, a paragraph without it. Hopeless, you say? Why, so it is—even if the words are well known, like: "To be or not...that is the question" (William Shakespeare, 1564–1616).

punctuation, word spacing, and capitalization

(Now imagine how much more difficult it would all be if some of the words were misused or misspelled. And please note that no word breaks have been shown at the ends of the lines because the material was set ragged-right. Both are conventions that are also needed to help extract the meaning from writing.)

Words are depicted on the page as separate units. That is a great help to understanding. The earliest writing, however, showed no spaces between words, as in the first example above. Today, word-groups representing a thought—sentences—are identified at the start by a capital letter and at the end by a period. Again, that is something we must not take for granted. The first punctuation, consisting of vertical lines between phrases, is found in the Semitic script on a Moabite stone inscription from 850 B.C.

The word *punctuation* comes from the Latin *pungere,* "to puncture or prick." A punctuation mark is a spot that has been pricked by an instrument (the past participle of *pungere* is *punctus*).

The purpose of punctuation is to help readers understand meaning. It clarifies thoughts and ideas by identifying the relationship of words to each other. Though they are apparently arbitrary, the rules to which punctuation must conform have developed through practice over the years. They represent agreements among literate people about how to use our language in writing.

If you think of writing as merely the visible translation of speech, then punctuation becomes easy. The pauses in speaking are signaled by marks in writing.

· A comma is the equivalent of a brief pause.

· A period is a longer pause.

· A dash is a different kind of pause, indicating an interruption of a thought.

The inflection of the voice is also translated into visible form in writing.

· A question mark suggests the rising of the voice at the end of a query.

· An exclamation point indicates emphasis.

The other punctuation marks have been evolved for other, equally functional purposes.

· Parentheses and brackets set off subsidiary thoughts.

· Quotation marks identify borrowed or special phrases.

· Colons mark the start of lists.

· Ellipses represent missing words.

Period The word *period* comes from the Greek *periodos* meaning "cycle," thus a complete thought or sentence. In the fifteenth century, the period was known as a *jot,* from the Greek *iota*.

Here are a few do's and don'ts for periods:

· Use them at the end of a sentence, unless they are replaced with exclamation points or question marks.

· Don't use them at the end of headlines or subheads. They mark the end of a thought and may discourage the reader from continuing reading. In the United Kingdom periods are called *full stops* for good reason.

· Don't use them in lists when the items are short and not complete sentences. More complex items and complete sentences may require periods, as in this list.

Exclamation point Whenever the Romans wanted to say "gee-whiz," "fantastic," "wowee," "cool," or the equivalent, they said, "Io." Scribes, saving precious space on the manuscript, wrote the two letters above each other, the "I" on top, the "o" beneath it. Soon the "o" filled in with ink and became a dot.

Don't punctuate your writing with lots of "screamers" or "bangs" to increase emphasis. It looks cheap and overblown. Instead, use them with discretion.

¡In Spanish, an upside-down exclamation point precedes a sentence ending with an exclamation point!

Question mark	The Latin word *quaestio* ("I ask") was shortened by space-saving scribes to "QO" . . . and soon a "Q" above an "O." The "Q" quickly degraded into a squiggle and the "O" into a little blob.
	In Spanish, an upside-down question mark is placed at the beginning of a sentence that ends in a regular question mark. A useful warning— alerting the reader, especially when reading aloud.
Colon	A colon might be thought of as a divider. It can be used:

- to introduce a list, as it just was

- in place of such expressions as *for instance, as follows, namely, to wit, viz, for example,* and *that is*

- to introduce a quotation or extract in dialogue

- to separate minutes from hours

- to set off a salutation in a letter

A colon is usually followed by a lowercase letter, especially if what follows is an incomplete sentence. It may, however, be followed by a capital if it introduces dialogue or a formal statement.

Semicolon	Think of the semicolon as a break in continuity greater than that implied by a comma. Most frequently it is used to separate the two main clauses of a compound sentence when they are not linked by a conjunction. It is also used to separate items in a series when commas would not be clear enough.
Comma	The word *comma* comes from the Greek *komma* ("segment, clause"), indicating a part of a sentence. In the fifteenth century it was also known as a *tittle,* from the Latin *titulus* ("label, title"). In early manuscripts commas appeared as a full slash mark, or solidus (/), but later shrank to today's size.
	Commas are used as needed for clarity: to separate thoughts from each other and to make sentences less unwieldy. There are, however, different rationales for the use of commas, and probably no two editors would agree in every instance. Here are some common uses:

- after a conjunction in a compound sentence

- to distinguish a nonrestrictive phrase or clause (one that could be omitted without changing the meaning)

- to separate three or more elements in a series

- to set off parenthetical remarks

- to separate month and day from year in month/day/year sequences

- to set off such expressions as *namely, for example,* and *that is*

- for words in apposition (unless they have a restrictive function)—for example, "Mr. Gold, my neighbor, ..."

Parentheses	Parentheses, nicknamed *parens,* are used for separating subsidiary phrases (or background information) from the flow of text. To enclose secondary parenthetical expressions within parentheses, use brackets (going from parentheses to brackets [like this]). Braces provide a third degree of enclosure or sign of aggregation—([{ }])—but it is best to avoid this situation altogether.
	All punctuation should occur inside the parentheses if the item is a full sentence. Avoid commas or semicolons before the opening parenthesis, unless the parentheses are used for numbers in a list.
Hyphen	Hyphens link words together, but must be used with care because interpretation can be affected by the inclusion (or lack) of a hyphen. Follow the practice suggested by a good, up-to-date dictionary.

Dashes There are two main kinds of dashes: the long em-dash and the short en-dash. There are also two-em and three-em dashes, but these are used infrequently (for missing letters and missing words respectively).

The em-dash is a full square of the type size (see page 52). One of its main uses is to signal sudden changes in tone. Or it may be used instead of parentheses to set off a clause or phrase. If you can't type an em-dash on your equipment, you can use two hyphens in a row (--). But, in general, use the em-dash sparingly, for it attracts attention to itself and can be disturbing.

An en-dash is only one-half of the square of the type size and resembles a hyphen. It is used primarily to represent missing but implied items in a series ("2–4" means the numbers 2 *through* 4). If your equipment doesn't have an en-dash, use a hyphen instead.

Solidus Also known as a *slash, slant, shilling mark, diagonal,* or *virgule,* the solidus originally functioned as a comma. Today its major uses are:

• separating the divisor from the dividend in fractions (1/2)

• separating the days, months, and years in dates (2/14/1987)

• implying the word *per* ($3/100)

• indicating choice (yes/no)

• indicating line ends when poetry is shown run-in (i.e., in a continuous stream rather than line by line)

Sometimes a vertical bar (|) may be used instead of the slanted solidus for aesthetic reasons.

Apostrophe The main use for an apostrophe is in forming the possessive of a noun. Normally, this is done by adding an apostrophe and an "s." The main exception is in plural words ending with an "s," which only need an apostrophe after the last "s." An apostrophe is also used in forming the plurals of certain abbreviations and letters written as letters. Keep in mind that if the word is italicized or underlined, the apostrophe and "s" are not italicized or underlined.

Ellipses Ellipses are three dots used to indicate the unfinished end of a spoken sentence or omission of a word or phrase from quoted material. If an entire sentence or paragraph is omitted, four dots should be used, with the first positioned as a normal period.

Quotation marks In the United States quotation marks begin with a 66 (or sometimes a flopped 99) and end with a 99. Single quote marks are used for quotations within quotations. Guillemets (usually starting « and ending ») are used instead of quotes in French, Spanish, and Italian.

Quotation marks are used:

• to set off direct dialogue

• to indicate a quotation from another source

• to denote irony or signal slang or obsolete terminology (but try not to overdo it and never use quote marks merely to give emphasis to an important word)

• to define letters or groups of letters discussed as letters

• for the titles of short poems, magazine articles, short stories, essays, comic strips, TV and radio programs, and songs (but the titles of books, long poems, periodicals, newspapers, movies, ballets, plays, paintings, and sculpture—as well as the names of airplanes, ships, and trains—are either underscored or italicized)

Underscoring and italicizing	Neither underscoring (also known as *underlining*) nor italicizing is strictly punctuation. But the fundamental purpose of punctuation is to help the reader to understand, and in a similar way underscoring and italicization offer clues to meaning.

Some of the most common uses of italics are listed on page 38. Also compare the use of quotation marks and italics for different kinds of titles described in the last entry.

If you use underlining instead of italics, it should be uninterrupted—the whole phrase should be underlined, not just the individual words. But do not underline the final period or any other punctuation mark that ends the phrase or sentence. |
| **Asterisk** | The word *asterisk* comes from the Greek *asteriskos*, "little star." This flexible mark (*) can be used:

· to represent a letter left out of a word

· as an itemizer (in place of the bullets used in this list, for instance)

· to signal a footnote

· to represent the word *born* when preceding a date

· as a prompt sign in computerese (where it is called a *splat*) |
Crosshatch	Also known as a *double hashmark*, the crosshatch (#) can be used as a substitute for the word *number* if it precedes the figure (#3) or a substitute for the word *pounds* if it follows a number (3#). It is also a proofreader's sign for "space" and a prompt sign in computerese (where it is called a *crunch*).
Dagger	Also known as an *obelisk* (from the Greek *obelos,* "a spit, skewer"), the dagger (†) is used as a signal for a footnote or as an indication that a word is obsolete. It can also represent the word *died* if it precedes a date.
Paragraph	Also known as a *pilcrow* or *blind P,* this symbol (¶) is used to represent a paragraph. It is most commonly used in legal work and editing.
Section	This symbol (§) indicates a subdivision of a paragraph in legal citations or a part of a chapter in a book.
Ampersand	This symbol (&) comes from the Latin *et* ("and"). The two letters "e" and "t" eventually became linked into a single squiggle by scribes. The name *ampersand* comes from the way children learned the alphabet by rote in the nineteenth century. It is really a mispronunciation of four separate words in one: "and per se and." The character itself offers incredible graphic variety and delight from typeface to typeface.

Signs are the basic unit of a communication system. They have a referent—they always stand for something. This somewhat bombastic trademark belonged to a printer who had no self-doubt about his workmanship. He operated in Strasbourg around 1537 and was known as the Crafft Miller shop. How puny and weak-willed do most of our contemporary logos look in comparison.

Symbols, pi characters, and rules

Type symbols not found on a normal font are often called *pi characters*. They include mathematical, commercial, advertising display, legal, multilingual, and even custom-constructed letters and symbols. Some common pi characters are shown on the facing page along with various rules.

In using symbols, take care that the reader will interpret the symbol in the same way you do. Check marks (ticks), for example, are generally understood in the United States to denote a correct response. In Sweden, however, a check mark on a school paper means "do it over." The implication is that the answer is wrong. A Swedish X, on the other hand, implies "correct," whereas in the United States, an X usually means "wrong."

Typographic spots	●	Bullet
	○	Open bullet
	□	Ballot box
	■	Square bullet
	◆	Diamond
	◇	Open diamond
Symbols	™	Trademark
	®	Registered
	©	Copyright
	@	At, apiece
	%	Percent
	℅	In care of
	$	Dollars
	¢	Cents
	£	Pounds sterling
	¥	Yen

Rules

━━━━━━ 2-point rule

──────── 1-point rule

──────── 1/2-point rule

──────── 1/4-point rule (hairline)

════════ Double rule

━━━━━━━ Scotch rule

-------------- Coupon rule (dashes of various proportions)

. Leaders (dotted lines)

Arrows and pointers

→ ← ↔ ↕ → → → ➔ → → → ➡ ◆

■➤ → → → → → → → → → → ➤➤ ➤➤

➤➤ ⇒ ▶ ➤ ➡ ➡ ⇒ ⇨ ◇ ⇨ ⟐ ⟐ ⟐

⤴ ▲ △ ▼ ▽ ▲ △ ▼ ▽ ▷ ◁ ▶ ◀

Printers' flowers

✳ ✳ ✳ ✳ ✳ ✳ ❋ ❋ ❋ ❋ ✳ ✳ ✳

✳ ✳ ✛ ✚ ❀ ❁ ❀ ✹ ✺ ✹ ✴ ❋ ✳

★ ★ ☆ ☆ ☆ ☆ ★ ★ ★ ★ ✴ ☆ ✴

Dingbats

☞ ☜ ☞ ☞ ☞ ☞ ☞ ☞ ☞ ☞ ☞ ☜ ☞

✂ ✌ ✌ ☎ ☎ ☎ ☎ ☎ ☎ ☎ ✆ ✉ ✦●

✓ √ ✔ ✿ ✿ ◇ ◆ ◆ ♠ ♥ ◆ ♣ ♤

This drawing of an early Italian "computer" is based on the system developed by the eighth-century English monk, the Venerable Bede. He described his number-crunching method in *On Calculating and Speaking with the Fingers* and could show any number up to 9,999 by varying the combinations and positions of his two hands.

Numbers in type

The question of whether to use figures or words is a common one. Normal practice calls for spelling out a number that starts a sentence. If it looks ridiculous, rewrite the sentence. Normal practice also calls for spelling out all numbers up to 10 or 20 if they occur in the text, though some publications choose to spell out all numbers up to 100. Unless there are outside standards governing your publication, the decision is up to you. If there are many numbers, is it better to set them as numerals and sacrifice the look of the piece to conciseness? Is it easier to gather the concept *twenty-seven* or *27*? Whatever you decide, try to be consistent.

You must also decide what kind of figures to use. There are two different kinds of Arabic numerals in type. *Lining* figures—also called *ranging* or *modern* figures—are the same height as the capital letters in the font.

XYZ1234567890

Old style figures—also called *old face, nonlining,* or *nonranging* figures—align on the x-height of the lowercase alphabet and have ascenders and descenders.

xyz1234567890

The lining figures look neater for tabular matter and other technical uses. On the other hand, old style figures look better in running text, because they are smaller and therefore less intrusive.

Equations and other difficulties

Mathematical typesetting is complicated and can be expensive. Electronic systems are the most efficient, because what you see on the screen is what you get in the printout. Nevertheless, the machinery can only be as good as the program—and its user. The first step in the process is crucial: a clean, legible, correct, and well-thought-out manuscript.

To typeset mathematics, you may need a variety of symbols, many of which are available on special mathematical fonts. Some of the most common are shown in the list below (for more detail, see the *Chicago Manual of Style*). Unusual symbols may need to be custom-made at great expense. (These special characters are known as *sorts*.) It may, however, be possible to substitute other pi characters, boldface, italics, or even regular characters with "embellishments" such as diacritical marks.

$+$	Plus	(This symbol is much simpler than the one used in Egyptian hieroglyphics, where a picture of legs walking to the left meant "plus," while legs walking to the right meant "minus.")
$-$	Minus	(Johann Widman first used this sign, along with the plus sign, in the fifteenth century.)
\pm	Plus or minus	
\mp	Minus or plus	
\times	Multiplied by	(This symbol was invented in 1631 by William Oughtred, a Scottish Episcopalian minister and mathematician.)
\div	Divided by	
$=$	Equal to	(Robert Recorde, a Welsh apothecary, mathematician, and politician, first used this sign in *Whetstone of Witte* [printed by John Kyngstone in London in 1557]. He said: "Noe 2 thynges can be moare equalle than 2 parallel lines.")
\neq	Not equal to	
\equiv	Identical with, congruent	(This sign was introduced by Carl Friedrich Gauss, a German mathematician, in *Disquisitiones arithmeticae*, published in 1801.)
$\not\equiv$	Not identical with	
\sim	Similar to	
\approx	Nearly equal to	
$>$	Greater than	
$\not>$	Not greater than	
$<$	Less than	
$\not<$	Not less than	
\geq	Greater than or equal to	
\leq	Less than or equal to	

⊥	Perpendicular to	
<	Angle	
⌀	Diameter	
∴	Therefore	
∵	Because	
∞	Infinity	(This symbol was proposed by the English mathematician John Wallis in 1655.)
√	Square root	
∫	Integral	
π	Pi	(3.14159265…)
○	Degree	
′	Minute, foot	
″	Second, inch	
∩	Logical product, intersection	
⊃	Implies, contains	
∪	Logical sum, union	
⊂	Is contained in	
⊆	Is a subset of	

You might also be interested to know that:

• Decimal fractions were introduced in 1576 by François Viète, a French mathematician.

• Letters standing for algebraic quantities were introduced by François Viète in 1591 in his *Isagoge in artem analyticam.*

• Exponents and logarithms were introduced by John Napier of Scotland in 1614.

• The letters a, b, and c, representing known quantities, and x, y, and z, unknown quantities, were introduced by René Descartes in his *Discours de la méthode* in 1637. He was also the first to use x for horizontal coordinates and y for the vertical ones on a grid: the "Cartesian coordinates" or x- and y-axes on charts. In inventing analytic geometry he can also be credited with inventing graph paper.

Metric system

Most scientific measurement uses the International System of Units, popularly known as the metric system. The main units of measurement are:

m	meter	length
g	gram	mass
l	liter	capacity
s	second	time
A	ampere	electric current
K	kelvin	thermodynamic temperature
mol	mole	amount of substance
cd	candela	luminous intensity

Note that the names are written in lowercase and that the abbreviations are also lowercase, except for the two derived from proper names (Messrs. Ampère and Kelvin). Note also that no periods are used following the abbreviations.

Prefixes can be added to a basic unit, raising or lowering the unit by a power of ten:

da	deka-	10^1	10
h	hecto-	10^2	100
k	kilo-	10^3	1,000
M	mega-	10^6	1,000,000
G	giga-	10^9	1,000,000,000
d	deci-	10^{-1}	0.1
c	centi-	10^{-2}	0.01
m	milli-	10^{-3}	0.001
μ	micro-	10^{-6}	0.000001
n	nano-	10^{-9}	0.000000001

Other kinds of measurements can be obtained by combining units in different ways:

m^2	square meter	area
m^3	cubic meter	volume
m/s	meter per second	velocity
m/s^2	meter per second squared	acceleration
kg/m^3	kilogram per cubic meter	density
cd/m^2	candela per square meter	luminescence

In using this system, scientists try to keep the numbers as concise as possible. Long strings of zeros may impress the layman, but they can confuse scientists. For example, instead of saying "45,000 meters," say "45 kilometers" or "45 km." Instead of saying ".005 kilograms," say "5 grams" or "5 g."

The one place where the international system is not entirely uniform is in the handling of the decimal point. The British and American practice is to use a period or a dot, while continental Europeans use a comma for the decimal point. Within this system, however, commas are not used to separate digits in large numbers. If those large numbers are not expressed in shortened form, spaces are used instead. For example, 76 000 000 000 for 76,000,000,000.

Roman numerals

Although Roman numerals have largely been replaced by Arabic numbers, it is helpful to know how they are formed. Mostly, it's a matter of addition and subtraction. If, for example, a letter representing a smaller quantity appears before a letter representing a larger quantity, it is subtracted from the larger number (e.g., IV = V − I). If the smaller quantity appears on the right, after the larger quantity, it is added on (VI = V + I). If a bar is placed over a letter, the quantity is multipled by 1,000 (\bar{V} = V x 1,000).

1	I	16	XVI	101	CI
2	II	17	XVII	110	CX
3	III	18	XVIII	150	CL
4	IV	19	XIX	200	CC
5	V	20	XX	400	CD
6	VI	21	XXI	401	CDI
7	VII	30	XXX	450	CDL
8	VIII	40	XL	500	D
9	IX	50	L	900	CM
10	X	60	LX	1,000	M
11	XI	70	LXX	2,000	MM
12	XII	80	LXXX	5,000	\bar{V}
13	XIII	90	XC	10,000	\bar{X}
14	XIV	100	C	100,000	\bar{C}
15	XV			1,000,000	\bar{M}

Leopold, margrave of Austria and earl of Babenberg, commissioned this pedigree. Assuming that his patron already knew the names of his antecedents, the artist just used initials for identification. Or are the letters keys to a list of names elsewhere? In either case, the artist abbreviated the verbal information to make room for bigger pictures—which is what designers always try to do.

Abbreviations

Every field of technical writing uses its own abbreviations. Standards vary from field to field, and practice is changing all the time. What should remain constant is common sense: the purpose of printed matter is to communicate. Puzzles are resented (except in their proper place). Nobody has time for guessing games, and the likelihood is that the reader is not going to bother to find out. So take care and make sure that the abbreviations are understandable.

Acronyms are a special kind of abbreviation. They are letter-groups derived from the initials or syllables of several words (e.g., *gestapo*, from the German *GEheime STaats-POLizei*, "secret state police"). Unless they are universally recognized, it is wise to spell out the words in full the first time; later in the same text, the shortened form can be used reasonably risk-free.

The question of punctuation in abbreviations is tricky, and there are no official rules. The fewer abbreviations used in running text, the better. Too many little punctuation dots and periods may disturb the eye in reading. The tendency today is to avoid periods, especially in abbreviations of agencies and organizations such as CIA or NBC.

Nevertheless, in the following list of common abbreviations, the periods have been included—so you know where to put them if you decide to use them. Also notice that, although the abbreviations here usually derive from Latin phrases, they are not italicized. The general rule is that if a foreign word (or abbreviation) is familiar, it should be treated like any other word—in roman type. Obviously, there are a lot of decisions left up to you. Just be consistent. Handle the same abbreviation the same way throughout your publication.

ad lib. (Latin *ad libitum*), at will

a.k.a. also known as

cf. (Latin *confer*), compare

d.b.a. doing business as

e.g. (Latin *exempli gratia*), for example

etc. (Latin *et cetera*), and so on

et seq. (Latin *et sequens* or *et sequentes*), and the following

f. or ff. (Latin *folio*), on the following page or pages

ibid. (Latin *ibidem*), the same (meaning the same source as the preceding footnote)

i.e. (Latin *id est*), that is

inf. (Latin *infra*), below

N.B. (Latin *nota bene*), mark well, take careful note

op. cit. (Latin *opere citato*), in the work cited (referring to a previously cited work by the author mentioned)

PS (Latin *postscriptum*), written later, postscript

PPS (Latin *post postscriptum*), after the postscript (an additional postscript)

q.v. (Latin *quod vide*), which see

Rx (Latin *recipe*, meaning "receive, or take"), a medical prescription

 o.d. (*omni die*), daily (i.e., once a day)

 b.i.d. (*bis in die*), twice in one day

 t.i.d. (*ter in die*), thrice a day

 q.i.d. (*quater in die*), four times a day

ult. (Latin *ultimo*), last month

viz. (Latin *videlicet*, from *videre* ["to see"] and *licet* ["it is permitted"]), to wit, namely

v. or vs. (Latin *versus*), against

A.D. (Latin *anno domini*), in the year of Our Lord

B.C. before Christ

C.E. common era

A.M. (Latin *ante meridiem*), before noon

P.M. (Latin *post meridiem*), after noon

Albrecht Dürer's schoolmaster is certainly getting the attention of his pupils. They deserve the rod because they were careless. They used the grave instead of the acute, and they put it in the wrong place. That is either plain wrong, or it can change the meaning. Putting funny accents on foreign-looking words may be an amusing ploy to sell a new brand of ice cream. In any other context it must be viewed as a serious and responsible duty, demanding care and discipline. That is as valid today as it was in the early 1500s.

Foreign languages and "accents"

Why is the word *accents* in quotes above? Because it is so often misused. True accents are marks added to indicate stress, loudness, or pitch. So-called accents are correctly called *diacritical marks* (from the Greek word for "to distinguish"). They are precisely that: distinguishing marks used to represent specialized sounds in various languages.

The following diacritics are the most commonly used, though there are numerous others. They can occur in conjunction with consonants as well as vowels. In some languages such as French, Spanish, and Portuguese, they can be omitted from capital letters, if preferred. With the exception of the cedilla, which is attached below the "c," all those shown here are added above the letters.

´	(é)	acute
`	(è)	grave
^	(ê)	circumflex
~	(ñ)	tilde
¨	(ä)	umlaut
¯	(ā)	macron
˘	(ĕ)	breve
ˇ	(č)	háček
¸	(ç)	cedilla

Some languages require special characters as indispensable parts of the full alphabet. The most common are:

Æ æ	diphthong
Œ œ	diphthong
Å å	Danish, Norwegian, and Swedish character
Ø ø	Danish and Norwegian character
ß	German double-s
Ñ ñ	Spanish character with tilde (smaller than normal N)
Ð	Icelandic and Old English edh (pronounced as *th* in *them*)
þ	Icelandic and Old English thorn (pronounced as *th* in *three*)

Greek alphabet

The modern Greek alphabet shown here evolved from the classical (c. 500 B.C.), which in turn evolved from early Phoenician and Near Eastern writing. The start of writing as we know it was so uncertain that even the direction was not agreed on. The earliest Greek inscriptions show lines written alternately left-to-right and right-to-left. The Greek-derived term for this somewhat confusing presentation is *boustrophedon* or "as the ox turns," from the way a field's furrows were plowed.

A	α	Alpha
B	β	Beta
Γ	γ	Gamma
Δ	δ	Delta
E	ϵ	Epsilon
Z	ζ	Zeta
H	η	Eta
Θ	θ	Theta
I	ι	Iota
K	κ	Kappa
Λ	λ	Lambda
M	μ	Mu
N	ν	Nu
Ξ	ξ	Xi
O	o	Omicron
Π	π	Pi
P	ρ	Rho
Σ	σ	Sigma
T	τ	Tau
Υ	υ	Upsilon
Φ	ϕ	Phi
X	χ	Chi
Ψ	ψ	Psi
Ω	ω	Omega

Cyrillic (Russian) alphabet

Saints Cyril and Methodius were monks who proselytized the Slavic tribes of Eastern Europe in the ninth century. They adapted the Greek alphabet to the Slavic tongues. Hence the name *Cyrillic*.

А	а	a
Б	б	b
В	в	v
Г	г	g
Д	д	d
Е	е	ye
Ж	ж	zh
З	з	z
И	и	i
Й	й	y
К	к	k
Л	л	l
М	м	m
Н	н	n
О	о	o
П	п	p
Р	р	r
С	с	s
Т	т	t
У	у	u
Ф	ф	f
Х	х	kh
Ц	ц	ts
Ч	ч	ch
Ш	ш	sh
Щ	щ	shch
Э	э	e
Ю	ю	yu
Я	я	ya

Proba or Proof, a minor Roman deity, is of great importance to publishing. In this image from Barberiis's *Opuscula* (Rome, c. 1482), she holds a proof sheet, which can accommodate many lines of type. In her other hand, she holds a finished book, with a stack of finished documents lying on the floor behind her. Her face betrays a healthy skepticism—a quality that all proofreaders need.

Proofreaders' marks

The advantage of learning proofreaders marks is that they provide a quick east way to note errors on proofs off your piece. They are helpful especially if you want to communicate clearly with a typesetter. but don't worry if you can't remember all these signs. The idea IS to communicate what to bee corrected. As long as if the intended message is clear to the recipient, it matters little whether correct symbol was used. Common sense and legile writing are the success of the main ingredients.

The advantage of learning proofreaders' marks is that they provide a quick, easy way to note errors on proofs of your piece. They are especially helpful if you want to communicate clearly with a typesetter. But don't worry if you can't remember all these signs. The idea is to communicate what needs to be corrected. As long as the intended message is clear to the recipient, it matters little whether the correct symbol was used. Common sense and legible writing are the main ingredients of success.

To bring attention to a problem area:

· Circle the words or letters in question

· Show where something is missing by drawing a caret (∧)

· Draw a slash (/) through the offending letter

· Draw a line ~~through~~ the mistake

· Draw an arrow to show desired change of location →

· Underscore the words in the appropriate way

Then write the appropriate symbol in the margin alongside:

ℊ	Delete from (Latin *deletus,* "wiped out")	∧	Insert comma	
stet	It is OK so leave it alone (from Latin *stet,* "let it stand"). Also shown by dotting beneath the words that are to remain.	∨	Insert apostrophe	
∧	Insert (from Latin *caret,* "there is lacking")	∨∨	Insert quotation marks	
¶	Begin new paragraph	⊙	Insert period	
tr	Transpose (also shown graphically thus)	;/	Insert semicolon	
sp	Spell out	:/	Insert colon	
⌒	Close up	\|=\|	Insert hyphen	
#	Insert space	⊥/M	Insert em-dash	
⊓	Move up	⊥/N	Insert en-dash	
⊔	Move down	lc	Lowercase (also shown thus for a full WORD)	
□	Indent by one em	cap	Capital (also shown by three underscores)	
⅃	Move right	sc	Small capital (also shown by two underscores)	
⊏	Move left	ital	Italics (also shown by a single underscore)	
⊐⊏	Center	rom	Roman	
=	Straighten or align horizontally	bf	Boldface (also shown by wavy underscore)	
\|\|	Make parallel or align vertically	wf	Wrong font, so reset in correct typeface	

PAGE INGREDIENTS

Even in 1506, when Johannes Dulaert published his *Quaestiones super octo libros physicorum Aristotelis* in Paris, there were disagreements between editors (*left?*) and designers (*right?*) about how to assemble the pages best.

Printed pages are looked at, scanned, interpreted, and understood in the same way. That is why every document, from the simplest to the most complex, is constructed of similar components.

There is usually a need to define the topic. There is always a need to catch attention. There is often a need to explain the significance of the information. There is normally a source to be credited. And, of course, there is always the message itself. Those are all the functional basics.

On a supporting level are optional elements such as descriptions and explanations that take the form of captions. There is ancillary information such as footnotes, references, and bibliographies. There is information organized and formally tabulated. There may be need for intellectually provocative quotes that intrigue the looker into becoming a reader. There may even be the need for purely visual embellishments such as initials.

Publication-making is not as monstrous a task as it appears at first glance. Realize that you have to manipulate a group of clearly defined elements, each of which fulfills its own separate purpose. This chapter defines each and shows variations from which to pick. How simple it would be if the options were embedded in the software and all you needed was to bring up the options on screen, double-click on the one you want, and—presto—there it is: WYSIWYG (what you see is what you get). Some such development is inevitable. Perhaps it will be a reality by the time this book is published.

In any case, whether you are using the latest technology or pounding out your manuscript on an ancient typewriter, the technique is the same: think building blocks. If you can put one stone on top of another you can construct a cathedral. But temper your ardor with patience and start with a doghouse just for practice. You will soon get the hang of it.

Filling pages with text has never been an easy task. This is a portrait of Bernardino Corio (and his dog), author of *The Chronicle of Milan*, published in Milan in 1503 by Alessandro Minutiano. He holds a quill pen in his right hand, ready to dip it into the inkwell on the desk. Inspiration, alas, is eluding him. Is he checking the propped-up book (whose pages are uninformatively blank), or is he watching something in the window?

Text or body copy

The text is the material for which your document exists. It is its reason for being. It is the bulk of the work. Yes, it is all that gray stuff, that dull reading matter.

Everything else—heads, bylines, decks, quotes, and all the other page ingredients covered in this chapter—relates to it. The signage, embellishments, and the other details all grow from it. Their purpose is to make the material in the text more easily accessible, the details more readily findable, the information clearer, the conclusions more palatable. Printed pages are made of a mix of elements. Each represents a separate decision, yet each affects all the others. Though it sounds difficult, it is not hard to arrive at a mix that will make ideal sense for your project, if you tackle it in stages.

The text is where you start. This is where the fundamental decisions are made. Once you have made them, the ancillaries become easy. Text typography is similar to the proverbial "little black dress," which can be dressed up or down with accessories (assuming it is just right in itself).

Here are four important questions you must confront before you can begin thinking about typographic detailing. Your answers will affect your subsequent choices and restrict your options.

How big is the page? Obviously something printed on a full-size newspaper sheet should be treated differently from something imposed on a half-sheet of 8½ x 11-inch paper. Or consider the difference between a thousand-page historical novel and a leaflet of instructions on how to assemble a bicycle. Page size affects how the product is physically held. That, in turn, affects the scale and arrangement of the type.

A lot of what we're talking about here is common sense (see page 6). The way you hold and read a pocketbook novel while lying in a hammock is quite different from the way you check facts in a manual in a three-ring binder so large and heavy that it has to lie open on the desk. The reading distance between the page and the eyes is different, so the typography needs to be handled differently.

The most common format in the United States measures 8½ x 11 inches. In metric systems the standard equivalent is an A4. (This is like an 8½ x 11-inch sheet that has gone on a diet: it is slimmer and taller, though not by so much as to make a serious difference. That little black dress will fit.) As you will see on pages 83–85, there are varied ways of using this kind of space effectively. But, first, there are more questions to ask.

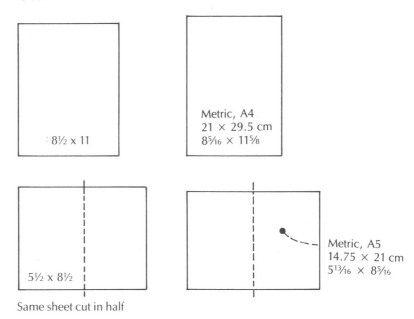

8½ x 11

Metric, A4
21 × 29.5 cm
8⁵⁄₁₆ × 11⁵⁄₈

5½ x 8½

Metric, A5
14.75 × 21 cm
5¹³⁄₁₆ × 8⁵⁄₁₆

Same sheet cut in half

In thinking about paper size. you must also ask: which way is up? Usually a sheet of paper is printed on vertically, in the portrait mode. If the printed matter is imposed on it sideways—that is, if the paper is used horizontally—it is known as the landscape mode. An inverse landscape mode (or tumble landscape) is the landscape mode upside down. Similarly, an inverse portrait mode (or tumble portrait) is the portrait mode upside down.

Note that preparing copy in these various directions is easy if you are following the traditional practice of pasting up mechanicals for photographic platemaking. If, however, you use electronic publishing, which dispenses with the pasteup stage, you may encounter difficulties. Most equipment cannot turn type around to make it fit the page sideways or upside down. Getting type to appear in a direction

different from the normal portrait mode requires having four separate versions of the font in memory: the portrait version (normal, like this page); landscape version (sideways); inverse portrait version (upside down); and inverse landscape version (sideways).

TYPE IN PORTRAIT MODE

TYPE IN LANDSCAPE MODE

TYPE IN INVERSE PORTRAIT MODE

TYPE IN INVERSE LANDSCAPE MODE

How will the pages be bound?

Binding affects the way a publication looks when it is opened up. It also affects the amount of space you must leave for margins. The different types of binding are discussed in the appendices. But here are some basic questions to ask.

Will the pages remain loose? If so, there are no restrictions on the way you can impose type on them. But you had better consider how to number and identify each sheet, because inevitably the recipient will get them out of order, borrow one or two for copying, lose a third . . . and soon the document will have disintegrated.

Will the pages be stapled in the top-left corner? If so, you have to decide how to impose the type on the back side of the sheet: the same as on the front or upside down? It depends on how you think the reader will read these pages. That, in turn, depends on tradition: contracts, for instance, often back up the second (verso) pages in the inverse portrait mode.

Verso page in regular portrait mode (normal)

Verso page in inverse portrait mode (upside down)

Will the pages be glued together with a "perfect" binding, as in a permanent book? If so, you have the luxury of making your margins narrow, because the mechanics of perfect binding require only a few sixteenths of an inch for roughing the edge before the adhesive is applied. But is it wise to bring type too close to the inner edge—the gutter? That depends on the thickness of the book. If it is thin and easy to handle, you can make the gutter margins narrower than if it is thicker and harder to handle. Perhaps it is best to play it safe and leave the traditional ½-inch (13 mm).

Perfect binding allows narrow gutter margins

Will the pages be mechanically bound? If so, you'd better plan on sacrificing a full ⅝ -inch (16 mm) at the binding edge. Ring binders need holes in the paper. On right-hand pages they appear at the left, on left-hand pages at the right. (It is amazing how easy it is to forget the second half of the obvious.) So you also have to sacrifice ⅝-inch on the opposite edge, or you'll lose some wording in the holes. Plastic comb binders and wire spirals take up less space, but it is wise to plan on losing the maximum, because pages bound that way are also often found in ring binders.

Edge of paper Edge of type

⅝"

Ring binding requires
⅝-inch gutter margins

Plastic comb binding

Will the pages be bound across the top? If so, the same questions as in stapling apply, but more urgently because the pages cannot be turned at an angle for easier viewing. It seems obvious, but if you put heads at the tops of the pages, where they should go when the product is bound on the side, you destroy their visibility by binding the product across the top. Unfortunately, many technical documents are done precisely that way—and people wonder why they are so hard to use!

Binding at top:
don't hide headlines
under the overlap

How much text will there be?
A short, concise memo is a very different animal from a 300-page technical specification. The bulkier the document is, the more daunting its muchness seems to be. Typography can be used cunningly to minimize that ponderous and frightening hugeness. But it requires a lot of care to work out an arrangement that encourages reading. It also requires clear organization and writing, with the mass of material presented in small, digestible components.

It has been shown that readers are much less afraid of many short segments than of continuous running copy. They feel they have the freedom to hunt and peck among small-sized units, whereas they feel forced to a major commitment of time and energy when faced with page upon page of text. The more breakup there is, the more acceptable the image becomes. A well-known adage in the newspaper business decrees that you should not be able to place a dollar bill on a newspaper page without touching some accented element. An area of plain gray type larger than a dollar bill will look depressingly, unattractively dull and will therefore be skipped. This may be an exaggeration, but the principle makes good sense.

The principle is particularly apt when the text is "difficult." If an amusing narrative is written in second-grade language, you are not likely to have many problems (though you risk boring the PhDs in the audience). If the text is complex legalese or technical jargon, however, the situation is somewhat different. And if the text contains a lot of

equations or chemical formulas, you have to accommodate the difficulty of understanding them, as well as the difficulty of composing and knitting them into the text. (That, incidentally, merely means that the columns of text must be wide enough to display the full formulas without breaking them onto another line. But it illustrates the functional importance of understanding the raw material and responding to its needs. It is little but common sense—as long as you remember to think of it ahead of time.)

How will the text be illustrated? The question here has less to do with the attractiveness or journalistic quality of the material than with the effect a lot of illustrations can have on the physical makeup of the pages. A publication that features illustrations (an art magazine, for instance) needs a different patterning from one in which the subject is essentially textual with a diagram or table inserted at a specific point here and there. The question is again one of common sense: if there are a lot of pictures, you'll need a variety of page arrangements, and the text becomes a subsidiary element. If there are only a few pictures, all you need to consider is whether you will want the pictures to be large, medium, or tiny. Unfortunately, all too often these questions aren't even asked. What happens is that the text patterning is chosen independently and the pictures are made to fit into it . . . and that can lead to problems. It is much better to plan the relationship of text and illustrations together from the start.

Picking a typeface

Before choosing a typeface, review the discussion of serif versus sans serif (pages 12–17), as well as the remarks on typographic variety (pages 44–50). Bear in mind that each typeface will give your publication a slightly different character. It therefore makes sense to base your choice of a face on whether you like it. That implies that it has the kind of character you deem appropriate for your piece and is likely to appeal to your readership. Of course, if that choice has been made for you because the organization has a house style, designed to create the desired image, so much the better. It relieves you of one major worry. Do what the style book demands.

Once you've chosen a typeface, some of the other decisions will begin to fall into place. Remember that one face may appear much larger or much smaller than another—it is all a matter of the proportion of the main part of the type (the x-height) to the ascenders and descenders. This difference in appearance brings with it a concurrent need to handle the material in different ways, with variation in the line length as well as the spacing between the lines (see pages 24–29).

Designing text type is all a matter of proportion and balance. But alas, there are no formulas to depend on. Nor is there such a thing as "correct" design, let alone "ideal." There is only the reader's judgment of effective or ineffective. Typography is a compromise of combinations. If it works—if it slips into the reader's mind easily—then it can be said to be good.

Who is the judge? You are, as stand-in for the reader. You can test to see whether the text reads easily, comfortably. If it does, you have made the right choices. Unfortunately, that's not the end of it. What may be just the right proportions for one face may look all wrong for another. That is why it's a good idea to experiment with each new piece you undertake, as professionals do. Editors, designers, and production people all invest time and money in testing an idea before they commit the entire project to the scheme.

It is also a good idea to collect samples of what you consider effective typography, keep them in a file, and refer to them when the need arises. If you cannot recognize the face or determine the technicalities of dimensions, spacing, and so on, you can probably find someone with the expertise to check those. One value of such a file is as a show-and-tell treasury. It is so much easier and more accurate to communicate about specifics than to talk in general principles such as "I'd like to see it nice and big" or the vague "make it easy to read." Nobody in his or her right mind specifies typography so as to make it hard to read. Type justifies its existence by being read. Unfortunately, what may be easy to read in one situation can be a disaster in another. Much depends on the circumstances. Use your reference file as a resource for comparisons, to help determine what is right for your specific situation. Just keeping a file will educate you to the options available and train your eye.

Using the space on the page

The space on the page consists of two parts: the outer margins, which have to be kept clear of type, and the area of "live matter" contained within the margins.

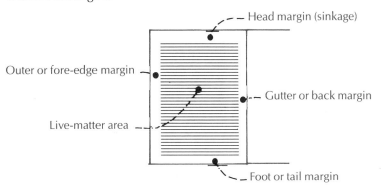

Head margin (sinkage)

Outer or fore-edge margin

Gutter or back margin

Live-matter area

Foot or tail margin

Margins The side margins must be wide enough to accommodate the binding, as discussed earlier. The top, or head, margin and the foot margin can be as deep as you wish, but it's best to leave at least ¼-inch (6.4 mm) so your type isn't cut off in the reproduction process. Keep in mind that a narrow head margin makes the page look oppressively heavy whereas a deep head margin, resulting in what is known as *deep sinkage*, makes it appear gentler and less aggressively insistent.

The idea is to use margins actively to give the publication a special look. All too often wide margins are seen as a "waste of space and therefore money" by those whose job it is to see that due economy is observed. Yet it is precisely the conspicuous consumption of empty space that can add a touch of class as well as individuality to a

Text off-center: left and right pages can be identical or mirror images

Traditional "luxury" proportions: 3 units at gutter, 4 at head, 6 outside, 8 at foot

Narrow sides, wide head and foot

Deep head margin

Extra-wide foot margin

publication. The contrast between a full type area and a generous, empty margin is a gratifying sight. All that space makes the text appear more valuable. It is the velvet cushion setting off the jewel. Besides, a little space for the eye to rest in is appreciated by the reader. No, you're not wasting space if the space contributes to the success of your publication. Don't make the mistake of taking space for granted as a fallow backdrop, useful only when filled to the brim with type—the important stuff.

Once the margin widths have been determined, they should become a precise constant, for they are a frame that repeats from page to page and helps to tie the pages into a sequence of rhythmically related impressions.

Live-matter area With the live-matter area, you have complete flexibility. You can subdivide it any way you wish. There are no correct or incorrect ways of handling the space, though there certainly are habits. Most of them are traditional and have little relationship to current needs. We continue using them because it seldom occurs to us not to. Our readers, too, are more comfortable with the expected look and scale.

Consider technical reports, which are usually set in large type in an extra-wide single column. That is the way the manuscript was typed, and it is somehow expected that this thesis-like treatment will be

continued in print. Is that the optimal way of presenting the material? It could be. But there may be better ways, more helpful to the reader. Perhaps one could express the structure of the report more evocatively. Or highlight various elements more effectively for faster analysis. Or open some doors into the material through clever handling of the headings. Or perhaps one could simply make it sparkle more so the whole thing seemed less ponderous. The seriousness and importance of the material would not be jeopardized; it would merely be more attractive or arouse curiosity. Seldom is that a damaging quality.

Now consider a typical magazine composed with two columns, three columns, or even four columns per page. The proportions were devised to accommodate standard-size advertisements, which must fit onto the same pages. The two- or three-column makeup has thus come to be the expected patterning even on pages without advertisements. Is it the optimal set of proportions? Again, it could be, but there are many other possibilities.

Relating the type to the column

Columns are merely areas into which type is inserted. They are like empty boxes, ready to be filled with important, valuable goods—words. Material of a certain size should be placed in the box that fits it best.

It is imperative to understand the relationship of type size to column width if you want to improve ease of reading. The principle is pure common sense: the narrower the column, the smaller the type size. Or the wider the column, the larger the type size.

Just think about it: a narrow column containing small type reads better than a wide column containing small type and vice versa.

The patterns used in the five examples of column structures shown in this section illustrate the principle. The single-column page shows large-scale lines widely spaced, whereas the two-column arrangements show smaller, narrower lines of type. The last example is the clearest: the narrowest, one-sixth-of-a-page column uses the smallest type, whereas the half-page-wide (three-sixths) column carries much larger type.

Where this principle comes into its own is when it is used editorially to differentiate the important from the less important. It's a relatively easy matter to give greater visibility to vital material than to supporting or background material by using size as a measure of comparative importance. What is large is interpreted as being important. What is small is seen as insignificant because it is small. This difference in scale sorts out the information for the readers, so they can tell at a glance what to read first and how the elements on the page relate to each other. And there is another benefit: this kind of contrast and emphasis looks lively, engaging the reader's interest.

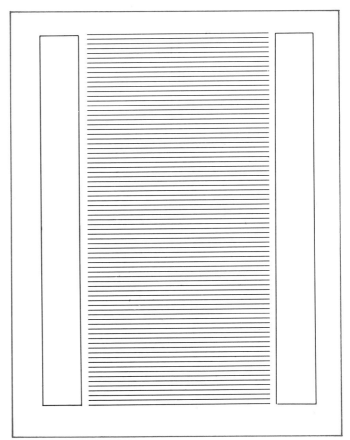

This single column is centered on the page, with space on either side for sideheads, annotations, or small illustrations. Captions for the illustrations can be inserted in the margins alongside the image or beneath it (if the picture itself extends into the margins). Note that the heads can also be carried over into the space on either side, so they can be written longer or set in larger type.

Measurements
Text column: 348 points (29 picas) wide
Margin columns: 72 points (6 picas) each
Column gutters: 12 points (1 pica)

Possible text type sizes
12/14 Baskerville
(meaning 12-point type with extra
2 points leading [12 + 2 = 14])
11/13 Optima
11/13 Times Roman
10/12 Helvetica
(all large and generously leaded)

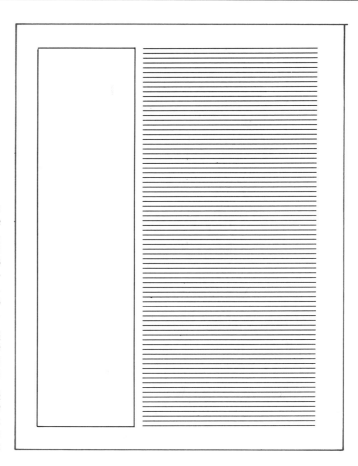

Here the single column is on the right, with an extra-wide swath of empty space on the left. The space is particularly useful for hanging heads, which poke out like outriggers for maximal visibility. Scanning the page for its contents becomes fast and easy—a virtue vital in multi-page, factual documents such as this book. Examine it to see the practical advantages of the wide left-hand margin.

Measurements
Text column: 300 points (25 picas) wide
Empty column on left: 192 points (16 picas)
Column gutter: 12 points (1 pica)

Possible text type sizes
10/13 Baskerville
10/12 or 10/11 Optima
10/12 Times Roman
9/12 or 10/11 Helvetica

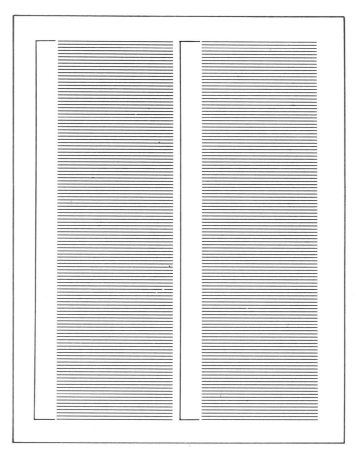

These two columns are narrower than the maximum. They offer an extremely simple variation on the standard two-column page, allowing interesting variations in heading treatment and lightening the page with a sliver more "air." In addition to hanging heads, the narrow empty space can be used for hanging numbers, running full-width rules as separators, or running emphasis lines alongside the text.

Another variant can be created by pushing the left-hand column all the way to the left edge, leaving the central gutter twice as wide— ample for placement of pictures of people, bios, captions, and similar material.

Measurements
Text columns: 210 points (17½ picas) wide
Empty spaces on left: 42 points (3½ picas) each
Column gutter: 12 points (1 pica)

Possible text type sizes
10/12 Baskerville
10/11 Optima
10/11 Times Roman
9/10 Helvetica

This setup uses two wider and two narrower columns. If this pattern is to make functional sense, the narrow columns must be exploited, instead of merely being left empty, with an occasional item inserted in them. This format is particularly good for running text with numerous sidebar elements, captions, thumbnail sketches, and the like. You can also at times set the text the full width, using a narrow and a wide column.

Measurements
Text columns: 168 points (14 picas) wide
Narrow columns: 72 points (6 picas) each
Column gutters: 12 points (1 pica)

Possible text type sizes
10/11 Baskerville
10/10 Optima
10/10 Times Roman
9/10 Helvetica

This six-column format splits the normal three columns in half and allows each unit to be used separately: blank, singly, or combined with one or more of the others. The richness of arrangements from such interplay is startling. It is especially helpful if the type size is appropriate to the column width. Here, the narrowest (single) column is shown using the smallest type size, the double-unit a medium size, and the triple-unit the largest. Imagine the capacity for effective communication with such possibilities.

Measurements
1-unit column: 76 points (6⅓ picas) wide
2-unit column: 164 points (13⅔ picas) wide
3-unit column: 252 points (21 picas) wide
Column gutters: 12 points (1 pica)

	Possible text sizes		
	1-unit column	2-unit column	3-unit column
Baskerville	9/9	10/11	11/13
Optima	8/9	9/10	10/11
Times Roman	8/8	9/10	10/11
Helvetica	7/8	8/9	9/10

Handling runarounds

No, the term *runaround* does not describe philandering, avoidance, or even frustrating bureaucratic buckpassing. It does describe what the text in a column does when there's an obstacle in the way: it "runs around" it. Essentially, the left or right side of the text column has to remain flexible, allowing space to be inserted for illustrations, cartoons, charts, graphs, tables, headlines, callouts, breakouts, decks, bylines, biographies, exegeses, maps, locator diagrams, cross-references, sidebars, boxes, definitions, formulas, initial letters, subheads, pictures, datelines, symbols, ornaments, icons, and who knows what all else to appear in close relation to the text. This is not a new development. The need for indenting has been part of page composition since the days of medieval manuscripts, when initial letters were incorporated into the rectangle of the column. And Lewis Carroll used a runaround in his manuscript of *Alice's Adventures in Wonderland* in 1865. But notice how Alice's dress overlaps the text: that is something that could be done easily in handwriting, but was nigh-on impossible to accomplish in the world of hot-metal type and copper engravings. It became possible, though very expensive, with type on film. Now technology makes it easy again to merge type with pictures, in their electronic manifestation.

Software for page assembly includes automatic runaround capabilities, which automatically wrap the text around an intrusion. To create a runaround in traditional setting, however, is much more complicated. You must first determine the width needed for the intrusive element and subtract that from the regular width of the column. But that's not all: a hole has height as well as width. So you must also calculate the height of the element to specify the number of lines to be shortened. Remember to add a sliver of space to separate the text from the illustration. A pica is usually sufficient. Add that pica to the dimension of the illustration itself. And add two of them—one above and one below the illustration—to the height.

If your runaround involves a complex shape, rather than a simple rectangle, the principle is the same, but it's a bit more work. The more complexity, the more measurements you need. It may even be necessary to make each line a separate length to parallel the outline of an illustration. In such an extreme case, you should first reduce the artwork to its final size, so the appropriate measurements can be taken.

A word of caution As useful and commonplace as runarounds are, you should be aware that there are difficulties. Use them judiciously and with your eyes open. Also, if you send out for type, remember that runarounds are time-consuming and therefore expensive.

One potential danger is that the part of the column left after the necessary space has been gouged out will be too narrow for good typesetting. A narrow column usually leads to too many word breaks at the ends of lines. In addition, too much space may have to be inserted between the words to retain the justified edges, so the texture of the text disintegrates. It becomes loose, arrhythmic, and hard to read. Avoid this violence to legibility. The first purpose of the publication is to be read.

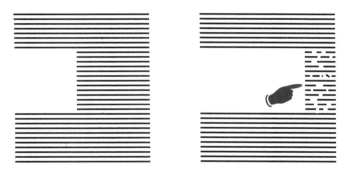

To look best, and be most effective on the page, runarounds must occur within uninterrupted running text. The Law of Bad Luck in Publishing decrees that subheads and paragraph breaks inevitably fall in the worst possible place: the middle or the edges of a runaround. Runarounds therefore demand special care in checking the page on-screen or at the hard-copy stage. Rewriting, re-editing, and remaking usually follow, much to the distress of all concerned.

All the problems of fitting are exacerbated when the runarounds occur between two adjacent columns. Electronic page makeup certainly makes the problem easier than it has ever been before. Greater care needs to be taken nonetheless.

Incorporating lists

Lists are a true marriage of content and form, where one cannot exist without the other. The material is specifically written to be presented in a visual pattern that will help to make the intellectual substance understandable. That is why:

• The information is segmented into its component parts.

• The different items each start on a new line.

• The typography makes each part visible.

• The organization of the type on the page shows how the parts fit.

For such information to make sense in terms of both meaning and presentation, it needs to fulfill five commonsense requirements.

1. It must have a clear purpose.

2. It must have a physical shape that organizes the data.

3. It must be typographically clear and legible.

4. It must be arranged neatly.

5. It must make an attractive, easily recognized package.

To succeed in producing such a simple but effective communication trick, which is what lists really are, the writer-editor-designer team must—

First, understand the problem to be communicated.

Second, analyze and divide it into its component parts.

Third, write the information so it fits the segments.

Fourth, invent the best typographic format to fit the material.

Precisely! the first three paragraphs were written as primitive lists. The first is a bulleted-item list, the second a numbered list, the third a sequential list. You recognized them as lists at first glance because:

I. Each list stands out from the text background.

 A. The shape looks different in the space that frames it:

 1. It is indented.

 2. It has a ragged edge at right.

 3. It has a sliver of extra space above and below.

 B. The texture of the type looks different:

 1. All the lines are similarly short.

 2. The text starts with similar words:

 a) The, The, The

 b) It must, It must, It must

 c) First, Second, Third

II. Visual and verbal clues are added to ensure correct interpretation.

 A. Items begin with symbols:

 1. Random lists start with bullets (●, ● . . .).

 2. Numbered lists start with numbers (1, 2 . . .).

 3. Sequential lists start with words (First, Second . . .).

 B. Lists are introduced with an explanatory sentence:

 1. With an actual colon that leads into the list.

 2. With a colon implied in the wording.

 3. With an em-dash that acts as a colon.

Exactly! The information you have just read was presented in the form of a list with two sets of sublistings. It could just as easily have been written as running copy, as in the following paragraph. You don't need to read it; it says the same thing as the list does. Just look at it.

You recognized the lists for what they are at first glance because they have a number of factors in common. Most important, perhaps, is that the shape looks different from the surrounding text because of the frame that surrounds each list. It is indented at left, and its right-hand edge is set ragged. A sliver of space above and below separate it from the text. The type's texture also makes the lists appear different. The separation is achieved by two characteristics: the similar shortness of the lines, and the similar wording at the start of each sentence (repeating "The, The, The"; "It must, It must, It must"; and "First, Second, Third"). Visual and verbal clues are added to ensure that you interpret the information correctly. Each item begins with a symbol, be it the bullets (● ●) that start the random list, the numbers (1, 2) that start the numbered list, or the words (First, Second) that start the sequential one. Each is also introduced with an explanatory sentence, which leads into the list with a colon, an implicit colon (implied in the wording), or an em-dash.

Compare this paragraph full of information to the list that precedes it. Where is the information presented more effectively? Where are the details more clearly ranked? Where are the data more accessible? Where can you find what you need faster? Perhaps this last sentence should have been imposed on the page like this:

 Where is the information presented more effectively?

 Where are the details more clearly ranked?

 Where are the data more accessible?

 Where can you find what you need faster?

Three kinds of information

Lists present information in a formalized, organized manner. The format of the list should not be arbitrary. The material should not be forced to fit the format, but the format should be tailored to the material. The way the list looks should visually represent the way the material itself is composed. The majority of information that can be listed can be categorized into one of three basic kinds.

Label or data lists These lists consist of a series of single elements, each describing or specifying a self-contained item. They can be names, quantities, dates, characteristics—any criterion or description that can be cited separately. The purpose is to expose the group as a group and to give both the group and the individual items maximum visibility.

Text lists These consist of items one or more sentences long. A pattern of short paragraphs is readily discernible as a list, but one assembled of multiparagraph elements is visually cumbersome. The purpose is lucid display of the key points of a discussion.

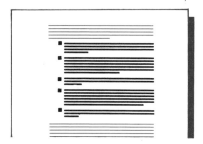

Outline lists Such lists present information requiring more than one level of indention (see the example on page 92). The purpose is a clear, organized presentation of information showing superior/subordinate relationships between items.

Some tips on list making

Traditional practice has been to set all lists in a smaller type size. The advantages (increased contrast, as well as more characters per line) do not outweigh the possible disadvantage. The danger lies in confusing the reader, who equates size with importance and interprets material set small as being skippable, second-string matter. Where the information is not merely an extract, quoted from elsewhere, but is an integral part of the running text, it is wise to run it in the same type size as the rest of the copy.

The three lists run at the start of this discussion (see page 88) are naturally set ragged-right, since all the items are short and fit on single lines. However, lists consisting of multiline items are better set justified. The clean right-hand edge contrasts most vividly against the indentions of the left-hand edge. It is the symbols and indentions at the left edge that are the vital clues to the list's structure. A similar irregular edge at the right undercuts their effectiveness.

Turnovers or runovers (all the lines of text that follow the first one in any item) should be indented so as to align with the first word following the numeral. There are two distinct advantages:

1. The numbers and letters stand out for faster scanning.
2. The structure of the entire list is clearer and more understandable.

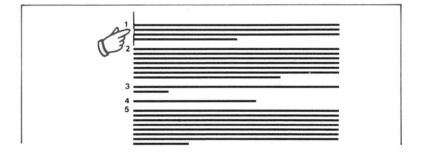

Each sentence following a letter or number should start with a capital letter, even if no periods end the preceding item. The capital letter makes it faster to understand the system.

What about the punctuation at the end of lines? Ending short items that are less than a line long with a period is a matter of choice. If they are single phrases or short statements, none may be needed. If they are full sentences, then periods can be helpful. The criterion is to make the information maximally clear.

In outline lists, when many degrees of subdivision are called for, an acceptable format for numbering and lettering might be as follows. (The wording describes the style and handling of each element.)

I. Roman capital numerals.
II. Follow numerals with, and align on, a period.
 A. Capital letters—roman or italic.
 B. Follow capital letters with a period.
 1. Arabic numerals—lining or old style.
 2. Follow numerals with a period.
 a) Lowercase letters, roman.
 b) Follow letters with a "close" parenthesis.
 (*1*) Italic numerals.
 (2) Enclose numerals in parentheses.
 (*a*) Lowercase letters, italic.
 (*b*) Enclose letters in parentheses.
 (i) Roman numerals, lowercase.
 (ii) Enclose numerals in parentheses.

This listing of alphanumeric symbols is arbitrary. It is not the only scheme, nor is it "the" correct one, for there is no such thing. The only purpose is to make the verbal material visually clear to the reader. Therefore, whenever the readership is used to a certain typographic style denoting ranking, follow it. But if there is no precedent to go by, use common sense.

Space between items is a visual clue to the list's recognition as a list. But deciding on whether to add extra space is not as simple as it may appear at first glance. Space on the page is a valuable commodity, and you do not want to waste it. Be generous with it only where it will make a difference in efficiency of communication. That is why you may not want to add extra space between items that are short—say, up to three lines apiece. Lists consisting of longer items, however, are helped by a sliver of space between segments.

Headlines, get it? These investigative reporters for *The Assyrian Times* and *Babylon News* are checking the headcount following the latest battle. They appear on a wall relief sculpture from the royal palace at Nineveh, built around 500 B.C.

Titles, headlines, headings, heads

What we're talking about here is wording set apart in display type and used to describe the topic covered in the text. Its purpose is both to inform and to intrigue the potential reader into reading. Whether you call it a *title* or *headline* or *heading* depends in part on the material and in part on your background. The distinctions are not always clear, but here are some general guidelines.

Title usually connotes a cut-and-dried label designating the subject of a serious, scholarly report or learned thesis. It is often written dispassionately, without any curiosity-arousing interest.

Headline suggests a newspaper article. It can be written to be objective and nonsensational (and possibly dull), or exaggerated and sensationalized (and probably not credible). Moreover, the words are selected to fit a restricted space (and may be stilted).

The word has a different connotation when used in advertising. Copywriters realize that unless the headline grabs people's attention and forces them to read the copy, the client's investment in the ad will be wasted. That is why ad headlines imply a promised benefit.

A third connotation arises in magazines, where headlines are likely to be provocative teasers beguiling the reader. The idea is to tweak the reader's curiosity, in contrast to a newspaper, which might run informative wording, summarizing the story.

Heading is perhaps the most neutral term. It does, however, have a specialized meaning in the world of book publishing, where it connotes any kind of display type. It can also denote the standing heads, which are the tags identifying the departments appearing regularly in periodicals. (They are called *logos* if they are made of special artwork rather than set in plain type.)

Head is a compromise nickname for both *heading* and *headline*. It is telescoped even further to HED in type specifications. Since it is the shortest, it is used as the generic label here.

Writing for attention

Readers skim, hop, and peck at pages. They shop around looking for what might be worth their time and effort to read. Reading is perceived as time-consuming work. If they are already interested in the subject or if the information is vital to their success or well-being, then they will read the material—whatever form it is presented in. But if they are only marginally interested, then they must be charmed into the text. And if they are merely looking for a specific item of information, they must be guided to it quickly and efficiently.

Pulling the reader in is the vital function heads perform. Yet, too often, they are the last-written and least-studied elements on the page. Usually the text is completed well before the head is tackled as an afterthought. Yet it is the display type (the head together with the captions and quotes) that is intended to catch the skimmer's attention. Without that attention, the piece will go unread.

Advertisements attract by promising a benefit. The benefit promised by heads in a less blatant sales-context is the benefit of the information itself. They had better be accurate and not oversell, for readers are skeptical and resent being fooled. That is why it is essential that the information in the text be understood. Only with such understanding can a simple, declarative phrase or sentence, summarizing the information, be written. That is the first disciplined step toward clarifying the thinking process. Rewriting and polishing should follow. That first sentence may not be the final version. It may well become the explanatory deck (see page 111) under a much more intriguing head, for bright writing is never out of place. Serious subjects need not be as boring as bad writing makes them. The goal is to communicate well, while giving life and sparkle to the subject.

Here are some common questions:

· Should heads be cute? Never. Clever, always. But flippant only when the subject itself is meant to be amusing. Serious matter should not be devalued.

· Should heads be short and succinct? Yes, the shorter the better, so their verbal and typographic makeup can be as startling as possible. But if they are short, they may need to be accompanied by a deck, or subtitle, expanding the information and identifying its benefit to the reader.

· Can heads be long? Yes. But if they are, then they must describe both the nub of the story and the benefit to be derived from reading it. Readers are not likely to search the text for reasons why they ought to pay attention to it. How long is "long"? As long as it needs to be without being verbose.

Think of heads as self-contained units, independent of the text that follows. For the most part, don't refer back to the head with a pronoun in your first sentence. It's better to repeat a word in the head and the text than to make the reader stop and check back. But avoid a direct, word-for-word repetition.

If the heads are segments in a series, make sure they relate in verbal structure, physical placement on the page, and typographic patterning. You want the reader to be able to recognize the relationship, discern the structure, and scan the highlights of the piece by reading from one head to the next.

As with most aspects of typography, there are traditions in setting up heads in type. With experience, you'll gain a better idea of when it pays to respect tradition and when it's worth breaking out on your own. To get you started, here are some practical tips about what generally works, as well as what doesn't.

- Heads are normally set in type sizes ranging from 18- to 36-point. Larger sizes are, of course, perfectly acceptable, if the handling is appropriate to the subject and the page design. They can also be smaller, though they tend to lose significance and impact if they are too small, light, and pale. It is impossible to make rules, as each decision depends on the specific characteristics of the case.

- Whenever you have more than one head, they must be considered as events in a sequence. Though they are independent and self-contained in any single instance, they also work in succession, so the reader perceives them as units in a group. This broader "reading" should affect all typographic decisions concerning face, size, style, and the like. Remember that too many competing elements just spell confusion. Keeping the head style consistent within a piece will improve clarity.

- Heads for important or long newspaper stories have traditionally been set in larger type than those for shorter, less important stories. This may or may not have validity in other printed matter; it is merely one factor to be aware of, because readers do tend to react to the way things are "supposed to be." They have been trained to interpret headline sizes that way: the bigger, the more important.

- Heads at the top of the page have traditionally been set larger than those near the foot of the page. That is a logical corollary of the preceding observation: important stories are placed at the top to give them greater visibility. Take this for what it is worth.

- Consider the option of setting the head in a smaller size, but in a bolder type. The boldness ensures the same noticeability, but the reduced size accommodates more characters in the same space.

This headline looks important
This head packs in more information

- Placing the head in ample, clearly articulated white space allows the type to be set small, yet the visual effect is equivalent to a larger, often even exaggerated type size.

- All-capital setting is traditionally regarded as yielding additional dignity and emphasis. That is probably true. The price exacted, however, is high: it is much more difficult to read all-caps than lowercase. As discussed in the beginning of this book, we recognize words by their silhouettes. Lowercase gives words an individualistic wiggly outline, whereas in all-caps all words have a similar rectangular shape. Readers must therefore decipher the words letter by letter, slowing the reading process. Nevertheless, there are times when an all-capital setting is perfectly appropriate. If the head is a label consisting of a word or two, as in a department heading or topic name, all-caps of the same typeface as the regular heads may be the ideal way of setting it apart. It looks different, yet retains typographic unity with the rest of the piece.

- The traditional style for setting heads is the "Up-and-Down Style," in which the initials of important words are capitalized. As I've already indicated, I think this questionable habit, whose ancestry can be traced back to nineteenth-century newspapers, should be discontinued. It brings no advantage, makes heads slower to read, and looks outmoded.

- Setting heads in downstyle is, in my opinion, the logical and most reader-friendly form of typographic presentation for heads. Set just like a normal sentence, differing only in type size and boldness, downstyle heads follow the patterns readers are used to. Besides, they are more economical of space, since capitals take up much more space than their lowercase equivalents. Furthermore, proper names and acronyms stand out because they are capitalized in the normal way and thus aid comprehension.

- To gain additional emphasis and more ink (blackness) on the page, underscoring is occasionally used in heads. It would be preferable to avoid this practice because the horizontal rules appear to straighten out the lower silhouettes of words, impeding recognition. Better to use a bolder, larger typeface—unless you know exactly what you are doing and why.

- Centering heads is another questionable traditional practice, in my opinion. Heads so placed are perceived by producers of printed matter as being dignified and scholarly. The price paid, however, is more difficult reading, especially when several lines need to be absorbed. As people read, they need to return to a vertical axis at left, where the next line is logically expected to begin. Since centered heads have no such axis, the reader must search for the line starts. This causes confusion and is an undoubted irritant. The design of heads is supposed to lubricate the eye/brain connection, not impede it. Use centered heads only when the need for traditional atmospherics demands them. To my eye, at least, they look static and stuffy, standing lonely and aloof.

- Flush-left heads are tied to the surrounding typography by the shared vertical axis at the left edge, so the eye is encouraged to flow from head to text. In this way flush-left heads participate actively in a lively, dynamic presentation.

- Heads set flush-right and ragged-left are the most difficult to read. Use them only if the page·layout demands a tricky departure from the norm.

- Setting heads flush-left and ragged-right carries an inestimable advantage: by not requiring justification on the right, it avoids the need to vary the spacing between words or characters. That ensures optimal legibility, because the visual rhythm of the type is consistent. Setting heads ragged-right carries a second advantage, which should be exploited: since setting lines to full measure is unnecessary, lines can be broken for sense, phrase by phrase, to make the meaning clearer, faster. Moreover, there is never any need—or excuse—for word breaks at line ends.

- It's best to use tight setting for headline typography. The larger the letter size, the larger the gaps between them. Not only do those gaps look unsightly, but they impede smooth, fluent readability. With the new technology, you can alter spacing and kern letters to any desired proportion (see page 54).

- Do not set a period at the end of the head. Though small and apparently insignificant, it acts as a stop and may keep the reader from moving down into the text.

When it comes to placing heads, there are no hard-and-fast rules—just the advice of experience. Obviously, the location of the heads must relate to the layout of the text. What works for a three-column format may not be appropriate for a single-column design. The tips here are meant to get you started thinking about different possibilities, but always keep the special needs of your publication in mind.

- Position heads on the page where they are most likely to be noticed. Since we read from left to right and from the top of the page downward, the first place we look on seeing a new page is the top-left corner (northwest). Later, our eyes travel downward in a diagonal direction (toward the southeast), searching for whatever else might be of interest. Obviously, it makes sense to put heads at the top. But that doesn't rule out other possibilities, as shown in some of the examples below.

- Keep in mind that four lines are about maximum for a head in narrow columns such as those in newspapers. If you want to use the headline as a strong visual element, then, of course, there is no limit to the number of lines. Such a ruse can be successful, especially if the lines are very short and the verticality of the stack becomes the distinguishing feature.

- Tighten the space between lines of large type. This concentration of type will make the head appear more massive and important; it will read better.

- Leave ample space around the head, for type must have room to "breathe." Always place the head closer to the text beneath, to make them look as if they belong to each other. The rule of thumb: the space above should be twice the space below the head.

- Make multicolumn heads reach partway over the last column on the right.

• Make the second line of two-line heads shorter than the first; it brings the eye closer to the start of the text beneath.

• Avoid the staircase effect on multiline heads at far right; in three-liners, the middle line should be either the longest or the shortest.

• Never indent the first line of the text beneath a centered head; the space in which the head is seen looks neater if there is a hard corner created by the flush-left line.

• Never allow fewer than three lines of text to appear beneath a headline at the foot of the page. It denigrates the importance of the head and looks untidy.

• Never allow fewer than three lines of text above a subhead at the top of a page. It looks weak. In multicolumn page makeup, such as typical magazine pages, no subheads should be allowed to appear at the top of a text column in running text, as they can easily be

mistaken for the start of a new story. Instead, rewrite or rearrange to bring over at least three lines. Even if rewriting is required, such perfectionism is well worth the trouble.

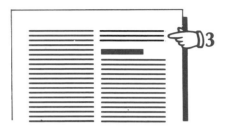

· Be careful to avoid tombstoning heads—placing them next to each other so they align. This line-up can cause confusion for the reader, who may mistake them for a single head and read all the way across.

· Remember to consider the binding in placing your heads. If your publication is bound on the side like a magazine (side-wire or saddle-stitched), bear in mind that when people first pick up the publication, they may hold it by the back (the spine) and riffle the pages. All they see on first scan are the outside halves of the pages, because the inside halves are hidden from view in the holding hand. In this case it may be a good idea to place heads in the outside halves.

Considering the many kinds of heads

Heads can have a variety of physical characteristics, as well as different functions. Understanding the full spectrum of possibilities can help you make the appropriate design choices.

Wall-to-wall head As the name implies, this head is written to fill out the space available, from one side of the page to the other.

Straddle head　This head is centered over more than one column. It is sometimes also referred to as a *cross-head,* when it is underscored with a rule and spans two or more columns of a table.

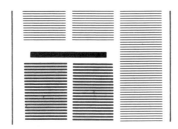

Centered head　This head is positioned equidistant from the left and right sides of a page or column.

Staggered head　Here each successive line is indented a step deeper.

Hanging-indent head　This head pokes out into the left margin.

Box head　Usually this head is centered inside an enclosing box. It may be a version of a standing head (see page 103).

Marginal head or side head Placed in the margin alongside the text, this head is used mainly with asymmetrical layouts, flush-right with the left-hand side of text or flush-left with the right-hand side. Set to a narrow measure, it is always set ragged-left or ragged-right, depending on which side of the page it is positioned. If the wording is independent commentary, it should be placed alongside the text at mid-paragraph. If the wording is a true heading, whose purpose is to pull the reader into a specific point, the first line should align with the first line of the paragraph to which it refers.

Over-head Here a separate line is set in smaller type, placed above the main head, and separated from it by a rule. The rule gives geometric distinction and makes the bold type look bolder by contrast with its own lightness and precision. There are three basic types of over-heads:

Eyebrow This term describes a freestanding and self-contained word or phrase centered above the head. The phrase usually defines the topic of the article below. Placed in the center, away from the left-hand reading axis, it is probably less noticeable than the kicker.

Kicker Here a word or short phrase leads into the main head beneath and is linked to it in meaning as well as by a colon, dash, or ellipses. Placed flush-left in the available space, often underscored for extra emphasis, it is made visible by the empty white space at its right, as well as by the white space often left beneath by the indentation of the head itself. The rule of thumb in determining the proportion of type size is to make the kicker half the size of the head. That way it is not so small as to be insignificant, nor so large as to appear as another line of the head.

Hammer This variation of the kicker reverses the type proportions. In this case the type size used for the kicker is twice the size used for the head.

Subhead or subtitle This heading, of lower rank than the main head, is used to signal subdivisions in the text or pauses in the narrative. If the text is sufficiently complex, it helps the reader to split it into its main parts. Subheads can also stimulate interest, if carefully written. Newspapers often use this technique to break up the text artificially, inserting a "breaker head" every five inches or so.

A subhead is usually set in the same size or slightly larger than the text, but in boldface. Single-liners are less disruptive of the text column than two-liners. It is best not to mix single-liners with two-liners in the same presentation. It is also wise not to surround subheads with a lot of space, creating too deep a gap in the text column. Ideally, one should allow one type-line space, slotting two-thirds above the subhead, one third beneath it. In text that uses indented paragraph starts, the text beneath the subhead may be indented normally or it may begin flush-left.

There are three basic variations of the subhead:

Crosshead Here the subhead is centered in the column. (Do not confuse this with a cross-head in a table, described above.) Although this format is quite common, it is giving way to the sidehead (see below). The problem is that the centered crosshead introduces white space both at left and right, which splits the text violently. In contrast, the sidehead retains the integrity of the column by adhering to the left edge and only introducing interrupting white space at the far right.

Sidehead This subhead is set flush-left in the column. (Do not confuse it with the side, or marginal, head described above.)

Cut-in head or inset head Set in larger and bolder type, this subhead is inserted in an area of space created by indenting several text lines at the left edge of the column. This is an expensive trick, especially when alterations need to be made, requiring much resetting.

Run-in head or boldface lead-in This kind of head may be used as a sub-subhead, or it may simply create emphasis. The first two or three words of the paragraph are emphasized by the use of boldface, capitalization, or a different typeface. The text may simply continue, or the head may be followed by a period or em-space, with a new sentence afterward. This head should be set flush-left. And take care that the boldface words are worthy of emphasis; the sentence or lead-in phrase must be written to make the most of this attention-getting capacity.

Standing head This tag identifies a regular department in a periodical.

Running head This identification, repeated in small type on top of each page, cites the title or a division of the work, such as the chapter heading or date of issue. In books, the title usually appears on versos (left-hand pages) and the chapter title on rectos (right-hand pages). In catalogs or directories, alphabetical or subject identifiers are used instead. Some publications use running heads as comments on the text below.

Jump head Here a pivotal word or phrase is taken from the main head and repeated to identify the continuation or "jump" of the article elsewhere in the publication. It is always followed by the essential reference line "Continued from page ———" in small, light type.

Stub head This is the title of the stub, the farthest-left column in a table—the column that contains the guiding entries.

Having fun with heads

Should you try to be "different" with the heads? Do they provide an opportunity to be creative with design? Yes—if your creativity is kept within the bounds of what works and what is appropriate. The purpose of the head is to inform the reader, not to be innovative for the sake of innovation. To misuse it as a showcase for your own cleverness is self-serving. The head should announce the subject matter clearly and intrigue the potential reader to go on with the text. Any trick you can think of is legitimate and can be exploited, if it is used to make the information visible, lucid, and accessible.

One warning: refrain from introducing variety for its own sake, especially when heads are part of a series. It is difficult to resist the temptation to vary the heads to add interest to the piece. Admittedly, there is always that nagging suspicion that readers will become bored if we don't serve them something new. But bear in mind that few readers are aware of subtle differences—only violent change is noticeable. And that is where the danger lies. The point is that the personality of a piece is largely the result of the display type. The unity of effect created by typographic consistency may well be a far more valuable attribute than an artificial variety that jumbles the piece's personality. Is cleverness worth the price?

Remember that the reader also uses the visual consistency of heads as a vital clue to understanding the structure of the document. Wherever heads are of equal importance, they should be given similar visual expression, because that regularity itself becomes an understandable symbol. Naturally, the ranking of heads has to be planned for and adhered to throughout the work, not only in the way the material is organized, but in how it is written and how it is turned into typography. If that is done, then the ranking of heads (A-head, B-head,

C-head) becomes easy. Few documents are complex enough to need more than three or four levels of heads. More than four require very strong typographic differentiation to prevent the reader from becoming confused.

The key to designing effective heads is to be aware of what you are doing and why you are doing it. There is a price to be paid for every departure from the norm. You have to calculate the cost/benefit ratio. The price may well be worth paying. But be sure to get the most value from it. Do whatever you decide to do courageously, strongly, and deliberately. Here are a few ideas:

· If the piece has clear subtopics, announce each with a head. The great virtue of heads for the communicator is that they are an irresistible combination of verbal meaning with visual form. Make the most of it by displaying the heads in enough white space to make them unskippable.

 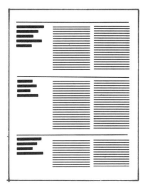

· Split heads into allied segments and tie them together with leaders, or dots (. . .). You can do this on a single page, across two pages (a spread) or overleaf (from page to page) if the heads are prominent enough.

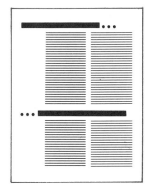

· Break heads into a series of subcomponents, each belonging to its text element, much as in a catalog. If you run these heads across the spread in horizontal alignment, it creates a strong, clear line, allowing you to play with the contrasting lengths of unequal text

blocks below. This technique actively exploits the effects of tombstoning. But take care: tombstoning is dangerous unless it is used deliberately (see page 99).

• Project the heads like outriggers into the margin, hanging the heads much farther out than might be expected. They attract maximal attention that way, for the first words are seen against clear white space, instead of being camouflaged by surrounding gray text. As a result, the piece can be scanned much more quickly. Just think of the advantages for a reference document, where the needed items can be found more easily.

• Pull out a key word that might be particularly meaningful or intriguing and display it in a much larger size or a color. It will pull the viewer's attention by virtue of its noticeable contrast. Then, later, use that word as the running head or jump head to identify continuations of the piece.

Here is the initial L to end all initial L's, with St. George and the Dragon, an influential angel (?), and a devil playing the bagpipes thrown in for good measure—not counting assorted flora and fauna. It is from Jean Dupré's *Mer des hystoires*, printed in Lyons, France, in 1491.

Initial letters

Initial letters—*initials,* for short—are the large capital or decorated letters at the beginning of a block of text. They may also be called *initial caps, raised initials,* or *drop caps.* Medieval scribes used them as decorative embellishments on the page, coloring them, gilding them, and often using them as opportunities for miniature paintings. The early printers continued the practice of picking out decorative initials in color, adding the color by hand or in a second pass through the press. Normally they were used to denote the start of a chapter. Initials continue in use to this day, in startling variety. The new technology makes them ever easier to import.

The initial letter creates a focal point by its startling size, its isolation, its own unexpected shape. The contrast of its scale and blackness with the surroundings attracts the viewer's eye and attention. When such a strong visual signal is placed to mark a change in the direction of the flow of thought in the text, it is used for a purpose greater than merely making the page look more interesting (or, as is too often the case, less uninteresting). It is an implied—unarticulated—headline. As such, it is a functional way of breaking up the text. Of course, it is also a decorative, colorful visual element.

One important factor to bear in mind is the character of the letter used as the initial. Since it is highly visible, its look affects the atmosphere of the page as well as the entire product. The larger it is, the more important its effect. Obviously, if the effect is repeated throughout the

publication, it is important to choose the letter style with care. It should either harmonize completely with the type used for the body copy, or it should be in direct contrast.

There are three basic types of initials:

· Raised or upstanding or stick-up initials rise above the first line.

· Cut-in or drop-cap initials are inserted into an indented space.

· Freestanding or hanging initials are placed outside the column.

Weaving initials into text

The initial letter must be carefully fitted into the text. It should "belong," sitting comfortably and confidently in its surroundings. The way to achieve this is by carefully controlling the space in which the initial sits, as well as precisely aligning the letter with the text lines alongside. Here are some additional guidelines:

· Do not make the space too large, to avoid leaving gaping canyons between the letter and text.

· Do not float the letter in its space, but anchor it visually by aligning the bottom of the letter with a line of the text.

L seque facil, ut mihi detur plena sit, ratiodipsa monet sic amicitian non modo fuerte. Null modo sine amicit oluptation. Mam et laetam amico

 L seque facil, ut mihi detur plena sit, ratiodipsa monet sic amicitian non modo fuerte. Null modo sine amicit oluptation. Mam et laetam amico

- Align the letter with the top of the text line alongside it to create a clean, squared-off look.

N orem ipsum dolor sit amet,
voluptat. Ut enim ad minim
vel eum irure reprehenderit
iusto odio dignissim ducim qui
sunt in culpa qui officia deserunt

- Indent the text to accommodate the various letter widths. Each typeface varies, but as a general rule, the alphabet falls into three groups: the letters "I, J, F" are narrow; the letters "M, O, Q, W" are wide; and the rest are medium width. (Obviously, if you want to fine-tune, the "I" is narrowest, "M" and "W" widest.)

- If possible, prevent a gap between the top of the letter in a drop-cap and the continuation of the word of which it is a part. This is particularly important (and difficult) with letters such as "L."

L orem ipsum dolor sit amet
voluptat. Ut enim ad
vel eum irure reprehende
iusto odio dignissim duci
sunt in culpa qui officia deserunt
cum soluta nobis est eligend optio

- Allow enough space at the right to avoid confusion if the initial is a self-contained word.

I earud rerum hic tenetury
eam non possing accommodare
ad augendas cum conscient
libiding gen epular religuard cup
videantur.

- Link the word as naturally as possible to the initial, even if it requires kerning. Type should, for example, tuck into the space beneath the overhang of the "P," "T," and "F."

- Shape the indent to parallel the line of letters that do not have vertical profiles. The letter "A," for example, requires corbeling the text, while "V" and "W" require pyramiding it.

Using several initials

When you have several initials on facing pages, unexpected problems can arise to spoil the results, unless you are ready for them.

· Take care that they do not spell an unintended word.

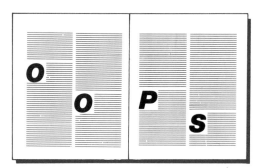

· Be careful to avoid poor placement. With the exception of the initial that starts a chapter, all subsequent initials must be seen to be in the body of the columns. Never allow an initial to fall at the top or bottom of a column, but insulate it from the margins by at least three lines of text.

· Be sure to avoid tombstoning, or unintended alignment of initials across the page.

Here comes the latest information from late nineteenth-century France. Headlines as well as supplementary facts (decks?) were shouted by the vendor. The velocity of dissemination was clearly related to the looseness of the man's trousers.

Decks, blurbs, and other prelims

The full title of this section should read: "Decks/subtitles/blurbs; Precedes; Summaries/synopses; Abstracts." This confusing array of names refers to a simple page ingredient: several lines of explanatory wording set in smaller type than the title, but larger than or in a different style from the text, and usually placed below the heading. The variety of nomenclature has two perfectly logical causes:

1. There are different traditions in different areas of publishing. Bookmakers' jargon varies from magazine-makers' and newspaper publishers' talk. And academic, scientific, legal, and other specialized publishers all have their own standardized usages.

2. There are differences in the function and character of the wording, its purpose and style. These subtle differences can affect the physical format, as well as its value to or interpretation by the reader.

In magazine publishing the title announces the topic of the article. It is usually accompanied by several lines of display type—known as a *subtitle** or *deck*—expanding the meaning of the title, explaining its significance, or in some other way helping to persuade the potential

*In book publishing terminology, the **subtitle** is the second part of the title of a book. It is sometimes not run on the front cover, but always appears on the title page, where there is ample room to accommodate its technical content and consequent lengthiness. This is a completely different meaning of the term *subtitle*.

reader to enter the text. If the basic idea of the story is proposed in the headline, the deck points out its significance and the first paragraph of the text announces its usefulness—presenting an irresistible sequence of thoughts that draws the reader in. Since the thoughts are written to flow in a logical sequence (1: title, 2: deck, 3: text), the typography should also flow in a logical sequence. The type size and boldness should reflect the degrees of importance of each of the three elements, while the placement down the page reflects the sequence of reading.

Decks are often misused, with wording from the title brought down or wording from the text brought up into them. Such repetition is resented by the reader as a waste of valuable time, and it is wise to avoid it. Decks are not the place to apply that cynical adage heard so often in editorial circles: "Tell 'em what you're going to tell 'em, then tell 'em, and then tell 'em what you told 'em."

A related problem arises when the deck is written as blatant sell-copy, intended to draw the hesitating reader into the story—in which case it is called a *blurb*.* What happens is that you devalue the potential usefulness of the deck by verbal repetition or by turning it into a blurb. The annoyed reader may skip it on the next story and consequently miss crucial information. It won't matter if the deck is used the way it should be the second time.

The typeface used for decks can either relate to the display type used in the headline or to the face used for the text. The most common practice is to use the 14-point size of the text face, assuming that the text is set in the usual 10-point size and the headline in the 24-point range. If the deck is set justified, then roman is commonly used. Italics are often chosen to complement the more informal look created by ragged-right setting. But there are no hard-and-fast rules. There is only the need for an appropriate style, based on an understanding of what makes type attractive, easy to read, simple to absorb. Here are some tips based on experience:

• Use a large-enough type size and generous leading to ensure legibility for lines that are very long.

• Set short lines in large type ragged-right to avoid the unsightly gaps between words that result from forced justification.

*The same term is used in book promotion for the copy praising the wonders of the book on the inside jacket flap, as well as for the endorsements from famous people on the back cover.

• A neat look can be provided by rules interspersed between the type lines, which are set ragged-right.

• Break lines for sense, phrase by phrase, for fastest reading, and let them flow informally down the pages as a special feature.

• Stack short lines set flush-left/ragged-right alongside the text to contrast color and texture on the page.

If decks are written in such a way that the thoughts and words flow into the title, they are called *precedes*. (Since they are placed ahead of the headline on the page, preceding it, here is a logical name at last.) Precedes can be written to be self-contained, with an implicit pause before the title, or they can lead directly into the wording of the title, with the typography responding to this difference.

If there is a gap between the thoughts in the precede and the headline, a typographic device such as a colon or ellipses can be used to bridge it. In any case, it is always a good idea to make the last line of the precede short in order to lead the eye to the start of the headline.

The subtitle, or deck, and the precede in its own way are active steps in a flowing series of informational statements. They are units in a coordinated sequence whose avowed purpose is to draw the reader into the story. On the other hand, *summaries* (a word synonymous with *synopses* in the sense used here) are different: they are self-contained compressions of the contents of the article. They are intended for quick reference by potential readers to help them decide whether to invest time and effort in this article or not. They should contain only clear, concise information on the subject covered. "Selling" is inappropriate and suspect. Summaries are used in specialized media such as scientific, legal, or learned journals, whose readers are already predisposed to reading.

A secondary use of summaries is information retrieval. That is why they need to be readily noticeable, for speed in the search is important. Often summaries are assembled out of context in printed catalogs or electronic data files, so conform the original typographic format to its secondary use to avoid rekeyboarding.

The visual character of summaries is usually more formal than that of decks. The serious and dignified context in which they are seen puts limits on the freedom of typographic expression. For some reason, journals frown on ragged-right settings as frivolous. Justification is the stodgy norm of such publications. If you are preparing a scholarly presentation, it may be unwise, if amusing, to challenge the status quo. It is better not to buck the system. Set the summaries justified—but work out a beautiful set of proportions. Distinguish it from its surroundings by simple, but well-chosen rules, or perhaps a decorative "printer's flower." Or try putting the summary in a box; then you can place it anywhere. Here are some other ideas to consider:

- Placing summaries at the top of the page makes them easy to spot and helps to announce the start of a fresh report.

- Centering the title and the summary creates solemnity, which can be enhanced by a little decorative feature.

- Beware of arbitrary sizing: two-out-of-three columns may be too narrow for large-sized type.

Abstracts are a special kind of summary, whose written format is prescribed by the particular academic discipline. Their length is usually restricted to about 120 words. In general, abstracts of research reports should state the problem, method, results or trends, and conclusions. They should also indicate the significance of the experiment. Abstracts of reviews or discussion articles should outline the central thesis, with the main arguments.

Abstracts are usually even more primly conventional than summaries. They are often run as the first element in the text, set in boldface, perhaps one size larger than the text copy. Or they may be placed in the center of the page in a bay surrounded by the text. Here are some points to consider:

· Inserting the abstract between the headline and the text creates a strong hurdle for the reader intent on reading the story.

· It's possible to allow the reader can enter the text directly or examine the abstract first.

· Some formats necessitate runarounds to make room for the abstract in the text area.

This professor instructing his students comes from Nicolaus Valla's *Ars metrica* (Florence, 1494). His youth suggests that his instructions may be quoted from the older authorities, at whose feet he learned not long ago. Notice the barred window, the book, and the hourglass. All are symbols: the barred window stands for concentration; the book represents wisdom; the hourglass exhorts speed.

Pull quotes or breakouts

You may have heard of *pull quotes, breakouts, readouts, pullouts,* or *quoteouts*. All these terms refer to the same thing—provocative or challenging statements prominently displayed on publication pages. They are always extracted from the text, sometimes as an outright quotation, and are set in large type to attract the potential reader's attention.

A valuable ingredient in the makeup of periodicals, pull quotes are steadily gaining in popularity. There are several reasons for this. In the first place, they make the value of the report more readily evident. They also make information visible at the scanning level, increasing speed of communication. From a design perspective, they break up the daunting and unappealing grayness of the text. They are a substitute for artwork, a simple way to create an interesting visual effect at little or no cost. Moreover, as a visual element, they can be used to "staple" two neighboring columns of type together, changing the scale of the page.

Obviously, to be effective, the quote itself has to be "meaty." Make the quote as long as it needs to be: its success lies even more in what it says than in how it looks on the page. It should carry rich, challenging thoughts.

There are five basic techniques to differentiate the quote from the text that surrounds it. They can be used singly or in combination, at will.

1. Surround the quote with a moat of space.

2. Set the quote in a type size and style that creates strong contrast. You want the quote to be large enough to signal its importance: the usual size is at least 14-point. You could go larger to increase the dramatic value. For quotes spanning more than two-thirds of the page, 18-point is the minimum type size.

3. Use quote marks as colorful signals.

Quote marks yield interest by their placement as well as by their charming shapes, if they are large enough to be discernible. Usage decrees starting with "66" and ending with "99," but "99" is often reversed left-to-right and used instead of "66."

4. Insert horizontal barriers and make them as simple or as embroidered as the character of the piece demands.

In the first example, two 1-point rules are set the same length as the quote, which is set justified. In the second example, short 3-point rules are used with embellishments, all set centered.

In the first example, two 2-point rules define space for a ragged-right quote. In the second example, a 6-point top rule, a 1-point lower rule, and an enormous initial set off the quote.

5. Imprison the quote in a defined area such as a screened block or a ruled box.

Boxes with rounded corners are more enclosing than less visually interesting, common rectangles.

Creating a three-dimensional effect on two sides adds color and character without difficulty.

An illusion of the shadow cast by a box "floating" above the paper surface is easily produced.

The startling effect of this "billboard" is created by the ruse of a triangle at lower right.

Placing the quote on the page

For maximum impact, you want to place the quote far enough from where it is used in the text so it challenges the reader without obvious repetition. You must also take care that the quote doesn't distract too much from the actual reading of the text. It is best to insert it within a paragraph, not between paragraphs. The reason is simple: the quote interrupts the flow of text in a column, deflecting the reader's eye. If such an interruption occurs in mid-sentence, the reader will be more likely to vault over it and continue reading. Also make sure there is enough text beneath the quote for the reader to look there and not skip this material by mistake.

The following diagrams show some of the options for placement and styling. Be aware that what works for one column may not be appropriate for two or three columns, and vice versa.

· A simple way to interrupt flowing text is with a sentence set differently from its surroundings: here in bold type indented on the left, set ragged-right.

· Staggered placement avoids the disturbing tombstoning of quotes aligned across the page in a narrow-column makeup.

· Quotes can be placed in the right-hand margin, alongside the wide text column. On the right they compete less with the headings (usually on the left).

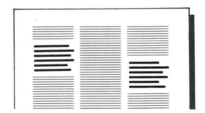

· If the margin is tight, you can cut the quote into the text column. This is best restricted to one side, though both options are illustrated here.

- A cut-in quote in a narrow column can be made noticeable by contrast: here by smaller type size, with lighter "color" than its surroundings.

- A quote interrupting two columns is best placed near the top of the page. You want the text below to be visible enough to ensure that it's not skipped in error.

- Though a quote run in the top margin is maximally visible, it fails to break up the mass of text below, nor does it embellish it with "color" contrast.

- Placing a quote atop the page in this informal fashion takes advantage of the top margin's high visibility, but it can be mistaken for a heading.

Inserting a quote between contiguous columns requires runarounds. Columns may then become narrow, causing poor legibility.

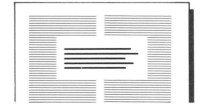

· Here the proportion of space devoted to the quote and its surroundings is well balanced: the runarounds are not too thin. Also, the quote ties the columns together.

· A tall, thin quote inserted between two narrow columns is visually striking, especially if the contrast of type size and color is strong.

Every author seeks recognition of his or her efforts by seeing that special name in print. Here Herodotus is seen writing his *History*... and not just getting credit, but a laurel wreath to boot. The wreath didn't cost the publisher much because the artist just had to draw it. Herodotus is getting it in lieu of royalties, because he had already been dead more than 1,000 years when this illustration was published in Venice in 1494.

Bylines and bios

The author's name—the byline—needs to be accommodated in a fashion appropriate to the document at hand as well as the author's prominence. There are two standards: one for normal circumstances, when the author's name is of normal importance, and the other for when the author's name can be used to add glamour to the publication.

If numerous bylines are expected in the publication, it is essential to establish a definite format and placement. The byline becomes one more clue, along with the title and deck, to the start of a new piece. Regularity in placement also simplifies page assembly by standardizing one of the minor decisions and counteracts the temptation to be clever and different where such playfulness adds little but confusion. For the reader, regularity helps in locating specific information. It also increases the drama of any departure from the norm by contrast.

In setting up the byline, there are a few details to bear in mind.

- Run names in the normal sequence: given name, middle initial, family name (*John H. Doe*).

- Add academic degrees (*MD, PhD*) after the name only if this information is appropriate or if the author insists.

- Run a title (*Chairman of the Board*) and/or affiliation (*Company, University*) in a second line below the name, but reduce its importance by setting it in a lighter typeface, italics, or a smaller size.

- Wherever there is more than one author, list the principal author first and then the other authors in alphabetical order.

Here are some diagrams showing the options for placement:

Above title:

Flush-left

Centered over
centered title

Flush-right on
longest line of title

Below title:

Flush-left

Centered beneath
centered title

Flush-right below
page-wide rule

Above deck:

Flush-left, deck
reading into title

Centered between
centered deck and title

Flush-right below
deck in unused space

Below deck:

Flush-left

Centered beneath
centered display type

Flush-right in
last line of deck

Above text:

In wide margin
at left

As first item in
text column

Centered atop
middle column

Below text:

At lower-left
corner of page

Centered near
foot of text blocks

At lower-right corner,
as end of text

Authors' biographies are often used as credentials, positioning them in their area of specialty and giving them, as well as the publication carrying their article, the requisite credibility and status. Such information, however, should not be allowed to interrupt the flow of thought from title to deck to text. Since the foot of the page is the area least scanned for fast information and so out of the mainstream of that thinking sequence, it is the ideal place for such a bio. If the bio is placed at the foot of the first page of the article, then this background information is given its due importance, though it is clearly subordinated to the vital material at the top of the page.

The name of the author should, of course, be repeated at the start of the biography. The information is usually set in smaller type than the text. One idea is to run it ragged-right, for contrast, if squared-off, justified copy surrounds it. It can also be set in italics or separated from the rest of the text by a rule. Although conventional design wisdom decrees that you should keep pages simple, it is of overriding importance to clearly present the variety of information the reader is looking for. Make the elements distinct but compatible.

An alternative placement for the bio is at the end of the article. Scientific and learned papers are often handled in this manner. It is an especially useful placement when a lot of information needs to be accommodated or more than one author's biography must be cited.

Sometimes a portrait photograph (known irreverently as a *mugshot*) accompanies the bio. In that case it may be a good idea to box the entire item in some way.

Here is the designer as he appeared in the *Ständebuch* by Jost Amman (Nuremberg, 1568). Designing and the act of drawing or mechanical drafting were considered a single skill. Thus this craftsman was both illustrator, drawing the pictures, and what would today be classified as art director, designing the product.

Captions, legends, cutlines

Picture captions are the most undervalued and therefore most misused page component in most publications. That is because they are usually written under the deadline gun and are not much more than afterthoughts. They tend to be seen as those less-than-important words needed to explain or identify a graphic item, which in turn is seldom deemed as important as the text. To most writers and editors, captions, legends, or cutlines are a nuisance. (Even the nomenclature is aggravating—see below.)

Yet it is precisely the pictorial graphic items (with their verbal explanations) that are looked at first when the new page is revealed. They are glanced at and studied before the text and often even before the title is read. They may be photographs, illustrations, renderings, charts, graphs, diagrams. It matters little what they are, as long as they differ visually from the surrounding text. The publications in which they appear can be technical or general, scientific or cultural, sophisticated or elementary. They can be newspapers, newsletters, contracts, magazines, legal briefs, learned papers, or any other multi-page printed piece. It doesn't matter what or where, human curiosity is attracted to any visual element that looks different from its surroundings. Anything that breaks a pattern stands out and makes us notice it. Furthermore, pictures are easy to take in. Reading demands concentration and work; looking at images is fun.

The recipient is receptive. The mood is right. Here is a chance to present vivid, interesting information. Is it not wise to exploit this built-in opportunity? That uninterested skimmer, who didn't intend to delve into the subject at all, may well be intrigued by an irresistible gobbet and become hooked into reading. That is why captions are so important.

Traditionally, the term *caption* refers to a title placed above or below an illustration, as distinguished from *legend,* which describes the subject of the illustration.* Today, however, both words may be used for the explanation of the illustration in the magazine as well as the book publishing world. In the newspaper publishing world, all illustrations are known as *cuts* (a synonym for engraving, which is the way pictures used to be reproduced). The words accompanying the cuts are logically known as *cutlines,* while headings are called *catchlines.* For convenience, they are all referred to as *captions* in this book.**

Writing the content

To produce fast, effective communication, you have to make the form express the content. How something looks cannot be separated from its substance. That's why you must be as concerned with what is said as with how you are saying it. Here are some suggestions:

· Do more than just describe what the graphic shows: give reasons why the viewer should bother looking at it. Point out what is significant, new, different, and what the implications are. Expand from the specific to the general. In newspapers people talk of the "news peg" on which the significance of the cut is hung.

· Make the caption long enough. Readers will happily stay interested for three lines. And you can say a lot in three lines of normal length (about 15 words apiece).

*This is, of course, unrelated to the other meaning of the term *legend*: a key for symbols on maps or diagrams.

**While on nomenclature, it might be useful to define some terms closely related to captions, which also often cause confusion. Printed photographs are known as *halftones.* (The term refers to the technique of reproducing tone by turning the various degrees of shading into tiny dots through a screening process.) Drawings without tonal variations, such as graphs or cartoons, are known as *linecuts* or *line art.* (Here the art is reproduced directly, as pure black-and-white contrast, just as type is.) All originals are known as *art* before reproduction, whether or not they are hand-drawn or worthy of such an accolade. Unfortunately, the word *art* is often misused to describe reproduced illustrations (cuts) as well. Don't be angry or frustrated at these complexities. They are cause for pride: their variety grows out of the breadth and importance of the publishing and communication processes.

• Don't write too much. If you have many more lines than three, the second half of the caption may go unread. It is too easy to be enticed by another beguiling element on the page. In any case, keep it concise enough to avoid the need for paragraphing.

• Avoid repeating information covered in the text. Readers resent wasting time that way. If the illustration relates directly to the text preceding it, you may want to skip a caption altogether. In other cases it may be better to put the information in the caption and cut it from the text. Not only does it gain higher readership in the caption, but it makes communication more vivid, improving retention.

• Think of each caption as though the graphic element it accompanies were a mini-story on its own. Pretend that the first sentence is a title or a headline setting the theme for the caption's message. That discipline will force you to put the important, reader-intriguing material first. You can then choose whether to express the "headline" typographically as a separate caption (above the illustration).

• Give each graphic item its own caption. You often lose more than you gain by bunching captions together. Though it may be easier to write and position them as a group, the reader can become confused and irritated by the complications of identification.

• Refer to elements within the illustration following a standardized sequence. It is customary to start in the top-left corner and follow around in a clockwise direction. In any case, give readers the clues to your system before starting the itemization, so they know where to look as they read.

• Split the material into two parts, if that's appropriate. Nearly every caption carries information identifying the subject in the image. It also carries supporting information of some sort or perhaps a quotation. By separating these elements from each other and using a different typographic treatment for each, you increase the possibilities of creating visual variety and interest.

• Handle credits for photographers or acknowledgments of sources for the illustration consistently. Traditionally, they are the last item mentioned in captions, especially in newspapers. This may not, however, be the best place, as it may give such secondary material undue prominence. Instead, place credits in small type separately alongside the illustration (see also the discussion of credits on pages 135–136).

Dealing with typographic technicalities

There are as many ways of handling the type in captions as there are editors and designers. There may be traditionally accepted ways, but there are no "correct" ways. If something works, then it is probably correct. The only rules are those of common sense. Here are a few general observations based on experience. If they don't work in your context, forget them.

• Follow your own preference about what type and size to use. Newspapers generally use a boldface for their cutlines because editors believe that the darkness of the type makes the words blend better with the halftone on newsprint stock. On the other hand, visually sophisticated magazines seem to prefer a pale, small type size, often using the italic of the text type. There is a school of thought, though, advocating strong contrast between text type and captions; they believe in sans serif for captions. Do what you feel is right for your publication.

- Also follow your instincts about line length. There's no such thing as the "right" line length for captions—it depends on the number of lines, the typeface used, the interline spacing, the color and reflective quality of the paper, and so on. On the other hand, the interest and goodwill generated by the illustration allows you a lot of leeway. Your readers will probably plow through whatever format you present them, as long as the material is interesting enough and there isn't too much of it. As a rule of thumb to be taken with a pinch of salt (quite a trick): you should start being concerned when the lines get to be about 60 characters long. You have to play it by ear—or rather, by eye.

- Run a single-line caption as wide as it needs to go, even if the graphic it accompanies is a full page wide. Readers will follow it easily. Long lines only become problematic if the reader has to return to the left edge to read the next line.

- Break captions into two legs of type when lines become too long for easy reading. The cutoff point is hard to define. Although 60 characters was just cited as a long line, breaking 60 characters into two columns is not wholly satisfactory either, because the two 30-character lines are very short. Again, use common sense.

- Avoid indenting the first line of a caption. It is neater set flush-left.

- Omit the period at the end of a caption if it is just a phrase. Complete sentences, however, require a period. If you mix styles, then be consistent and use periods in both situations.

Observing the picture/caption relationship

The overriding consideration with all captions is to blend the graphic element and its accompanying explanation into an entity. They must be seen to belong to each other.

- Put the words where they are looked for by the viewer: below the image. That way you are making use of a valuable habit pattern. Obviously, this is not a hard-and-fast rule. But experience shows that if you put a legend above a picture, people tend to bypass it, since the image is so much more interesting than an "overline" (which is what cutlines positioned above an illustration are called in newspaper parlance).

- Place the caption above the illustration only when there is a functional reason, such as a picture bleeding off the foot of the page.

- Set up a standard placement when you have a series of pictures and captions. The immediate findability of the captions is crucial in a reader-friendly presentation. In such situations, varying the placement gratuitously becomes counterproductive.

- Place the caption as close to the image as is sensible. Closeness is the clearest clue that two items belong together. How close is close? That is a question of proportion and scale on the page. It is better to define what is too far: a pica tends to look as wide as the Grand Canyon.

• Leave at least one and a half text lines of empty space between the bottom of the last line in a caption and the top of the text below.

• Take great care in using the ultimate closeness of all: putting the caption on top of the illustration. If it is line art and the background is plain paper, there is no problem (other than actually finding the caption within the linework of the illustration). If it is pictorial and therefore a halftone, be sure that the area over which the caption is placed is not mottled, or the type will be undecipherable. If the area is pale in tone, surprint the type in black. If the area is dark, drop out the type in white. But use this technique with circumspection: it is a trick (see also pages 39–41).

• Drop the caption out in white type from a panel of black, if that panel is attached to the picture in some way. Often pictures are made to cast a "shadow" on the paper. The shadow is a good place for a reversed-out caption.

• Place the caption on the page in the same orientation as the picture so they belong to each other.

Refining caption placement

In placing captions, base your decisions on logic and understanding. Avoid arbitrary decisions based on axioms that sound good but may well not apply to the special circumstances of your project. Once again, there are no hard-and-fast directives that decree official ways of solving word/picture relationships. It is much better to know your alternatives and pick the option that makes the best sense. The options described below are the most common.

Exploring the geometric arrangement

When you lay out a page, you are not just turning words into type, but you are simultaneously assembling a composition. That may sound arty, but you cannot escape it: each bit you place on the page is an object that has its own individual shape and direction. (For instance, type has a left-to-right direction, since that's the way we read. Pictures are more static, unless you deliberately manipulate them. Tables just sit there like bumps on a log, especially if the headings are centered.) Understanding the relationships based on the geometry of these various bits can affect the way you handle them.

• Try centering the caption below or above the illustration: the centering creates an axis that ties them together. This is particularly effective when the illustration does not have a rectangular outline, but is a random-edged drawing.

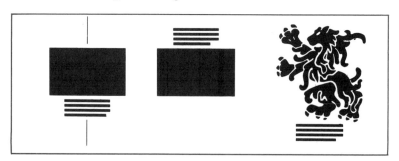

- Or center the caption in the middle alongside the illustration, at left or right. The relationship here is a little more tenuous than centering above or below. Furthermore, be aware that if the leftover spaces above or beneath the caption are small and insignificant, the visual result is untidy. Under such circumstances, it is wiser to align the caption at the top or bottom.

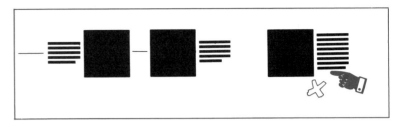

- Fill out the last line of the caption if you want the look of high-style precision and quality. That demands writing to fit the character count of the line, and then rewriting when the results don't quite work out. Although it is a time-consuming and expensive bother, the result is sometimes well worth the trouble.

- Center the last line of the caption, but make sure it is short enough for the effect to be visible. This old-fashioned detail can be a useful option, imparting a traditional look—if that is what you want.

Aligning picture and type The caption and accompanying graphic element are one unit of information. Linking them into such unity visually encourages the viewer to link them intellectually and to interpret the message that much more clearly and vividly. The most obvious and also most effective graphic trick that does this is alignment. There are many ways in which it can be made to work.

- Align both sides with the sides of the illustration. Such "picture-wide" captions give a hard-edged, crisp, professional look.

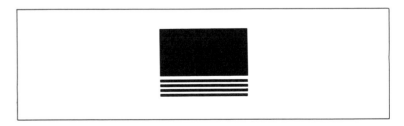

• Avoid the insignificant 3-em indent on either side of the caption so often seen in newspapers. The narrow indents merely look inaccurate without adding visual drama.

• Align one edge of the caption with one of the vertical edges of the illustration.

• Align the top of the first line of the caption with the top edge of the illustration, left or right.

• Align the last line of the caption with the bottom of the illustration, left or right.

Using the "sticky edge" If you set captions ragged (with one edge unaligned), the justified edge tends to "stick" to the straight edge of a rectangular picture. Furthermore, the contrast of texture and informality between feather-edged captions and justified, rigid text columns can add visual variety and flavor to the piece.

· Whenever possible set the caption flush-left/ragged-right. The neat, vertical left edge makes reading easier, because the reader knows precisely where to return to find the start of the succeeding line.

· Use flush-right/ragged-left setting with care, as this is harder to read because of the ragged left-hand edge. You can risk it if there are not too many lines (a dozen or so maximum) and if the lines are not too long (exceeding 35 characters or 7 words). The thing to avoid is stretching reader patience. Use the final test: would you read it? That should affect the decision.

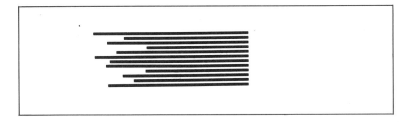

· Exploit the adhesive quality of the flush, vertical edge to tie caption and illustration together. Place the flush edge next to the picture's vertical edge. The ragged edge should be away from it.

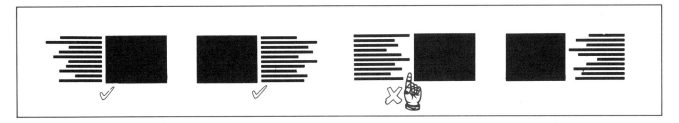

· Emphasize the interdependence of the caption and the graphic by aligning the top of the first line of type with the top of the picture or the last line with the bottom of the picture, on the left or right. Do this in addition to placing the sticky edge next to the illustration.

• Align the flush edge of the caption with the vertical edge of the illustration when the caption is above or beneath it, on the left or right. It binds them together clearly and effectively.

Adding external effects

An illustration and its caption do not have to remain in their original pure state. There may be a good reason for adding other elements. You might, for example, enlarge their apparent importance by capturing some of the surrounding space. Or you might make them more visible by adding tones or frames. You can also enhance their special atmosphere with mood-producing effects. Here are a few examples to start your ideas flowing. But be careful not to overdo it. The illustration and its caption must always remain the most important element. Don't let the tail wag the dog.

• Place both illustration and its caption on a unifying background of color or a light screen of black. This works particularly well if the illustration is linework such as a chart or diagram. If it is a halftone, a window will have to be knocked out from the background into which it can be inserted (stripped).

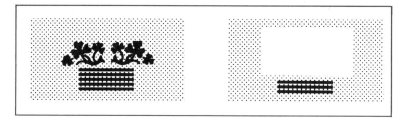

• Put the illustration with its caption in a box.

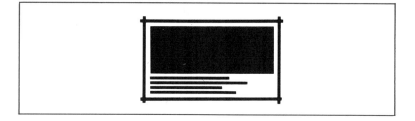

• Use a framing device to staple the two elements together.

Working with callouts Another way to be innovative with captions is to recognize when the information can be conveyed through callouts.

- Place the name of various elements needing identification around the outside of the illustration instead of trying to tell the reader where to look in a lengthy caption. Run lines or arrows from the word to the element it refers to. This turns the illustration and its caption into a visual diagram—a far more interesting object to study.

- Consider a hybrid presentation if the caption consists of independent descriptions that add up to a threateningly long mass of type. Why not subdivide the caption into its components and present them as callouts with lines pointing to the areas of the illustration they refer to? There is no reason why a callout should be limited to a word or two.

- Make the lines straight or curved, direct or angled, dashed or solid, heavy or light. Let them end in arrowheads, blobs, triangles, or just stop. Make them dark (if the background is light) or light (if it is dark), or a combination of both (responding to the background). There is no standard.

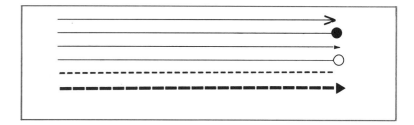

Titling the caption

If you consider each illustration and caption combination as a ministory, then it is quite logical to write it with a title, often called a *catchline.* (A good name, as its function is to catch the viewer's attention.) This self-contained thematic label can be placed in a variety of relationships between the illustration and the rest of the caption. But note that in the following examples the caption with its catchline is always placed below the illustration. That is the traditional and most effective placement. Of course, other arrangements are possible— they're just riskier.

Flush-left Centered Outrigger Sideline Cut-in sideline

Another possibility is to use a run-in head or a boldface lead-in. Here an initial phrase or the first words of the first sentence are set in a contrasting boldness (or different typeface, larger size, or all-capitals) to make them stand out. This device acts as a mini-headline without actually being a headline. Used correctly, it can be an editorial tool for speedy communication as well as attention-catching.

Lead-ins must be written with the typographic treatment in mind. The emphasized words must contribute a significant clue to the idea or significance of the item. The importance implied by boldface must not be wasted on words that are not worthy of such emphasis. The test: do they make sense if read by themselves? If not, you know what must be done. Avoid blunting your precious weapon of emphasis: never give something the appearance of importance without the solid support of meaning.

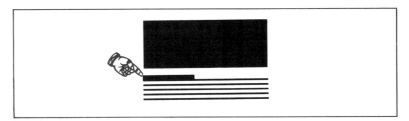

Handling technical material

Technical publications bring their own special problems. Often the illustrations are referred to in the text, necessitating a consecutive numbering system for clarity. But even with the numbering, you should place the illustrations as close to the text as is practicable.

How should you refer to the illustrations? The term *figures* (or *exhibits*) refers to graphics occurring in the body of the text, while *plates* are usually printed on better stock and run as a group elsewhere in the publication. It is clearer, however, to call all illustrative elements *figures* and number them consecutively, than to distinguish among figures, charts, diagrams, and plates, with each set numbered separately. Nevertheless, each specialty in publishing must follow its own conventions.

Typographically, the boldface lead-in just described is often used to signal *Figure, Plate, Chart,* or *Diagram* in technical publications. This convention is the most convenient way of keying the illustration to its accompanying text. The price paid, however, is high: the inability to use boldface lead-ins as excitement generators.

One final note: if the captions consist of merely the words *Figure 1* or *Plate 1,* then spell the words out in full. It is acceptable, however, to shorten them to *Fig. 1* or *Pl. 1* when they are followed by more wording.

No wonder Mr. Catnach was proud of his published products: he claimed assistance from the Muse. Or at least that is how Thomas Bewick designed it in this British logo from about 1780.

Credits

All those whose work is published should have their contribution recognized. You must acknowledge photographers, artists, sources of information, as well as the providers of permission to reprint or quote from previously printed pieces.

Giving correct credit is legally necessary to prevent lawsuits. There is a minefield of copyright ownerships, work-for-hire obligations, public domain questions, and all sorts of other quibbles. It is the author's contractual duty to disarm the boobytraps one by one, and produce the correct and acceptable credit line for each item that requires such acknowledgment.

Giving visible credit can be especially important if payment is minimal. Creative people often justly complain of underpayment; they are mollified and feel partly repaid by seeing their names prominently displayed next to their work. Besides, they hope to find future clients through its publicity.

In addition, giving noticeable credit near the illustration can cost less. Picture agencies, whose business it is to represent photographers and place their pictures in publications, often demand higher fees if the credit line does not appear next to the image. (You have been warned.)

Finally, giving ample credit is a good investment. Nothing creates goodwill so effectively as seeing one's name in print. It ensures future cooperation.

The only exceptions to the need for crediting are:

· Materials produced and supplied by the author.

· Materials in the public domain (as a general rule: anything published in the United States before 1906, or in some cases 50 years after the death of the author—but make sure.)

- Materials drawn from sources such as clip-art services specifically intended for public use without payment in addition to the original cost of the service or book.

- Materials that are so clearly and legibly signed by the artist that a second credit line would be superfluous.

Deciding on placement

Under the lower-right corner of the illustration is the photographer's or artist's favorite place. The credit line is noticeable there even in minimal-sized type. You can choose roman, italics, lowercase, small capitals, all-capitals—there are no standards, so please yourself. Set it small, but do make it legible.

You can also place the credit line above the illustration or alongside it, flush to a corner. The convention is to have the wording reading upward on the left side of the picture and downward on the right side of the picture. That apparently unnecessary complication begins to make sense when you put the credits to two neighboring pictures in the narrow alley of space between them.

One problem with running the credit line next to the illustration is length. If the credit line is much longer than the usual "Photo: John Doe," and it can overwhelm the illustration. Do you live with it (because it rarely happens so it doesn't matter), or find another solution (because it would spoil your publication)? The only rule is common sense.

A different possibility is to work the credit into the text of the caption. Or you can run it as the last element of the caption, in italics and parentheses. The latter method is a common practice, especially in newspapers. Its disadvantage: too much prominence, perhaps. Its advantage: you remember to put the credit in if it becomes a standard.

Yet another possibility, if there is only one credit and it happens to be very long, is to run it as a footnote at the bottom of the page.

Sometimes, especially if the individual items are long, they may be assembled into a group. They can then be placed at the end of the piece as box credits. Or, in the case of a book, they might be listed on a separate page in the back. If there are not too many names or page references, they can be included in the acknowledgments.

Grouped formats can be arranged in two basic ways: (1) run in as flowing text (which is concise but hard to scan) or (2) itemized by page on separate lines (making citations easy to find).

Pedantic precision is nothing new. Scientific treatises in the form of collections of information filled the growing need for organized knowledge at the beginning of the Renaissance. This illustration accompanying the chapter on stones is from *Hortus sanitatis (The Compendium of Health)* by Jakob Meydenbach (Mainz, 1491). The volume includes encyclopedic information on herbs, beasts, birds, fish, and, yes, urine. The opportunity for footnotes staggers the mind.

Footnotes, references, and endnotes

Notes, referring to items mentioned in the text, may be placed at the foot of the page (footnotes) or the end of the article or book (endnotes). In scholarly material it is common to use references, citing the author, date, and sometimes the page number of a source in the text and then giving the full bibliographic information in a reference list at the end of the article or book. It is possible to have both footnotes (for substantive remarks) and references in the same work.

Notes, however, are questionable elements:

- The reference numbers, letters, or symbols can trip up the smooth flow of the sentence. (That is why it is best to place such marks at the end of a sentence, if possible.)

- Placed at the bottom of a page, they can be distracting. At the end of an article or book, they may be a nuisance to find.

- They can bedevil page makeup and therefore raise costs considerably. Admittedly, they are less expensive to produce with the new computerized technology than with photocomposition (requiring hand-pasting of small swatches on the mechanical) or hot metal (requiring moving lines of type by hand from galley to pages).

- They are a vulnerable point, where mistakes can be made without painstaking checking for accuracy.

Are they necessary? It is wise to resist the temptation to bring up questionably relevant material or parenthetical discussion. When clearly pertinent, material should be integrated into the body of the text, if it does not interrupt the flow. But, in general, content that has tenuous connections with the matter at hand ought to be omitted.

Yet there are some publishing formats that cannot do without footnotes. Legal ones are the obvious example. Scholarship, too, may well require copious references and cross-references. In such cases it may help to combine several references into one footnote, taking care to have the sequence of notes follow the sequence of thoughts in the text. Another possibility is to remove subsidiary information from the mainstream of the text and quarantine it in an appendix. Obviously you can only do this with material that is related and can be organized that way. A simple reference can then direct the user to it.

Styling the notes

Correct referencing to previously published material is extremely complex. The combinations and possibilities are uncountable and the technicalities subtle. They are needed for consistency as well as clarity of communication. That is why commonly accepted standards have been established. See the *Chicago Manual of Style* for the clearest, most concise and complete guidelines. Here are a few basics:

Reference to a book:

1. Author's Full Name, *Title of Book* (City: Name of Publisher, Year), p. 00.

Reference to a periodical:

2. Author's Name, "Title of Article," *Name of Publication,* Volume and Number (Date), p. 00.

(If italics are unavailable, indicate the italicized item with underscoring.)

Numbering can be by column, by page, by chapter, or consecutively for the entire publication. There are several possible styles you can use for numbering:

· superior numbers[1] [2] [3] [4] (small figures above the line)

· superior letters [a] [b] [c] [d] (where the use of numbers might be confusing, as in technical works, math texts, or tables)

· asterisks *** (done by page to avoid too many)

· symbols in the correct sequence: * † ** ‡ § ¶ (asterisk, dagger, double asterisk, double dagger, section mark, paragraph symbol)

Setting and placing footnotes

It is preferable to use the same typeface as the text for footnotes. The rule of thumb is to set footnotes smaller than the text, but not so small as to be illegible. In most faces 7-point is at the low range of comfortable reading. In some instances 6-point or even 5½-point can be used if the face has a large x-height and the paper and printing can be relied on for quality. But remember that footnotes in annual reports, prospectuses, and other financial documents coming under the jurisdiction of the Securities and Exchange Commission (SEC) may not be smaller than the text size (and the smallest is 10-point).

Footnotes are usually set to the same width as the text column above. If, however, the text is set page-wide, and the small-size type in such long footnotes would be illegible, break the column in two.

Always start footnotes on the same page as the item in the text to which they refer. If they are too long, you can carry them over to the foot of the next page and even to succeeding pages.

Place each footnote on a separate line, for maximum ease of reference. Or run footnotes in, paragraph-fashion, to save space. It looks neater, but you sacrifice ease of reference. Add extra space between run-in footnotes to ensure the visibility of the figures or letters.

If you run the footnotes on separate lines, start each one flush left, for maximal noticeability of the symbols. Or indent each footnote by a pica, following traditional practice. Or center the footnote, if there is only one and it is short.

Allow at least one line of empty space to separate the text from the footnote beneath. Or insert a hairline (quarter-point) rule above the footnote to separate it from the text above. This is especially useful to help distinguish footnotes from captions, table notes, or extracts run in the text in smaller type. In terms of width, the rules can be the traditional 4 picas, 1½ inches, or a full column.

Group all footnotes at the foot of the right-hand column, when pages are broken into two or three columns.

Make sure the last line of the footnote falls on the lowest edge of the live area of the page (the area within the margins).

Position the footnotes at the bottom of the page even on pages such as chapter ends, where the text runs short.

Variations for endnotes

When notes are run at the end of a chapter or book, the common-sense restriction on length (i.e., as short as possible) does not apply. The author is freer to include a lot of detail. Endnotes can also be set a size larger than footnotes. That is, should the text be in 10-point, then footnotes might be in 8-point and endnotes in 9-point.

If the notes are placed at the end of a book, the section should begin on a fresh page. The material should be grouped by chapter, showing both chapter number and chapter titles for easy reference.

Numbering of endnotes is usually done chapter by chapter, rather than consecutively from start to finish of the entire work. In reprinting or revising a work, fresh items may need to be introduced, so you want to avoid having to reset the entire numbering system at inordinate expense and labor. Numbering new notes with "a" and "b" (e.g., 10a inserted between 10 and 11) is not acceptable as quality workmanship.

This is not strictly a table, though its geometry resembles one at first glance. It is a page from an Egyptian papyrus manuscript of the *Book of the Dead*. It was left in the tomb as a user's manual for the mummy on "How to Get to Heaven."

Tables

At first glance, tables look like complicated geometric constructions. They appear hard to figure out, let alone design in type. If you see them as nothing more than a combination of simple lists, each presenting a single set of related data, then they become much less daunting.

When data in two or more lists are compared to each other in organized fashion, item by item, a simple tabulation results.

If the information is further condensed into a formalized presentation of facts (whether in words, numbers, or symbols) and the categorization of data is explained by headings, then a true table results.

Topics are usually listed in the column at left (the stub) and variable factors are listed as heads across the columns.

The table then shows the interaction of a "factor" with a particular "topic." This new information—relating two known items—appears at the intersection of the horizontal rows and vertical columns.

	Factor 1	Factor 2	Factor 3
Topic A			
Topic B			●
Topic C			
Topic D			

Information located in cell at intersection of vertical column and horizontal row

Tables are a concise means of compressing a lot of information into a small space. They are often clearer than paragraphs full of text. Properly constructed, they can make arrays of similar facts easily graspable.

Essentially, there are two kinds of tables. Statistical tables present facts in numbers (dollars, amounts, percentages, frequency of occurrences, and so on). Verbal tables present facts in word form. But, whatever the kind of table, what is most important is how the information is classified and presented visually, as this can affect the way the reader draws conclusions. In general:

• Set data forth systematically to make interrelationships as visible as possible. The method of presentation must facilitate comparison both within the table and between tables.

• Make sure the table complements and supplements the text, giving it credibility. It should never simply duplicate it.

• Condense statistical data as much as possible, consistent with clear communication.

• Keep all explanatory wording self-contained and clear, even though it needs condensing because of space limitations.

Seeing tables as "pictures"

Think of tables as though they were illustrations. That is the way the viewer sees them. They look different from the surrounding text. That is one major reason why it makes good sense not to set them the same width as the column of type in which they occur. When they are narrower or wider, they become more of a welcome interruption in the stream of text.

An even more compelling reason for freeing tables from the tyranny of the column width is legibility. As the discussion of horizontal tracking below makes clear, tables should never be arbitrarily spaced out to fit the overall width. Artificial gaps between columns impede reading. Tables should be set to their natural width and centered on the column or placed flush with the left margin.

If the headings atop the table's columns require too wide a table, consider turning the table 90 degrees and running what used to be column headings in the stub, as stub heads (see page 146). A tighter, more legible table may well result.

Fencing tables in closed boxes is the customary way of presentation. There is little choice if the style specifies boxing. Full frames, however, are seldom essential to define the space enclosed by the box. The vertical lines merely add ink to the page. Instead:

· Set a bold rule across the top and bottom perimeter of the table. That creates an optical illusion of a rectangle more in keeping with the contemporary geometric page formats. Besides, it also yields more "color" contrast, which helps to enliven the page.

· Place the table on a tinted rectangular background, using a light color or very pale gray (no darker than 10 percent black).

Horizontal tracking, or reading across the table

We are accustomed to accepting information the way we read: from left to right. Interrupting this smooth flow creates problems in comprehension. Tabular matter cannot help interrupting the flow because tables are, by definition, broken into vertical columns. The critical problem in makeup is to make the left-to-right relationships clear. The up-and-down relationships within the column are much easier to understand and can take care of themselves.

The fundamental requirement is to make the spaces between columns as narrow as possible. Traversing wide gaps confuses the reader, because the eye is expected to leap across vast, empty areas and alight

at the right place. Too often it finds the line above or below. The size of the gaps is usually caused by the length of the column headings above.

	Very long heading	Long-winded heading	Verbose, prolix heading
Topic A	mmm	mmmm	mmmm
Topic B	mmmm	mmm	mmm
Topic C	mm	mmm	mm
Topic D	mmm	mmmm	mmmm

Stacking the words in the column headings (or perhaps editing them or even using abbreviations) narrows the gaps.

	Very long heading	Long-winded heading	Verbose, prolix heading
Topic A	mmm	mmmm	mmmm
Topic B	mmmm	mmm	mmm
Topic C	mm	mmm	mm
Topic D	mmm	mmmm	mmmm

Here are some some other ways to improve horizontal tracking:

• Use generous leading between the lines. Spacing lines far apart allows the eye to travel sideways more easily.

	Very long heading	Long-winded heading	Verbose, prolix heading
Topic A	mmm	mmmm	mmmm
Topic B	mmmm	mmm	mmm
Topic C	mm	mmm	mm
Topic D	mmm	mmmm	mmmm

• Group three or four rows together and separate the groups with an extra sliver of space. Such grouping works because the viewer recognizes "the top line," "the bottom line," "the second one down," and so on.

	Factor 1	Factor 2	Factor 3	Factor 4
Topic A	mmmmmmm	mmmmmm	mmmmmm	mmmmmm
Topic B	mmmmmm	mmmmmmm	mmmm	mmmmm
Topic C	mmmmmmm	mmmmm	mmmmmm	mmmmmm
Topic D	mmmmmm	mmmmmmm	mmmm	mmmmm
Topic E	mmmmmmm	mmmmm	mmmmmm	mmmmmm
Topic F	mmmmmm	mmmmmmm	mmmm	mmmmm
Topic G	mmmmmmm	mmmmm	mmmmmm	mmmmmm
Topic H	mmmmmm	mmmmmmm	mmmm	mmmmm
Topic I	mmmmmm	mmmmmmm	mmmm	mmmmm

• Add a light band of color under every other entry or every other group of entries.

• Add a band made of a light screen (10 percent) of black under every other entry or every other group of entries. Use the finest screen possible to ensure tiny dots, and use a face that is bold enough not to be affected by the dots surrounding it. When printing type on top of a screen, always use a 0 in front of decimal points (0.000) to make sure they are noticed.

- Run thin, horizontal, ruled lines between entries or between groups of entries. They use less space than extra leading. But use this device with care, since it may be confusing to distinguish rules that merely help to read across from those that are used functionally to bracket and define groupings of vertical columns.

	Factor 1	Factor 2	Factor 3
Topic A	mmm	mmmm	mmmm
Topic B	mmmm	mmm	mmm
Topic C	mm	mmm	mm
Topic D	mmm	mmmm	mmmm

Understanding the five main parts of a table

There are infinite variations of tabular arrangements. The information to be transmitted must be allowed to dictate the shape that will aid understanding most effectively. There are, however, some standard parts that most tables have. Understanding their functions helps to rob table-making of its apparent difficulty. Complex objects are constructed of simple ingredients.

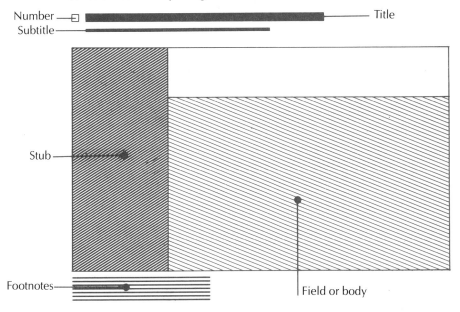

Number and title Most tables have a number for reference as well as a title and sometimes a subtitle.

Number Each table is normally numbered in consecutive order, starting from the beginning of each article, chapter, or book. Numbering makes it easy to refer to the tables in the text, but tables should still be positioned as close to the first reference as possible. Arabic numerals (1, 2, 3) are used to identify tables occurring in the main body of a work, but it is wise to avoid adding suffix letters to the numerals (1A, 1B, 1C), since that can cause confusion. Tables appearing in appendices are identified consecutively in each appendix (A-1, A-2, B-1, B-2). Double-numbering (1-1, 1-2, 1-3) can be used to locate tables in their respective sections of a publication. (Roman numerals are seldom used anymore.)

Title There are two schools of thought on the "correct" way of titling tables. Both are right, because there are no correct or incorrect ways, only effective or ineffective solutions to specific problems.

• A terse, concise label describing the topic (more academic, technical, scientific)

• A sentence describing the implications of the data (more journalistic, explanatory, didactic)

Circumstances must dictate which is more appropriate. The majority of situations demand a plain, straightforward, unslanted presentation of facts from which readers can draw their own conclusions. These conclusions may then be discussed or commented upon in the text. In other situations, however, it may be advisable to guide the reader to the conclusion from the outset, in the title.

Subtitle Where additional explanatory or descriptive information is required to make the main title fully comprehensible, a subtitle may be useful. It is usually set in a type visually related to, but smaller than, the main title.

Stub The stub is the left-hand column of a table, listing the subjects or categories into which the information in the table is divided.

Stub head This head classifies or describes the principal subject of the topics listed below it. Often, however, the table title describes the material clearly, so the stub head becomes unnecessary and is therefore omitted.

Stub column topics These listings define the individual elements in the table, and they should be long enough to do so fully and intelligibly. The first line of each item should be set flush-left, with turnover lines indented. Deeper indents should be used to distinguish subordinate items, as in any verbal listing.

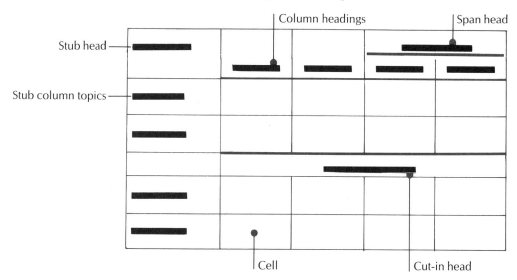

Column headings To describe the subject of each column of information, headings are used. They often carry subheads set in parentheses indicating the units of measurement of the statistics below. Usually, they determine the overall width of the table, so they are written concisely, and sometimes abbreviated, making them as condensed as possible (see page 148). Only when it is absolutely unavoidable should they be set sideways to save space. Then they should be set reading upward, never down the page. And they should never be set with letters reading vertically top to bottom, since that is undecipherable unless one is willing to spend

time working it out. Setting them slanting at an angle looks good, saves some space, and reduces the need for the reader to swivel the page (or his or her head) to make the wording legible, but angling is difficult to produce.

Span heads As the name implies, span heads span over two or more columns. Their function is to bracket those columns into a discernible group. They do so by their placement (usually centered) and the ruled line beneath them.

Cut-in heads These are headings that interrupt the vertical flow of the table and signal a change in subject below them. They can occur anywhere in the field or body.

Field or body The bulk of the table—the field or body—contains the data called for by the stub and the headings. Each unit of the field where a horizontal item intersects with a vertical column is called a *cell*. Empty cells usually carry a one-em dash (—) to help define their presence.

Alignment of the vertical columns and horizontal rows is essential to make the information and its relationships intelligible. Vertically, align figures on the decimal point or flush-right. If the information is verbal, align the type flush-left. Both are clearer than centering.

In verbal tabulation (where each item is not merely a word or two or a number, but a statement in sentence or even paragraph form), legibility of text set in too-narrow columns is of deep concern. To avoid problems caused by excessive word- or letterspacing, it is wise to set such matter flush-left and ragged-right rather than justified. Setting the first lines of items in verbal tabulation full width and the following turnovers indented (i.e., "first line hanging indent") makes each item more noticeable. It also helps to define the structure of the table at first glance.

In verbal tables in which the elements vary in length, align the first lines in each row. Let the ends of the elements fall where they may. The first lines of the next row down will fall below the end of the longest item in the row above. Such an arrangement appears to waste space, but it guarantees clear organization of the information. Save space by rewording the long items to make them shorter.

If a table includes totals at the foot of some or all of the columns, insert a rule running across the full field but not across the stub. Subtotals interrupting a column of figures are similarly expressed, but if the column of figures continues below the subtotal, then a second rule is used to separate the subtotal from the continuation.

Footnotes Each table is an independent entity, so each table's footnotes should be handled separately, without reference to the text or other tables. The numbering always starts at the beginning in each table ([a], [1], or [*]). Number tabular elements horizontally, left to right across the table, not vertically down the column.

Set footnotes table-width, preferably with each note on a separate line. If all the notes are very short and there are not too many of them, it is possible to run them in (one after the other in the same line) to save space. If the line length is such as to impede the legibility of the small-sized type, it might be a good idea to set the material in two columns instead of full width.

Footnotes preceded by the word *Note* qualify, explain, or provide information relating to the table as a whole. They are always run first in the sequence of footnotes. On the other hand, footnotes preceded by the word *Source* credit the source of the information. They are always run last in the sequence of footnotes.

One final point: as mentioned in the section on footnotes, most tables use letters to avoid confusion with the numbers in the table itself. Of course, in verbal tables superscript numerals ([1] [2] [3]) are easier to identify than letters. In tables containing chemical formulas or similar alphanumeric mixtures, typographic symbols can be used to avoid confusion. They should be displayed in the commonly understood sequence (* † ** ‡ § ¶).

Deciding on the type

Conventional practice in bookwork has established a set of do's and don'ts that have come to be the expected norms. They may not, however, fit the varied contexts of nontraditional book publishing. Use common sense, based on the requirements of the situation.

Keep in mind that much of the effect of a printed piece is created by the visual elements it includes, and tables fall into that category. Although they are indeed typographic, their arrangement is perceived as more pictorial or illustrative than "plain" text. Tables gain readers' attention precisely because they are not plain text. How they are patterned therefore affects the perception of quality of the publication as a whole more than one might think. That is why the need for consistency throughout all the tables in a single volume or series of volumes is of overriding importance.

In bookwork the type used in the tables is two sizes smaller than that of the text, though never smaller than 6-point. The average size is 6-point. The premise on which this practice is based is questionable: since the tabulated information is as important as the text, it deserves the same legibility. Conventional reduction of the type size merely accommodates the need to squeeze too much information into too small a space. If you don't have to do it, don't do it just because "it is always done that way."

Instead, assume the worst conditions for reading: bad light, less than ideal reproduction, cramped and distracting surroundings, and competition from more amusing material. Make the tables as clear and easy to read as circumstances allow. Use the largest face that will fit. Use the least disturbing face. Avoid peculiarities of spacing for visual effect, such as overly tight setting or minus-leading or spacing out between characters. Give each table as much space as it will need to be used comfortably.

Consider using a moderately condensed typeface, with which a larger size takes no more space than a smaller sized, normal-width face would. If space is limited, perhaps a condensed version of the face will help you avoid a smaller size. Be careful, though: very condensed faces are hard to read.

Titles should be as large and as bold as is consistent with the style of the publication as a whole. They are the main gateway into the table and deserve—in fact, require—immediate visibility. They should never be set in all-capitals, though that is the way they are often shown in the original manuscript. If the "house" style does not specify Up-and-Down-style for setting, I urge you to use downstyle (also called sentence style), where only the first initial is capitalized and the wording that follows is lowercase (except for proper names and acronyms). That is much faster and easier to read (see pages 34–35).

Column heads are the main problem in type choice. Their length is usually the determining factor in the spacing of the columns. That is why they are often set one or even two sizes smaller than the rest of the table. Such diminution is regrettable because identification of the data is vitally important to fast understanding. Their function is better served if they are set large and bold rather than small and scrawny. It is better to stack the words flush-left and abbreviate wherever necessary. If condensed type is required, use it.

Footnotes are traditionally set a size or two smaller than the body of the table for no better reason than that they are footnotes. Here again, common sense must be used to determine whether this idea is good or bad. Tininess is a signal of unimportance. If the material is vital to understanding the implications of the data, then it deserves a size that will prevent its being skipped. The reader is guided to what is worth seeing by the way the type is handled.

Placing the headings

Titles are customarily centered over the table. To determine whether this is the wisest position, consider where people look to start reading a table: the top-left corner. That is where scanning stub heads and column heads begins. Logic demands that the main titles be tied into that pivotal point. Hence, whenever possible, place them flush-left. It works better, though it defies the conventional.

Column heads are also traditionally centered over their columns. In my opinion, a neater, crisper, more squared-off look is achieved if they are placed flush-left with the column beneath if the subject is verbal and, in some cases, flush-right if it is mathematical.

Span heads and cut-in heads are usually centered, but they can be placed flush-left if the rule beneath them is bold enough to define and link the elements to which they refer.

Rules help to distinguish the headings. Rules separating the heading area from the data in the field are set table-width; those beneath the span head form a "roof" over the columns to which the span head refers; those beneath cut-in heads are set as wide as the material to which the cut-in head refers.

CONSTRUCTING
PUBLICATIONS

This depressed gentleman should have done his cogitating when there was a bit more of him. Perhaps he could have reached some useful conclusions. But he procrastinated, and now he serves only as an illustration for Andreas Vesalius to show how bones fit together in *De Humanis corpore fabrica* (published in Basel in 1543).

There is a logic that holds us together and ensures our workability as objects moving around in space. Imagine what it would be like if them footbones weren't down there touching the ground. We'd be somewhat flabby. Fortunately the footbones hold up the legbones, which reach upward to support the backbone—which stops the headbone from swaying in the breeze.

Few human artifacts have ever been created that don't have some form of structure similar to a skeleton—even music, that most abstract of art forms, cannot exist without one. The need for it is integral to intellectual organization and logic. Printed matter, too, has evolved a traditional framework on which each piece is constructed.* Understanding it and complying with its requirements ensure the usefulness and acceptability of the product to the people for whom it is intended.

The user of the document—whether it's a book, periodical, contract, newsletter, or anything else printed on several pages—expects to find various elements of information in their normal places. If they are there, fast and efficient use of the document results in goodwill and liking. If they are not where they are supposed to be, then the reader becomes confused, uncomfortable, and probably irritated. To make matters worse, that irritation is often transferred from the document to the subject of the document and from there to the company that sponsors them all.

That is why the "s'posed-to syndrome" is a factor that canny publication-makers ought not to ignore. If something has worked so well for so long, there is an advantage in its continued use. Yet, clearly, freedom of choice must be left to the individual responding to the specific situation. If there were no departure from the norm, there'd be no variety, no progress, no experimentation, and not much opportunity for a little fun. It is better, though, to know what you are choosing to depart from, than to guess at what you are supposed to be doing and not get it quite right.

This chapter describes the most common and most basic elements found in printed documents, presented in the sequence in which they are normally expected to appear. Specialized documents such as technical, promotional, or training manuals may require additional ones. On the other hand, booklets, brochures, pamphlets, and other such small-scale publications may not warrant most of them. Common sense must be the guide, with clarity, accessibility of information, and helpfulness to the document's user the paramount considerations. It may be wise to err on the side of giving too much rather than too little.

Here's the skeleton, ready to be fleshed out.

*Is it mere coincidence that anatomical names have been given to many elements in publications? For instance, the *spine* of the book (its "back"), the *head* of the page at the top and the *foot* at the bottom, *bleeding* a picture off the edge of the page.

Protecting printed papers between covers is a wise precaution. It keeps them clean and together. Imagine if they were loose and the winds that Albrecht Dürer drew around his armillary sphere in 1525 were to blow all at once. What a mess.

The outer package

The title for this section—"the outer package"—has been chosen deliberately. Every publication (book or pamphlet, manual or magazine) is a self-contained object enclosed within an outer skin of some sort. Whether it is an additional layer of heavy binding or just the outermost sheet of paper doesn't alter the fact that it is an enclosing wrapper and therefore must be used differently from all the other pages. Obviously the front is used to identify and often to sell the object. But there are many other standardized techniques to take into account. Their very standardization gives them validity, because the habits of the users must be understood and catered to. They must quickly find what they are looking for, so you must put it where they will be looking for it.

Dust jacket

If a book is casebound (hardcover) or issued as a special softcover edition, a dust jacket is used to protect it. The design is usually flamboyant, since the prime purpose is advertising.

The front cover displays the title and author. A lot of thought should go into its design, as this is the first thing the reader usually sees. The back cover is also considered an important selling tool. Often it carries quotations from reviews or background copy, as well as the ISBN number (see page 158).

On the "inside," the jacket has two flaps. The front flap has a blurb outlining the purpose of the work and touting the reasons why the book is an essential investment. It may also note the price of the book, the name of the publisher, and other prosaic information. The rear

flap may carry a continuation of the front-flap blurb, followed by a biography (with photo) of the author and a shorter one of the illustrator, if any. It may also give the publisher's address, as well as the place where the jacket was printed.

The spine displays the title, the author's name, and the publisher's name or logo at the bottom. The title should read across the spine or downward. (In Europe the name usually reads upward, which makes it impossible to read without craning one's neck when the book is lying face up on the table... but that's tradition!)

Paperback covers

With paperbacks, as well as some pamphlets and booklets, the front cover contains the title, version (edition), author, publisher, and sometimes the price. You may also need to insert management signoffs. As with the jacket front cover, *sell* is the operative word here, whether the book is intended for sale or not. The function of the cover is to attract readership, arouse curiosity, create an aura of value (all aspects of salesmanship) while simultaneously identifying the product.

The back cover may include sales information, extracts from reviews, or other copy oriented toward selling the work. It also includes the ISBN number and, if they are not on the front, the publisher and the price (if any).

The inside front cover (cover 2) is usually left blank, especially if there are special or decorative endpapers. If, however, the document is a working publication, you may want to use this space for a list of related publications, information on ordering related publications, or information on ordering additional copies. The inside back cover (cover 3) may also be used for this kind of information or for legal information, if needed; or it may be left blank. The information on the spine is the same as that on the spine for the dust jacket, described on page 152.

Magazine and journal covers

As with books, the front cover of a magazine or journal is meant to sell the issue. It may do this with an inviting image, listings of the main features, or a complete table of contents (in academic journals). In addition to giving the name of the publication, the front cover usually carries the date and/or volume and number of the issue, as well as the price.

Unlike books, however, magazines and journals often use the inside covers as well as the back cover for paid advertising. If this is not the case, the inside front cover may be used for the masthead, copyright information, or the contents. Highly specialized publications and association journals may place information on "How to write for this publication" on the inside back cover.

If the magazine or journal has a spine (and many do not), it includes the name of the publication, date, and volume and number. As with books, the type should read downward.

Comment card

A reader response card may be bound in preceding the back cover. If it is glued onto a page, it is said to be *tipped-in*. If it is loosely inserted somewhere in the pages of the document, like all those cards that drop out of magazines, it is called a *blow-in card*. And that is exactly how the insertion is accomplished: by blowing it in during the binding operation.

This woodcut from 1500 purports to depict the magistrates of the merchants' and wine merchants' guilds of Paris. But if you look closer, it is actually an annual-report-type group shot of a publishing venture. The big guys at top are vice-presidents, who will disagree about the reports the angry editor-in-chief and managing editor are about to submit to them for approval. The pontificator at top right is a lawyer. The editorial department at the desk in the middle is checking galleys, while on the right the treasurer is reluctantly paying off the consultants. Are the rows of people in the foreground readers? (They couldn't all be designers who have been laid off.)

The insides

If all you are preparing is a four-page flyer, then you don't need to pay attention to what follows. Even if you are making a more magazine-like periodical, this is only by-the-way information. But if you are producing a publication that is more like a book—in all the shades of meaning that can be interpreted—you might be well advised to become familiar with the customary organization of the material. You don't have to follow it slavishly, if you have a cogent reason not to. It is here merely as a guide to show you what you are rejecting.

Traditional customs (which you cannot ignore)

There are some generally accepted conventions that multipage publications follow, no matter whether the final product is hardcover, paperback, ring-bound, looseleaf, or anything else. One of the main conventions has to do with the way the pages are numbered. But before going into details, let's look at some of the common terminology.

Running head or header — Head margin — Gutter — Gutter margin, or inside margin

Outer margin — Columns

Live-matter area inside margins — Column space, or column gutter

Folio (even nos. on versos) — Folio (odd nos. on rectos)

Foot margin

Running foot, or footer — Verso (left) page — Recto (right) page

Right-hand pages are called *rectos* (Latin for "right"), while left-hand pages are called *versos* (Latin for "reverse"). Rectos are always odd-numbered (1, 3, 5, 7), while versos are even-numbered (2, 4, 6, 8). The page numbers themselves are callled *folios*.

Often there are three sections to a work. In books these are (1) the front matter (preliminary matter), (2) the text (the body of the work), and (3) the back matter (end matter, reference matter). Similarly, with periodicals, you have (1) the front of the book (FOB) with the contents, editorial, news, letters, and columns; (2) the middle of the book (MOB) with the feature stories; and (3) the back of the book (BOB) with the departments, columns, and miscellaneous items. (Note that many magazine people refer to their products as "books"—just another of those confusions.)

In books, front-matter pages are usually numbered separately with Roman numerals in lowercase (i, ii, iii, iv) to allow flexibility in production. Some books, however, start numbering pages with an Arabic "1" on the first right. Either is acceptable, but if there is a strong tradition in your discipline it may be best to follow it. In any case, front-matter page numbers are often not printed, in which case they are called *blind folios*. Usually the only front-matter pages with folios are the foreword, preface, and acknowledgments (if any).

The remaining sections of a book—the text and back matter—are numbered with Arabic numerals (1, 2, 3, 4), starting with "1" on the first right-hand text page (unless the front matter begins with "1"). Display pages—pages devoted to pictures, chapter titles, or other special uses—often have blind folios. Some of these pages, such as part or chapter title pages, may always be placed on right-hand pages (see pages 157–161 for specifics).

Periodicals are numbered somewhat differently. Some start with an Arabic "1" on the first right following the cover in each separate issue. Others start with "1" on the front cover (but usually as a blind folio). Still others start with "1" on the first right of the first issue in a volume and number incrementally from issue to issue until the volume is completed. That is usually six months' worth, though this may vary from publication to publication.

With periodicals, there is one other convention to note. Usually they have the logo or name, date of issue, volume number, and issue number clearly displayed on the contents page, as well as the cover.

Front matter

Only multipaged publications such as books and technical documents have enough material to demand organization into front matter, text, and back matter. The information that follows refers only to them. Other kinds of publications have fewer requirements and thus far greater latitude in the disposition of the elements.

Half-title Usually just the title of the work is placed on the first right-hand page. If, however, the work is part of a series, then the title of the series can be inserted. The reason for the name *half-title* is that this is a shortened form of the title page (described below).

Page ii There are several options for using this valuable space. If there is an illustration, it can be placed here as a frontispiece. Or the space may be devoted to listing other books by the same author. If the work is part of a series, then the other titles can be listed here, together with pertinent information about them. If the design calls for a spread (two facing pages) to be used for the title, then this space may be used for that. Or the page may be left blank.

Spread or double-truck (two pages together). Never say "double-spread"— that's saying it twice, like "pizza pie."

Title page Any of the following items may be found on the title page. Pick those appropriate to your needs.

—title and subtitle of the work

—number of the edition (if it is not the first) or revision

—version number or update number

—publication date

—product or application area

—security level and copyright notice (but see also below)

—name of author, editor, or translator

—name of sponsoring organization

—name of publisher

—names of cities in which publisher operates

The title page used to be an opportunity for typographic and design fireworks in the days when bookmaking was an art form reserved for the elite. Nowadays, given the much more mundane purpose for most publishing, the practice is to keep it simple. Avoid overelaborate cosmetics. Echo the typography of the front cover. Follow the style of the rest of the book.

Copyright page In books the copyright information appears on page iv, following the title.

To be legally binding, the copyright notice must follow the prescribed form and contain specific information. The title, author, date, edition, country of printing, printing history as well as the publisher's address should be correctly given. In a large company you may want to turn over the chore of gathering these details to the legal department, since many of them depend on contractual obligations.

This page also contains the printing history listing any:

—reprints or impressions (without changes)

—reprints with corrections (minor alterations or improvements)

—editions (substantive changes and additions necessitating renumbering pages or even resetting the entire work)

Also included on page iv is the CIP information (Library of Congress Cataloging-in-Publication Data). This string of numbers classifies the book according to the Library of Congress catalog, which is the standard for library reference throughout the United States and in many countries overseas.

At the bottom of the CIP data is the ISBN information (International Standard Book Number)—a multidigit number identifying the country, publisher, and individual book for commercial inventory control and sales. Every version of a book (hardcover, paperback, pocket size, microfiche) needs to have its own separate ISBN.

Essential though all this information is legally, it can be set in a type size considerably smaller than the main text. It is intended merely as background reference material for those specialists who actually need it.

Dedication or epigraph Sometimes the author wishes to dedicate the work or print an epigraph (a relevant quotation) that relates to the entire work. The place for this is page v, the right-hand page following the copyright page.

Table of contents The TOC is a diagram of the book's skeleton. Its purpose is twofold: to help the reader understand the structure at first glance and to be a guide to the various segments. It should therefore include the titles and page numbers of all the major elements in the front matter, text, and back matter. Whether minor subdivisions of the major elements should be included depends entirely on the specifics of the case.

Great care must be taken to distinguish the various elements typographically on the page, so the relationships and rankings are clear at first glance. Contrast in type sizes and degrees of boldness need to be combined with placement on the page as well as indentation to present the information lucidly.

The table of contents may spread over several pages. Let it absorb as much space (and as many pages) as it needs, for it is a vitally important door into the document.

Multivolume contents If a document is part of a series of separately bound volumes, it helps the reader to know where the present volume fits into the full range. A listing of the titles of the other volumes and synopses of their contents should follow the TOC.

Lists One or all of the following lists may follow the table of contents, starting on a new right-hand page. The expected sequence is:

—illustrations or plates (pictures, photographs, renderings)

—figures (pictorial line drawings)

—diagrams (technical or explanatory line drawings)

—maps

—tables

The type size and layout style used for these lists should match that of the table of contents. They are similar in function and content, so their form should be related.

Foreword If you remember that this is a fore-word, or word before, you won't misspell it "forward," as is so often done. It is a short introductory essay by someone other than the work's author. This contribution is valued because of the person's significance in the field. Usually the person's byline (name and sometimes affiliation) is displayed prominently at the start of the foreword or even on the title page of the book. A thumbnail biography (bio) may be added at the end of the piece.

The typographic design should relate to the main text in general terms, though some variation (in column width, perhaps, or in the head or foot margin) might help to distinguish this section as a special part of the overall package.

Preface Written by the author, the purpose of the preface is to explain the book's objectives and how to use it; give warnings, disclaimers, and the like. It also includes any acknowledgments, unless they are run as a separate section. In revised editions the major changes should be pointed out as a service to librarians and would-be purchasers of the updated version. The preface is usually set in the same type style as the text and begins on a new right-hand page.

Acknowledgments The author's acknowledgments are usually run as part of the preface. If, however, they are lengthy, then a separate section, labeled *Acknowledgments,* is inserted following the preface. (Note: there's no "e" after the "g" in the American spelling. The spelling *Acknowledgements* is British.) The type style of the text is usually followed.

Other front matter Various other short pieces of information may be included in the front matter, before the text begins. You might want to put in a list of abbreviations, a glossary, a chronology, or a list of contributors (in multi-authored works). All these items should be short—not more than a page or two. If they are longer, they deserve a section at the back of the book.

Text

Only publications with enough material to classify them as books, including reports and documentation, need to be concerned with what follows. Smaller-scale publications need not follow set patterns.

But make sure the reader is never confused. It is essential—whatever your publication—to see the product from the user's point of view rather than your own. It is so easy to fall into the trap of believing that you are presenting information clearly because you know what you are trying to say. Yet readers have not been exposed to that information before. That is why they are investing their time, money, and effort in your publication. You owe it to them to guide them through it clearly.

Summary of recommendations If there is a summary of recommendations, it needs to be placed in a highly visible position. It is an integral segment of the text, unrelated to the ancillary front or back matter. Therefore it is usually positioned as the first—or sometimes the last—item of the text.

Introduction An optional element written by the author, the introduction sometimes incorporates the preface, outlining the key concepts, defining the audience at which the publication is aimed, summarizing its content, citing key terminology, and so forth. The distinction is really one of length and substance. If the material is essential to an understanding of the text—setting the stage, so to speak—it should be written as an introduction and numbered with the text. The introduction follows the typographic makeup of the text.

Chapters The text is usually divided into discrete, self-contained segments called *chapters*. Chapters are numbered with Arabic numerals (Chapter 1, 2, 3, 4). They may follow a formal pattern that always starts on a recto or verso; or they can mix, beginning left or right; or they may simply run on without a formal, fresh page-top beginning. There is no "right" or "wrong." The only criterion to follow is consistency within the chosen pattern.

Sections Chapters may be split into sections, each identified by its own subhead. Sections may be further subdivided into subsections, which, in turn, may be broken down into paragraphs. The typographic organization must clearly reflect the organization of the thoughts. Some documentation requires that the organizational construction be expressed by reference numbering (e.g., Military Specifications: 1, 1.1, 1.1.1).

Parts Groups of chapters in a large work may logically combine into parts. In such cases, each part is signaled by opening on a recto page, followed by a blank verso. Depending on the complexity, a subsidiary table of contents for each part may prove helpful to the user. Parts are usually numbered with Roman numerals (Part I, II, III, IV).

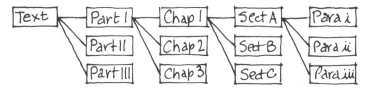

It is useful to remember that the word *parts* refers to "parts of a book," whereas *sections* refers to "sections of a chapter." Avoid confusing the nomenclature: yes, there is indeed a "part" of a chapter, just as there is a "section" of a book—but not in publishing jargon.

Summary or Conclusion Like the introduction, a summary or conclusion is an optional element of the main text. If the list of recommendations is not placed as the first item in the text section, it logically follows the conclusion.

Back matter

Any publication that has an index or appendices at the end has back matter. It may not, however, need to be formally sequenced, if there is little of it. As everywhere else in the process of publication-making, common sense must be your guide.

Appendix Referenced attachments or supplementary information not integral to the text, but deemed important to its understanding, should be placed in an appendix. When several appendices occur, their opening pages usually are on a new right-hand page. The appendices can be numbered or lettered consecutively (Appendix A, B, C, D).

Often, appendices are set differently from the text. If they are collections of subsidiary reference material, then it is logical to set them a size or two smaller than the text, both to conserve space and to signal their secondary function in the work. Such a condensation of type size is accompanied by a change in the column structure of the page, since there is a direct relationship of type size to line length: the longer the line, the larger the type size. If, however, the appendices are of importance commensurate to the text, they should be handled typographically the same way as the text.

Notes and references As discussed on page 137, notes and references may be run at the end of the book. The opening page is usually a recto and the type a size or two smaller than the text. But keep in mind that, unlike a short, freestanding footnote, notes go on for several pages. Although 7-point is very small indeed, it is an acceptable size for the few lines of an individual footnote. However, massed into page after page of notes, 7-point becomes discouragingly small; 8-point should be considered minimal. But don't forget to consider the face that you are using. Some 7-point faces can look as "large" as some 8-point faces, whereas some 8-point faces look as "small" as some 7-point faces. You have to base your decision on the way the samples in front of you look.

Credits As mentioned on page 136, acknowledgments for the sources of illustrations or lengthy permissions may be placed in the back matter. The opening page is usually a recto. The typography is handled the same way as the notes.

Bibliography Unlike references, which are cited directly in the text, a bibliography is a list of related books suggested for further study. Even if it's a simple list of titles and authors, it should include the publishing information needed to locate the works (see the *Chicago Manual of Style* for guidelines on styling the entries). Some works go further and contain an annotated bibliography, with brief reviews of the cited volumes. Since the bibliography is just another listing of reference materials, the type style should be similar to that of the notes.

Glossary It may be helpful to include a glossary, explaining technical terms to the lay reader. The opening page is usually a recto. There is a wide variety of typographic handling for this material. It can be condensed (both verbally and in terms of space) as in a dictionary. It can also be spread out, with each entry running the word in question on a separate line and a full paragraph of explanation and definition following. Or it can be something in between. The one crucial characteristic is the findability of the required word entry. Only if it can be found easily and quickly will the glossary fulfill its purpose.

Index Since the index is as important a doorway into the document as the table of contents, it should be given the space it needs to display the information attractively and legibly. Where there are several indexes (e.g., by name and by subject), the names come first. The opening page is usually a recto.

Normally, the type size used is smaller than the text, set in two or perhaps even three columns to the page. But this may not be the best way of handling this material. It should have the ease of scanning and reading that its importance deserves, so it can be used with pleasure instead of being the resented struggle it so often is.

Colophon The last verso page sometimes carries information on the production facts of the book: its designer, typesetter, typeface, paper manufacturer, printer, binder, and so on.

APPENDICES

This is a picture of bureaucracy and paperwork in the late nineteenth century. The privileged status of the bureaucrat's work hidden in the caves of his desk adds to the perception of his power. For him, enough is never enough: more is always wanted. Hence appendices.

The new compact discs have made my beloved collection of classical LPs obsolescent. I don't even have a player to play my old 78s. Is that cause for regret? In some cases probably so, because the subtleties of interpretation in the older versions have been lost to me. The new versions are clearer, more vibrant, and one can hear every nuance of the various noises the players make. The question is whether it is better music.

It is so easy to concentrate on the wonders of technology. Every new invention seems to displace everything that came before. Obsolescence is built into everything we work with. The question is whether it improves the product.

Let's be optimistic and look on the bright side. Certainly technology opens the door to the communication process to an ever-growing number of people. Communication is not becoming easier; its means are just becoming more accessible. It is up to the newcomers—as well as the old pros—to use it well. To that end, it is essential to know where to find out about some of the basics.

Here, in the appendices, you'll find what, I hope, will be the most useful of these general facts and figures. Clearly, it is a narrow selection. It is impossible to be encyclopedic in a field as wide as printed communication. Every specialized area has its own needs and requirements, as well as traditions and nomenclatures. However, what is included here is not idiosyncratic. It is based on the same criteria for choice as the rest of this book: the commonsense facts you need to know (or look up) to help you produce that document. You must decide whether the result is better communication.

In this image of the papermaker from Jost Amman's *Ständebuch* (Nuremberg, 1568), you can see that the paper was made by hand, sheet by sheet. The size was limited by the size and weight of the tray. The accompanying verses by Hans Sachs describe the sequence of actions, including soaking cut-up rags ("for which I need a lot of water"), placing the mass on sieves, pressing it, then hanging the sheets out to dry: "snow-white and smooth, that's how they like them."

Paper

How big is a piece of paper? It depends. And that's the problem.

Desktop systems

In the United States desktop publishing equipment is geared to the same sizes and proportions as photocopiers. The standard stock is 8½ x 11 inches. Folded in half this sheet yields the standard 5½ x 8½-inch size. A double sheet (11 x 17 inches) is available on most equipment. There is also the "legal" size: 8½ x 14 inches.

That does not mean that other sizes cannot be produced. It just means that variations from the standard will cost more. The greatest economy results from using the full sheet of paper, without cutting and thus wasting expensive material.

Traditional sizes

In the United States and wherever U.S. equipment is used, printing is done on sheets larger than the final page size. Most multipage pieces are run in multiples of 4 pages at a time. Each group of pages run on one sheet of paper, passed through the press in one pass and later folded and trimmed to final size, is called a *signature*. The smallest is a 4-page signature, the largest is 64. Most common are 8-page or 16-page signatures.

Obviously, different presses are made to run different-sized sheets. (Some do not use sheets at all, only rolls.) To complicate matters, different grades of paper come in different-sized sheets. The most common, though by no means the only, sizes available are:

• Bond paper (for letterheads, business forms, etc.): 17 x 22 inches

• Newsprint (for newspapers, tabloids, etc.): 24 x 36 inches

• Offset and coated papers (for magazines, books, etc.): 25 x 38 inches

• Text papers (for high-quality booklets, brochures): 25 x 38 inches

• Cover stock (similar to text but heavier): 20 x 26 inches

All these sizes leave an allowance for trimming.

The variety of available sizes is not haphazard. It has developed through use and need over the centuries. The entire printing industry's infrastructure is built on the relationship of press to sheet size, manifested finally as page size. Tradition, practice, and capital investment in plant and equipment demand adherence to the forms and sizes that now fit. It is unlikely that across-the-board change will come soon. When the time comes, however, the system for a substitute is ready. It is already widely applied in countries using metric. The elegance of its logic deserves to be described in sufficient detail to be understood.

Metric sizes

The International Standards Organization (ISO) developed standard sizes variously known as:

—A-sizes (from the A-series)

—ISO sizes (from International Standards Organization)

—ISPS sizes (from International Standard Paper Sizes)

—DIN sizes (from Deutsche Industrie-Normen)

—metric paper sizes (based on the meter)

All sizes are specified as trimmed (i.e., finished) sizes. They are based on the same proportion—1: $\sqrt{2}$ (or 1: 1.414).

The rectangle is constructed by dropping an arc from the end of the diagonal through a square. The resulting proportions are 1:1.414, or 1:$\sqrt{2}$.

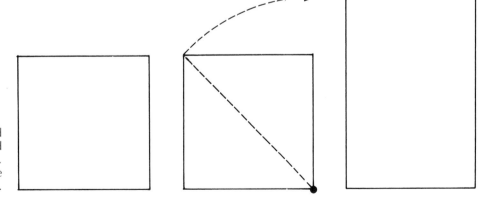

The A-series, designed for printing and stationery, is the most widely used of the metric systems. It is based on subdividing a square meter proportioned to the golden rectangle. The basic size measures 1189 mm x 841 mm. All the A-sizes derive from this standard: A1 is half of A0; A2 is half of A1; A3 is half of A2; A4 is half of A3, and so on.

A0	1189 × 841 mm
A1	841 × 594
A2	594 × 420
A3	420 × 297
A4	297 × 210
A5	210 × 148
A6	148 × 105
A7	105 × 74
A8	74 × 52
A9	52 × 37
A10	37 × 26

Subdivisions of A0 sheet

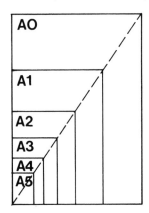

Proportions of all shapes are constant

The first dimension is always understood to mean the vertical. It is assumed that the page is used upright (in the "portrait" mode), and therefore the sizes (e.g., A4, A5) are vertical. Where the sheet is used sideways (in the "landscape" mode, or "oblong") it is labeled with an L suffix (e.g., A4L, A5L).

The B-series is based on a larger sheet (1414 mm x 1000 mm). Its subdivisions are intended for sizes midway between the subdivisions of the A-series. Some sizes are suitable for general publications, such as periodicals, but none fit into standard envelopes. Rather, envelopes are based on subdivisions of the C-series, which is intended solely for producing envelopes to fit the A-series.

Irregular subdivisions of an A0 sheet can be accomplished economically, to produce sizes that are not based on the 1:1.414 proportion. For example, a sheet one-third of the A4 may be used for brochures and lists; two-thirds of the A4 may be used for certain forms (when A4 is too large and A5 too small); and the A4 plus one-third may be used for A4 forms with a removable coupon.

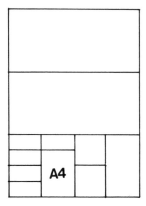

Irregular subdivisions of an A0 sheet: the long side is divided into three, the short side into four. The resulting units are, from the left: four one-third A4s, one one-third and one whole A4; two two-thirds A4s, one A4 plus one-third.

THis is to give Notice to all Perfons in Town and Country, that are Indebted to *Andrew Hay*, Poft-Mafter at *Pertb-Amboy*, for the Poftage of Letters, to Pay the fame, or they may expect Trouble ; fome having been due near four Years.

Andrew Hay.

Mail carriers were individual entrepreneurs, carrying the mail on credit. Collecting postage fees after delivery was often frustrating, as this notice from the *American Weekly Mercury* of October 23, 1735, pointedly suggests.

Envelopes

Envelopes with the opening on the long side are known as *commercial, bankers,* or *booklet* envelopes; those with the opening on the short side are known as *pocket* or *catalog* envelopes. Some common envelope styles and sizes are shown here.

Commercial

Name	Size in inches
6½	3⁹⁄₁₆ x 6¼
6¾	3⅝ x 6½
7	3¾ x 6¾
7¾	3⅞ x 7½ (Monarch)
8⅝	3⅝ x 8⅝ (Check)
9	3⅞ x 8⅞
10	4⅛ x 9½
11	4½ x 10⅜
12	4¾ x 11
14	5 x 11½

Booklet (open side)

Name	Size in inches
6½	6 x 9
7	6¼ x 9⅝
7½	7½ x 10½
9	8¾ x 11½
9½	9 x 12
10	9½ x 12⅝

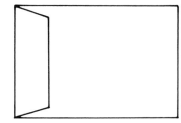

Catalog (open end)

Name	Size in inches
1	6 x 9
1¾	6½ x 9½
3	7 x 10
6	7½ x 10½
10½	9 x 12
12½	9½ x 12½
13½	10 x 13
14	10 x 15
14½	11½ x 14½
15½	12 x 15½

The following are common international styles and sizes.

C4: 229 x 324 mm for A4 sent flat

C5: 162 x 229 mm for A4 folded once or A5 sent flat

C6: 114 x 162 mm for A4 folded twice, A5 folded once, or A6 sent flat

DL: 110 x 220 mm for A4 folded into thirds or one-third of A4 sent flat

B6/C4: 125 x 324 mm for A4 folded once long or half of A4 sent flat

There are also special envelope sizes to fit standard envelopes as enclosures.

B4: 250 x 353 mm
to enclose C4

B5: 176 x 250 mm
to enclose C5

B6: 125 x 176 mm
to enclose C6

This woodcut of a bookbinder comes from Jost Amman's *Ständebuch* (Nuremberg, 1568). The accompanying verse by Hans Sachs starts out: "I bind all kinds of books, sacred and secular, large and small, in parchment or planed wooden boards, fit them with hasps and clasps, and embellish them with stamping; but I earn my best fee for guilding the edges."

Binding

As discussed earlier, the page design you use must take into account the binding that will be used for the finished product, as different methods require different "clearances." Keep in mind that choosing a binding affects the way the pages lie when the piece is opened, which has a lot to do with the usability of the publication, as well as the perception of its value. Cost factors, however, may dictate your choice, leaving you few options.

Essentially, there are two fundamentally different production methods for binding: one for pages printed on multipage sheets (in signatures) and another for pages printed as single sheets.

Multipage sheets

As noted on page 164, multipage printing is done most commonly in multiples of 4, resulting in 4-, 8-, 16-, 32-, or 64-page sheets, which are folded into signatures or booklets. The signatures are assembled to produce the book. Books are then bound in one of four ways, described below.

Sewing With this method the signatures are sewn together with thread. The advantage of Smyth sewing is its permanence, coupled with the fact that the pages lie flat in spite of the thickness of the overall volume. It is, however, a relatively expensive technique, so nowadays it is reserved mostly for traditional books (casebound books with hardcovers, end leaves, cloth covering, and headbands). Its expense can also be justified for other high-quality products of lasting value.

Saddle stitching Here signatures are progressively inserted into each other and then into a heavier cover folder. They are stitched with two or three staples in the middle fold, known as the *saddle*. The three outer sides are then trimmed. Normally no more than 64 pages (or 96 pages of lightweight stock) are bound in this fast and inexpensive way. Since the pages lie flat when the piece is opened, the gutter margin can be kept quite narrow and the type will remain visible.

Side-wire stitching With this method, folded signatures are stacked on top of each other and wire staples inserted through the binding edge. Strong, durable, and cheap, this binding method has a distinct disadvantage: pages cannot lie flat. Therefore a very deep swath of space at the gutter must be left empty. It is wise to leave at least 1 inch for a book up to a ½-inch thick, a little more for a thicker one.

Perfect (adhesive) binding

In this process folded signatures are stacked on top of each other, and single sheets or different paper stocks can even be interspersed between them. All four sides are trimmed, and the back is mechanically roughed. Glue is applied and the stack inserted into the cover, to which it adheres. Generally used for booklets whose bulk is greater than ¼-inch, the technique is inexpensive, but the product can be fragile: the pages can fall out if the production process is not closely controlled. Furthermore, its shelf-life is limited. The pages lie flat when the book is opened, so gutter margins can be narrow—but remember that at least ⅛- to ³⁄₁₆-inch of space at the spine edge will be used in the roughing process, so calculate that in when deciding on the gutter margin dimensions.

The square-back spine is an area for displaying the product's name and reference information. It also has an aura of value lacked by saddle stitching.

Single sheets

What we're talking about here is the normal, fast-reproduction, xerographic process using standard sizes of paper. Binding can be done several ways, described below.

Stapling

Whether done by hand or by machine, stapling is usually in the top left-hand corner, parallel to the left edge, top edge, or on the diagonal. This method is a satisfactory solution for low-image, low-budget, low-circulation products.

Side-wire stitching

The process here is the same as for multipage sheets. Single-sheet printing, however, is normally done on paper that bulks more than the harder papers used for multipage printing. It may weigh more or less the same, but it is less concentrated and therefore feels softer. When heavy stacks of such paper are side-wired, the staple can cause an unsightly dimple, making the product look inelegant.

Perfect (adhesive) binding Again, the process is the same as for multipage sheets. The advantage of this technique is its capacity to accommodate products assembled from a variety of papers.

Wire spiral With this method, individual leaves are stacked, all four sides trimmed, holes drilled, and a flexible wire spiral woven into them. Its ends are tucked in, forming a permanent binding—although the pages are easy to tear out and, as there are so many holes, it's tempting. The gutter margin can be quite narrow, since the pages lie perfectly flat, and the holes for the wire can be small and near the edge. The precise measurement depends on the equipment used: check with the supplier. But bear in mind: trimming all four sides, drilling the holes, and inserting the wire are costly operations.

Plastic comb The same process used for the wire spiral is used here. However, the slots for the plastic comb must be punched out because they are rectangular. The plastic combs are fragile and tend to become brittle after some time on the shelf. They are also intrusive in the product, forming a strong, colorful barrier between the two facing pages.

Ring binder Here loose leaves with holes punched in standard configurations fit into metal rings attached to a metal backbone. The more rings, the more securely the sheets fit the binding. Unfortunately, sometimes the rings do not fit very well and the paper is damaged when it catches at the joint. Rings come in ½-inch-diameter increments. The larger the rings, the greater the capacity of the binder (and the heavier and more unwieldy it is, and the larger the gap between the two facing pages). Turning the sheets is difficult. Due to the physical structure of the object, it is very hard to flip pages quickly while looking for specific items. Therefore the typographic makeup must compensate, and headings and labels need to be emphasized. Tab inserts help to organize the material into its components. The major advantage is the ease

with which revisions can be made. It is simple to replace, add, and remove pages (if you can persuade the owner to do it). A minimum of a ½-inch space is required for the inside edge of the sheet to leave enough room for the punched holes, but ⅝ to ¾ inches is perhaps safer.

Binder posts The loose leaves here are contained in binders fitted with two or more metal posts. Their capacity can be expanded by simply using longer posts, providing a lot of flexibility. But there is a big disadvantage: the binder is hard to keep open, and so a lot of space along the binding edge must be sacrificed to excessively deep margins.

Checklist of criteria

To sum up, in choosing a binding consider the following criteria:

· general character of the piece and its appropriate image

· kind of user

· how, when, and where the product will be handled

· probable number of pages

· required durability of the material

· flexibility to add pages

· cost of drilling or punching holes

· amount of space at the inner margin each method demands

· type of paper

· direction of grain in the paper (if it is parallel with the binding edge, then the book will be easier to open)

Most important: make your decisions early to avoid production errors and costly "retrofitting."

Proportions and mathematical relationships were matters of deep concern to the humanist philosophers and designers of the early Renaissance. Euclid's ideas on squares and circles were elaborated by Vitruvius. This woodcut shows one of Vitruvius's figures from Verini's *Luminario,* a writing manual of 1526, and formed the basis for the design of his letterforms.

Measuring equivalents

Measuring has always bedeviled the printing and publishing professions. Pierre Simon Fournier le Jeune, a French printer, made the first attempt to standardize type measurements in 1737. François Ambroise Didot perfected the European system still used today. That was in the 1780s. In the United States, however, every producer continued to use his own measurements. Type sizes were named rather than sized, so accuracy or equivalency was not expected.* A standard U.S. system did not come into general use until 1892, when it was adopted by the newly formed American Type Founders combine. At last type sizes were measured in points. And so matters remained until today, when instead of getting better, the situation seems to be getting steadily worse.

*This list shows the type name in use from the 1600s to 1890 along with the equivalent body size in U.S. points.

Minikin or Excelsior	3	Small Pica	11
Brilliant	4	Pica	12
Diamond	4½	English	14
Pearl	5	Great Primer	18
Agate	5½	Paragon	20
(still used to measure space in newspaper advertising columns at 14 lines per inch)		Double Pica	24
		Five-line Nonpareil	30
Nonpareil	6	Double Great Primer	36
Minion	7	Canon	48
Brevier	8	Five-line Pica	60
Bourgeois	9	Six-line Pica	72
Long Primer	10		

Although typography today continues to be measured in the traditional "points," unfortunately there are two kinds of points.

1. In the U.S./British system there are 12 points to the pica.

2. In the Didot system, used in most countries where metric is the norm, the "points" are slightly larger. There are 12 Didot points (sometimes known as *corps*) to the *cicero* in Germany, *douze* in France, *riga* in Italy, and *augustijn* in Holland.

Yet many countries that use metric measurement nevertheless use the U.S./British points rather than the Didot ones because their equipment is imported from the U.S. and is therefore calibrated to U .S. standards.

And there are other measuring systems. Metric sizes measuring the height of the capital letters are slowly coming into use, since many manufacturers of type fonts are building this form of measuring into their equipment. Electronic rasters, pixels, dots-per-inch, and all the other new ways of defining sizes developed for new technology further complicate the situation. Add to this the use of metric versus inch/foot measures for paper and other nontypographic elements, and the confusion only grows.

Since printed matter is measured in minute amounts, one would think that a precise system would be essential. So it is. None exists yet, though technically there is little to prevent its development. The problem is stubborn human habit. People are used to certain ways of measuring. Certain descriptions (like "6 picas") mean something to them because they are used to them and they know what they imply. They can imagine them. They don't want to give them up. So approximations and conversion tables are an inescapable, if regrettable, fact of life.

Converting fractions to decimals of an inch

fraction	decimal	fraction	decimal
1/32	0.03125	13/32	0.40625
1/16	0.625·	7/16	0.4375
3/32	0.09375	15/32	0.46875
1/8	0.125	1/2	0.500
5/32	0.15625	9/16	0.5625
3/16	0.1875	5/8	0.625
7/32	0.21875	11/16	0.6875
1/4	0.250	3/4	0.750
9/32	0.28125	13/16	0.8125
5/16	0.3125	7/8	0.875
11/32	0.34375	15/16	0.9375
3/8	0.375		

Converting inches to millimeters

The formula to use is: inches x 25.4 = millimeters
(or inches x 2.54 = centimeters).

inches	decimal inch	mm	inches	mm
1/32	0.03125	0.79	2	50.8
1/16	0.0625	1.59	3	76.2
1/8	0.1250	3.18	4	101.6
3/16	0.1875	4.76	5	127.0
1/4	0.250	6.35	6	152.4
3/8	0.375	9.53	7	177.8
1/2	0.500	12.70	8	203.2
5/8	0.625	15.88	9	228.6
3/4	0.750	19.05	10	254.0
7/8	0.875	22.23	11	279.4
1	1.000	25.40	12	304.8

Converting feet to meters

The formula to use is: feet x 0.3048 = meters.
Note that 1 yard (3 feet) = 0.914 meters.

feet	meters	feet	meters
1	0.3048	6	1.8288
2	0.6096	7	2.1336
3	0.9144	8	2.4384
4	1.2192	9	2.7432
5	1.5240	10	3.0480

Converting millimeters to inches

The formula to use is: millimeters x 0.03939 = inches
(or centimeters x 0.3939 = inches).

mm	inches	approx.	mm	inches	approx.
1	0.03939		11	0.43329	
2	0.07878		12	0.47268	
3	0.11817		13	0.51207	1/2"
4	0.15756		14	0.55146	
5	0.19695		20	0.78780	
6	0.23634	1/4"	25	0.98475	1"
7	0.27573		30	1.1817	
8	0.31512		40	1.5756	
9	0.35451		50	1.9695	2"
10	0.39390				

Converting meters to feet

The formula to use is: meters x 3.28084 = feet.
Note that 1 meter is about 39 inches, or 1.09 yards.

m	feet	feet/inches	m	feet	feet/inches
1	3.281	3'3⅜"	6	19.685	19' 8¼"
2	6.562	6' 6¾"	7	22.966	22' 11⅝"
3	9.843	9' 10⅛"	8	26.247	26' 3"
4	13.123	13' 1½"	9	29.528	29' 6⅜"
5	16.404	16' 4⅞"	10	32.808	32' 9 ¾"

Converting U.S. points to inches

The formula to use is: U.S. points x 0.01383 = inches.

U.S. points	inches	U.S. points	inches
1	0.01383	12 (1 pica)	0.16596
2	0.02766	18	0.24894
3	0.04149	24 (2 picas)	0.33192
4	0.05532	30	0.41490
5	0.06915	36 (3 picas)	0.49788
6	0.08298	42	0.58086
7	0.09681	48 (4 picas)	0.66384
8	0.11064	54	0.74682
9	0.12447	60 (5 picas)	0.82980
10	0.13830	66	0.91278
11	0.15213	72 (6 picas)	0.99576

Converting inches to U.S. points

For an approximation, assume 1 point = ¹⁄₇₂ inch.
In other words, inches x 72 = U.S. points.

inch	approx. U.S. points	inch	approx. U.S. points
¹⁄₇₂	1	⅝	45
⅛	9	¾	54
¼	18	⅞	63
⅜	27	1	72
½	36		

Converting U.S. points to millimeters

The formula to use is: U.S. points x 0.351 = millimeters.

U.S. points	mm	approx.	U.S. points	mm	approx.
1	0.351		10	3.51	
1½	0.53	0.5	11	3.86	
2	0.70		12	4.21	4
3	1.05	1	18	6.32	6
4	1.40		24	8.42	8
5	1.76		30	10.53	11
6	2.11	2	36	12.64	13
7	2.46		48	16.85	17
8	2.81		60	21.06	21
9	3.16	3	72	25.27	25

Converting millimeters to Didot points

The formula to use for an approximation is:
millimeters x 2.66 = Didot points.

mm	approx. Didot points	mm	approx. Didot points
1	2.66	10	26.60
2	5.32	20	53.20
3	7.98	50	133.00
4	10.64	100	266.00
5	13.30		

Converting Didot points to millimeters

The formula to use is: Didot points x 0.3759 = millimeters.

Didot points	mm	approx.	Didot points	mm	approx.
1	0.3759	0.4	11	4.1349	4
2	0.7518	0.8	12	4.5108	5
3	1.1277	1	18	6.7662	7
4	1.5036	1.5	24	9.0216	9
5	1.8795	2	30	11.2770	11
6	2.2554	2	36	13.5324	14
7	2.6313	3	48	18.0432	18
8	3.0072	3	60	22.5540	23
9	3.3831	3	72	27.0648	27
10	3.7590	4			

Converting Didot points to inches

The formula to use is: Didot points x 0.0148 = inches.

Didot points	inches	Didot points	inches
1	0.0148	12 (1 cicero)	0.1776
2	0.0296	18	0.2664
3	0.0444	24 (2 ciceros)	0.3552
4	0.0592	30	0.4440
5	0.0740	36 (3 ciceros)	0.5328
6	0.0888	42	0.6216
7	0.1036	48 (4 ciceros)	0.7104
8	0.1184	54	0.7992
9	0.1332	60 (5 ciceros)	0.8880
10	0.1480	66	0.9768
11	0.1628	72 (6 ciceros)	1.0656

Converting Didot points to U.S. points

The formula to use is: Didot points x 1.07 = U.S. points.

Didot points	U.S. points	Didot points	U.S. points
1	1.07	11	11.77
2	2.14	12 (1 cicero)	12.84 (≈ 1
3	3.21		pica 1 pt)
4	4.28	18	19.26
5	5.35	24	25.68
6	6.42	30	32.10
7	7.49	60	64.20
8	8.56	120	128.40
9	9.63	180 (15 ciceros)	192.60 (16.5
10	10.70		picas)

Converting U.S. points to Didot points

The formula to use is: U.S. points x 0.934 = Didot points.

U.S. points	Didot points	U.S. points	Didot points
1	0.934	12 (1 pica)	11.208
2	1.868	18	16.812
3	2.802	24 (2 picas)	22.416
4	3.736	30	28.020
5	4.670	36 (3 picas)	33.624
6	5.604	42	39.228
7	6.538	48 (4 picas)	44.832
8	7.472	54	50.436
9	8.406	60 (5 picas)	56.040
10	9.340	66	61.644
11	10.274	72 (6 picas)	67.248

Converting inches to spots-per-inch (spi)

The following ratios are commonly used in electronic publishing.

inches	60 spi	300 spi	inches	60 spi	300 spi
0.1	6	30	2.0	120	600
0.2	12	60	2.5	150	750
0.25	15	75	3.0	180	900
0.3	18	90	4.0	240	1200
0.4	24	120	5.0	300	1500
0.5	30	150	6.0	360	1800
0.6	36	180	7.0	420	2100
0.7	42	210	8.0	480	2400
0.75	45	225	8.5	510	2550
0.8	48	240	9.0	540	2700
0.9	54	270	10.0	600	3000
1.0	60	300	11.0	660	3300
1.5	90	450	12.0	720	3600

Converting millimeters to spots-per-inch (spi)

The following ratios are commonly used in electronic publishing.

mm	60 spi	300 spi	mm	60 spi	300 spi
2	5	24	100	236	1181
4	9	47	110	260	1299
6	14	71	120	283	1417
8	19	94	130	307	1535
10	24	118	140	331	1654
20	47	236	150	354	1772
30	71	354	160	378	1890
40	94	472	170	402	2008
50	118	591	180	425	2126
60	142	709	190	449	2244
70	165	827	200	472	2362
80	189	945	250	591	2953
90	213	1063	300	709	3543

Learning technical nomenclature has always been a problem. Knowing the words is necessary if the concepts they stand for are to be used. Here the trainer is instructing his pupils, and wrong answers undoubtedly brought the pointer's secondary purpose into use. The image comes from the book *Spiegel des Menschlichen Lebens (Mirror of Human Life)*, which was printed in Augsburg, Germany, about 1475.

Glossary

The new electronic technology has brought with it an interesting human phenomenon: the blending of two separate skills and backgrounds. People who have been in publishing now have to learn new methods of working—and the new language that accompanies them. Technologically oriented people, who know all about computers, now have to learn about publishing—and the traditional language that accompanies it. The glossary that follows covers the basic terms in both areas.

Absolute placement specification of the exact position on the page where a line of text is to start or the corner of a graphic element is to be anchored (*see also* Coordinates; Origin)

Access to find an area of memory or auxiliary storage for retrieving or storing information

Address identification of the location in memory or auxiliary storage for accessing stored information

Algorithm the rules by which a problem is solved by the computer, represented by a sequence of instructions

Alphanumeric mixture of letters and numbers

Analog varying continuously along a scale (as opposed to fixed increments or steps)

Anamorphic scan scanning an original piece of artwork so that the width and height are not enlarged or diminished in proportion, but are altered to produce an image that is taller and skinnier or shorter and fatter than the original

Application job to be performed

Art any visual element used on the page, whether a photograph, drawing, illustration, chart, or hand lettering

Ascender the part of the lowercase letters "b, d, f, h, k, l, t" that protrudes above the body (called the *x-height*). Its opposite is the *descender* (see below).

Auxiliary storage storage of data in a device outside the computer's own internal storage

Back matter	pages following the main text of a publication, devoted to reference matter such as appendices, glossary, and index
Backup	copy of work or information saved in case of later loss or damage to the original
Baseline	imaginary horizontal line on which the bottom of the main part of the letters is arrayed. The descenders of the letters "g, j, p, q, y" drop beneath it.
Batch processing	processing where similar tasks are delayed and grouped for combined handling
Baud	measurement of rate of speed of flow of information between devices measured in units of bits per second
Binary code	code using only two characters: 1 and 0 (on and off)
Bit	(BInary digiT) smallest unit of electronic data: 1 or 0 (on and off, yes or no)
Bit-mapped type	dots representing the shapes of characters that are stored in the digital typesetter's memory and are called up as needed by a beam of light
Bleed	when an element, usually an illustration or screened area, prints to the edge of the paper
Block	group of words or elements handled as a unit
Bodyline capacity	number of lines on a page
Boilerplate	standard stored text, elements of which can be rearranged and combined with fresh information to produce new documents
Boldface	a darker version of the regular type formed from heavier strokes
Boot	act of starting up a processor by loading operating software
Buffer	device separating other devices in a system; also an intermediate area for temporary storage of data
Bug	error in a program; "debugging" removes it
Byte	set of eight consecutive bits
CAD/CAM	(Computer-Assisted Design/Computer-Assisted Manufacturing) system used to produce graphic output
Callout	wording placed outside the figure but attached by an arrow to the part of the illustration to which it refers
Caps	short for capitals (uppercase letters)
Caption	explanatory wording appearing in conjunction with an illustration; also called a *cutline,* or sometimes a *legend*
Character cell	rectangular area containing a single character and the space needed to separate it from its neighbors horizontally and vertically
Character count	number of letters (including numerals, word spaces, and punctuation marks) in a given piece of text
Character set	collection of all characters available in a font: alphabetic, numeric, symbolic, punctuation, and special
COBOL	(Common Business Oriented Language) programming language for business or commercial use
Code	set of symbols used to represent data or instructions
Color display	multicolored screen
Command	coded instructions in the form of a string of characters
Compatibility	a characteristic of equipment permitting one machine to use the same information or programs as another without conversion or modification

Computer graphics	pictorial representations such as diagrams, drawings, or charts generated on a computer
Condensed type	narrow, compact version of the normal typeface
Coordinates	precise locations in an area described by the crossing of the horizontal *x* and vertical *y* scales (*see also* Absolute placement; Origin)
Copy	wording of a manuscript. Also, in printing, all the material to be printed.
cps	(characters per second) unit of measure defining the number of characters an output device can produce in one second
CRT	(Cathode Ray Tube) screen on a terminal—a glass tube with a vacuum inside, in which beams of electrons are focused onto a phosphor-coated surface to create visible images
Cursor	blinking rectangle or other graphic signal marking the current working position on screen, movable by keys, mouse, light pen, or other means
Daisywheel	removable disk with typewriter characters on spokes radiating from the center and used in impact printers for letter-quality hard copy
Data base	integrated file of information organized for access and retrieval
Deck	wording following a headline but preceding the text
Default	values the system normally uses unless the operator overrides them
Density	amount of data stored within an area of memory. Also: measure of spots-per-inch (spi) used for scanning art (*see also* Resolution).
Descender	the part of the lowercase letters "g, j, p, q, y" that extends below the body of the type (*see also* Ascender)
Diagnostics	software designed to verify operation and identify reasons for failure
Digital image	any image (whether type or pictorial) that has been digitized on a digitizer (i.e., encoded into electronic bits)
Disk, diskette	plate with magnetized surface on which data are stored. Floppy (flexible) disks are one- or two-sided and 5¼ inches in diameter; hard (rigid) disks are 8 inches in diameter.
Disk drive	mechanism used to rotate a magnetic disk at high speed past a read/write head (*see also* Tape drive)
Display highlight	ability to intensify, blink, or otherwise select certain portions of the image on the display screen to call attention to it (*see also* Inverse video)
Display type	general term for type larger than 14-point, used in headlines, decks, and other nontext situations and intended to catch attention
Dot	unit of measurement representing 0.08 mm or $\frac{1}{300}$ inch; also known as a *pixel* or *spot*
Download	transferring information, usually from the computer's memory into auxiliary storage
Downstyle	headlines or titles set in lowercase, capitalizing only the first initial, proper names, and acronyms
Dropout type	type appearing white on a dark background
Duplex	in electronic publishing, the ability of a printer to print on both sides of a sheet of paper simultaneously (*see also* Simplex)
Em	the square of the type size: in a 10-point type size, the em measures 10 points high and 10 points wide
Em-dash	long dash, used primarily to indicate a break in thought
En	half of the em: in a 10-point type size, the en measures 10 points high and 5 points wide

En-dash	short dash, slightly longer than a hyphen, used instead of the words *to* or *through* (e.g., letters "A–Z")
Extended type	wider version of a normal typeface, sometimes called *expanded*
Face (of type)	a named design or style of type, such as this, which is Optima
File	set of related pieces information stored and retrieved under a single name
Fixed pitch	typeface in which all character cells are of equal width
Floating accent	an accent character that does not require spacing but combines with a normal character to print as a composite
Flush-left (or flush-right)	even or aligned on the left (or right) edge; the opposite side remaining deliberately uneven
Folio	page number
Font	complete collection of one size of a given type style, including lowercase and capital letters, small capitals (if available), accented characters, numerals, fractions, symbols, and punctuation
Format	general shape and appearance of a page, including its margins, type columns. Also: the combination of instructions for reproducing it, stored in a computer's memory for future use.
Front matter	pages preceding the main text of a publication, devoted to title, table of contents, and preface or foreword
FSL	(Forms Source Language) programming language used to design forms
Galley	proofs of type before it is arranged on the page
Gateways	services providing compatibility between incompatible systems
Global search	capability of a system to search for repeated occurrences of a unit of information such as a word. Global search-and-replace modifies them.
Gutter	inner space between two facing pages. Also, sometimes, the space between columns of type.
Halftone	printable version of a continuous-tone original such as a photograph. Grays are converted to dots of varying sizes to simulate dark or light tones.
Hanging punctuation	typographic refinement, in which punctuation is set in the margin alongside the text, to create a precise and clean edge
Hard copy	output printed on paper
Hardware	the physical components of a system: electrical, mechanical, or electronic (*compare* Software)
Head	title or headline summarizing content, gaining attention by its prominent size and boldness of type
Host	the mainframe computer accessed by users, and the source of high-speed data processing
Icon	graphic symbol on the screen representing selectable functions, files, or operations
Impact printer	printer producing fully formed characters by the impact of a striker through a ribbon (like regular typewriters) or by means of a dot matrix
Initializing	preparing a disk for use in a computer (also known as *formatting*)
Ink-jet printer	nonimpact printer shooting a stream of tiny droplets of electrostatically charged ink at the page, forming characters
Input device	any device such as a keyboard used to give a computer alphanumeric or graphic information. An output device does the reverse.

Integration	combining different functions into a single system (e.g., word processing, data processing, and telecommunications)
Interface	boundary where two or more devices interact, or a program enabling separate elements to work together
Inverse video	mode of displaying characters on a screen opposite to normal presentation to make them stand out (e.g., white letters on black instead of black letters on white). Also called *reverse video*.
ISO	abbreviation for International Standards Organization, which develops and publishes standards for technical, data processing, and communications applications
Italics	type resembling handwriting with the letters slanted to the right, in contrast to roman, which is vertical
Justified type	type spaced out between words to create columns with both edges flush, or evenly aligned
k	symbol for prefix *kilo* (1000); also *kilobyte* (1024 bytes)
Kerning	tightening space between letters
Keyboarding	entering information into the computer's memory by means of a keyboard
LAN	(Local Area Network) a communications network linking computers and other equipment into a unified system in a small area such as an office building
Landscape	page orientation where the two longer edges of the paper are at the top and bottom
Laser	(Light Amplification by Simulated Emission of Radiation) a device used for communications, facsimile, storage, and electronic printing, utilizing an extremely narrow beam of light
Laser printing	technology using a laser beam to transfer data to paper
Leading	additional space inserted between lines of type; also known as *line spacing*
LED	(Light-Emitting Diode) display lighting employed in many products
Letterspacing	spacing between individual letters
Ligature	two or more characters joined into a single unit
Light pen	stylus that detects light generation on a CRT and is used to create or move elements
Line art	artwork consisting of plain black or white areas, with no middle tones, and therefore reproducible in print without halftone screening
Line printer	output peripheral that prints a complete line at one time for speed
Logon, logoff	signing onto a terminal before starting to use its function and signing off when finished, usually by means of a private, assigned password
Lowercase	small letters of the alphabet, as distinct from uppercase or capitals
m, mb	symbol for *mega* (one million); *megabyte* (1,048,576 bytes)
Machine language	data expressed in a code read by the machine directly; hence machine-readable
Magnetic media	any magnetically coated materials used for storage of text, data, or program: floppy or rigid disks, cassettes, computer tape or drums
Mainframe	a large-scale computer's central processing unit (CPU)
Matrix printer	printer that produces images formed of dots that conform to a matrix unit. Most low-resolution output devices use a unit that has 5 x 7 dots.

Measure	length of type lines; same as the width of the column
Menu	display of options in the program visible on screen
Microcomputer	personal computer containing processor, input and display devices, and memory
Microfiche	sheet of film carrying miniaturized images for storage. Usually 105 mm x 148 mm (4.1 x 5.8 inches) accommodating 98 8.5 x 11-inch pages at 24x reduction in 7 rows x 14 columns.
Microprocessor	integrated circuit or single chip containing the CPU (central processing unit) of a personal computer or computer-based device
Modem	(MODulator/DEModulator) device coverting data from a computer into signals transmitted over telephone lines and back again
Mouse	palm-sized device attached by wire to the computer. Rolled over a surface, its motion and position control the placement of the cursor on the screen.
Negative leading	type set with less space from baseline to baseline than the size of the type itself (e.g., 18-point type with 16-point leading). Though ascenders can bump into descenders, this technique is useful for special effects. Also known as *minus leading*.
Nonimpact printer	printer that forms images without striking the page, such as ink-jet, thermal, or electrostatic printers
Oblique	slanted type apparently italic, but actually merely the roman pushed over at an angle
OCR	(Optical Character Recognition) electronic means of scanning (reading) printed or written copy and converting the images into digital equivalents
Online, offline	when parts of a computer system are, or are not, connected to communicate with each other
Orientation	printing on a page in the portrait (vertical) or the landscape (horizontal) mode
Origin	the zero point of an *x-y* coordinate system by which the placement of a corner of an element on the page can be defined (*see also* Absolute placement; Coordinates)
Page printer	high-speed electronic device capable of printing out a full page at a time
Page scrolling	displaying whole pages of a multipage document in forward or backward sequence
Password	required code permitting an individual user's entry into protected parts of a program
Peripherals	equipment added to a computer system to enhance its capabilities
PERT	(Project Evaluation and Review Technique) method controlling complex projects to ensure that the steps are completed in time and in correct sequence; sometimes called *CPM* (*Critical Path Method*)
Pica	traditional unit of printer's measurement: 6 picas roughly equal 1 inch. The pica is subdivided into 12 points (*see also* Pitch).
Pin register	pins on the scanner's frame fitting holes in mounting boards of artwork, ensuring correct positioning
Pitch	the width of characters, or the number of characters fitting into the horizontal inch. To say "10-pitch" means that there are 10 characters to the inch (called *pica* type). There is also 12-pitch (called *elite*). Do not confuse this 10-to-the-inch pica with the printer's pica (see above).

Pixel (PICture ELement) smallest addressable unit of a bit-mapped screen; also known as a *dot* or a *spot*

Point basic measurement of type: there are 12 points to the pica and about 72 points to the inch

Port connecting point between a device and the means of data transmission to the rest of the system. Cables are connected to ports.

Portrait page orientation in which the two shorter edges of the paper are at the top and bottom, as in this book

Preview preliminary view of a document on a display terminal before printing; also known as *soft proof*

Printout printed "hard-copy" record of a computer's work

Program instructions commanding the device to perform the required operations in the proper sequence

Prompt hint shown on screen reminding the user of a choice to be made

Proportional scan enlargement or reduction of an original whose height and width remain in proportion to each other (*compare* Anamorphic scan)

Protocol rules governing the exchange of data between devices

Publishing system in electronic publishing, a comprehensive and integrated system for the production and management of documentation

Qwerty keyboard standard typewriter keyboard. The Dvorak keyboard, which arranges letters more efficiently but requires retraining of the operator, has found limited acceptance.

Ragged type lines of type with one (or both) margins uneven, as opposed to justified type

RAM (Random Access Memory) temporary memory on disk or chip, alterable by the user while working

Random access storage form of storage allowing data to be stored and retrieved directly after being located by an address

Recto right-hand page

Registration alignment of the corner of the glass on a scanner with the edges of the rectangle of the original. In printing, the precise superimposition of one printed impression on top of another to create accurate results.

Relative placement positioning of a line of text at a point related to its current position or that of others on the page (*compare* Absolute placement)

Resolution fidelity of reproduction, depending on number of spots-per-inch. High resolution (with more spots) is finer and more precise than low resolution, which yields coarser and rougher-edged results.

Response time time a system requires to react to a command

Reverse video *see* Inverse video

ROM (Read Only Memory) permanent memory in a computer, which cannot be rewritten or altered by a program. It is the program that governs the operation of the computer itself.

Roman type type with vertical emphasis in contrast to italic or oblique

Routine set of instructions to the computer to perform a certain function; often a subset of a large program

Runaround type set following the contour around an intruding element such as an illustration

Run in to close a gap between type elements so one follows the other directly

Sans serif	type lacking serifs, sometimes known as *gothic*
Scaling	calculating the proportions of artwork in readiness for enlargement or reduction to fit into an area on the page
Scanned art	in electronic publishing, artwork that has been digitized by means of a graphics scanner
Scrolling	to cause an element displayed on the screen to move up or down vertically, or side to side horizontally, to show more than can fit in the space on the screen or a window on the screen
Serial printer	device that prints out characters individually, left to right, right to left, or both bidirectionally
Serif	cross-stroke at the end of the strokes of letters
Simplex	in electronic publishing, printing on only one side of the paper, as opposed to duplex
Small caps	capital letters corresponding to the x-height of a font, in addition to capitals of the normal height
Soft proof	*see* Preview
Software	programs and routines that govern the computer's operation
Sort	in electronic publishing, arranging data in sequence following specified patterns (e.g., a program that alphabetizes). In traditional publishing, a character that is not part of the regular font.
Spine	the folded and bound edge of a publication, also known as the *backbone*
Spot	unit of measurement representing 0.08 mm or $\frac{1}{300}$ inch; also known as a *pixel* or a *dot*
Spread	two contiguous pages, also known as a *double-truck*
Standalone	single-station computer or word processor that does not share resources or communicate with others
Tab	skip in spacing to predetermined positions on the page: horizontal tab is sideways, vertical tab is up or down
Tape drive	mechanism used to pass tape through a read/write head at high speed (*compare* Disk drive)
Terminal	device that has a keyboard and screen, connected to a computer or a network (*see also* VDT)
Text type	type between 6 and 12 points in size, used for text composition; also known as *body type*
Thermal printer	nonimpact printer using heat-sensitive paper
Timesharing	sharing of a large computer facility by many users, each at his or her remote terminal
Toner	minute particles of electrically charged resin and carbon black, used to make images by the electrostatic (xerographic) process
Turnaround time	time elapsed between submission of a job and delivery of the finished result
Turnkey system	system containing all the hardware and software needed to perform a particular application and ready to use
Turnover	continuation of a line in a list or table, which may be indented
Typeface	*see* Face (type)
Underscore	a line set beneath the type as underlining

Uppercase capital letters in contrast to lowercase

Utilities routines used to perform housekeeping tasks such as file maintenance, disk initializing, copying for backups, recovery of information from damaged disks

Variable text keyboarded or prerecorded text (such as addresses) added to standard recorded text to complete a document

Verso left-hand page (the reverse side)

VDT (Video Display Terminal) input-output device consisting of a keyboard attached to a CRT screen

Weight relative thickness of the strokes of a letter. Bold type has heavy weight, pale type has light weight.

Window section of a display screen provided by the program, allowing the user to deal with two or more separate applications simultaneously

Word processing entry, editing, storage, and accessing of words using a keyboard or terminal and magnetic storage

Word spacing spacing between words

WYSIWYG (What You See Is What You Get) when the image on the screen resembles hard copy

Xerography electrostatic printing process using dry resin powder and heat to fuse images onto paper

x-height height of the lowercase "x," thus the height of the main part or body of the type. Its bottom is known as the baseline, and its top as the mean line. Ascenders tower above it; descenders extend below it.

The Printers

Leaue fetting thy page fpent is thine age.

Let printing ftay: and come away

A *memento mori,* or reminder to the living that death awaits them, was a popular printed item in the sixteenth century. This twosome from *A Book of Christian Prayer* by Richard Day (London, 1590) is directed at publishing. Death even has something to say: "Leave setting thy page, spent is thine age" and "Let printing stay and come away." Perhaps the best reason of all for the increased speed that technology permits.

Communication timeline

Please don't expect this chronology to be an encyclopedic or even scholarly piece of research.* It is nothing of the sort. It is just a list of trivia I have collected over the years on backs of envelopes and thrown into a drawer. I find the development of communication such a fascinating process that whenever I come across something to do with it, I jot it down. My hope is that you'll skip around my timeline, find fun stuff in it, discover synapses that hadn't occurred to you before, and realize that our profession as communicators is indeed an old and distinguished one. It didn't all just happen; everything evolved a step at a time. The current technological explosion is nothing more than a stage, albeit an exciting and fascinating one, in an ever-developing series of changes. Where will it ever end? Let's hope it never does.

*Regarding the dates: many are hard to pin down precisely. Some authorities cite one year, others another. Does it matter? Not really, if we manage to come close to it. Besides, I think it is the relationships that are significant, not the academically pedantic scrupulousness. Nonetheless, if you do find inaccuracies, please drop me a line care of the publisher, and we'll fix the mistakes for the next edition. Thanks.

B.C.

800,000	Man learns to control and use fire
80,000	Aboriginal petroglyphs in Australia
32,000	Earliest known decorations in caves
20,000	Cave paintings in Altamira, Spain
20,000	Invention of needle makes clothing possible
20,000–6,500	Keeping records by notches on bones: first "writing"
8,000	Painted pebbles at Mas d'Azil, France
3,500	Sumerian pictographic writing
3,100	Earliest known Egyptian hieroglyphs, combining pictures and symbols
2,800	Stonehenge built in England, pyramids in Egypt
2,800–2,600	Sumerian cuneiform wedge-shaped writing, left-to-right
2,700	Chinese artists paint on shell, bone, bronze, wood, silk, bamboo
2,500	Sequential sentences in cuneiform text on the Stone of Vultures
2,500	Egyptians invent papyrus (from reeds) and hieratic (cursive) script to write on it
2,300	Pictorial symbols on seals used in Indus Valley to mark property
1,750	Hammurabi's code of laws transcribed on stele; less important information recorded on clay tablets in Babylon
1,600	First real alphabet developed in Mideast; brought to Greece by Phoenician traders around 1,100 B.C.
1,500	Minoan civilization in Crete develops two scripts: Linear A and B (see A.D. 1952)
1,500	First book: Egyptian *Book of the Dead,* a long papyrus scroll

The Egyptian scribe at work: in his left hand, a strip of papyrus; in his right hand, a reed pen; behind his ears, a spare pen; in front, a case for the papyrus scrolls; beneath, the hard floor.

1,500	Chinese develop ideographs (characters representing ideas)
1,400	Ten Commandments incised on "stone tablets"
1,000	Calendar for farmers, earliest Hebrew text yet found
850	Punctuation appears as vertical lines between phrases in Semitic script on Moabite stone
800	Greeks develop modern alphabet with vowels
800	Etruscans learn alphabet from Greek colonists and teach their conquerors, the Romans
753	Rome founded
750	Homer's *Iliad* and *Odyssey*
750	Earliest Greek inscription on Athenian vase: "to him who dances most delicately"
700	Demotic script in use in Egypt for official and secular writing
700	Persians simplify cuneiform to near-alphabet form
650	Earliest inscription in Latin alphabet on gold pin: "Marius made me for Numerius"
586	Temple at Jerusalem destroyed by Nebuchadnezzar II
585	Torah, first five books of the Bible, written by exiles in Babylon as history of the people of Israel
540	Pisistratus establishes library in Athens

Carrier-pigeons, which could fly 700 miles a day, were the most efficient (if not totally reliable) means of long-distance communication in ancient times. This woodcut, depicting a town in Syria, comes from Richel's 1481 book on Mandeville's travels in the Orient.

479 K'ung Fu-tse (Confucius) dies

450 Carrier-pigeons used for fast communication between Greek city-states

399 Socrates dies

350 Greek city-states adopt 24-letter alphabet

350 Demosthenes, world's greatest orator, practices with pebbles in mouth, recites poetry while running, and rehearses in front of mirror

323 Euclid's *Elements,* the standard work on geometry

300 Chinese invent wheelbarrow

300 Aristotle describes a camera obscura

300 Alexandria, center of culture, has two libraries with half a million scroll books

256 Chinese introduce paintbrushes made of hair

207 Guild of scribes founded in Rome

200 Parchment developed in Pergamum (still called *pergament* in many Western European languages)

159 Rome's first water clock, the clepsydra

140 Venus de Milo sculpted

131 *Acta diurna,* first newspapers in form of official announcements, posted on walls of Roman public places

100 Rome has flourishing book industry with parchment rolls copied by teams of slave scribes, listening to reader; censorship and copyright laws; libraries

51 Julius Caesar writes account of his conquests; orders drafting map of empire; orders periodic publication of debates in senate

50 Chinese emperors use geese flying 50 mph to carry messages

A.D.

48 Roman soldiers invade Alexandria and destroy libraries

105 Ts'ai Lun invents paper made from tree bark, cloth, hemp waste, and fishnets; Chinese Emperor Ho Ti makes him marquis

114 Most influential capital letters cut into Trajan Column, Rome

This bas-relief from the Villa Albani in Rome conveys communication in classical times. Phaedra (on the throne on the right) pines for Hippolytus (seated on the lion's skin on the left). She has sent him a letter through the good offices of the unclad youth with the staff. One deduces that the lady on the far left is not in favor and the dog is positively opposed to the match.

150 Books of folded parchment begin replacing scrolls

170 Ptolemy publishes maps of 26 countries

320 Constantine orders the Bible copied on vellum codexes (parchment cut into rectangles, folded, and bound, written on both sides): for example, *Codex Sinaiticus,* 15 x 13½ inches, with 390 leaves

391 Romans complete destruction of Alexandria libraries on orders of Emperor Theodosius I

400	Dark Ages begin, following fall of Roman empire; but learning and culture continue in monasteries, where monks illuminate hand-copied manuscripts in writing rooms (*scriptoria*)
400	Lampblack ink invented in China
400	Wood blocks used to print textiles in Egypt
411	St. Augustine writes *The City of God* after the sack of Rome
552	Silkworms imported to Constantinople
595	Decimal calculation first used in India
600	Papermaking spreads from China to Korea, Japan, and Persia
604	First church bell in Rome
641	Arabs stop book-copying industry in library at Alexandria (which has 300,000 papyrus scrolls)
650	Arab caliphs organize first news service
700	*Beowulf,* Anglo-Saxon epic poem
748	First newspaper printed in Beijing
751	Chinese papermaking technology travels to West via Samarkand and Silk Route, following capture of two craftsmen at Battle of Talas
770	Japanese Empress Shotoku sanctions first printing on paper: a million prayers to ward off smallpox epidemic
781	Alcuin establishes school at the court of Charlemagne, Emperor of the West (France); Carolingian script developed
790	Golden period of Arab learning under caliph Harun al-Rashid
797	Messenger system with horse-changing posts established in France
814	Arabs take over Indian numerals (including zero)
840	Paper money introduced in China; inflation ensues
863	Cyril and Methodius, missionaries to Moravia, invent Cyrillic alphabet
868	*Diamond Sutra,* Buddhist scripture, first book completely printed on paper from wood blocks
900	Current writing forms develop during reign of Charlemagne in France
900	*Book of Kells,* Irish illuminated masterpiece
942	Arab empire linked by communication service of some 1,000 stations
1025	Guido d'Arezzo improves system of musical notation; invents *do, re, mi, fa, sol*
1034	Pi Sheng invents movable type made of baked clay
1100	William IX of Aquitaine, first known troubadour, sings *Chanson de Roland*
1120	Playing cards invented in China
1151	First mention of papermaking in Europe—in Spain
1157	Jean Montgolfier sets up papermaking mill in Vidalon, France
1167	Oxford University founded
1200	University of Paris chartered
1204	University of Vicenza founded
1221	Chinese develop movable type made of wood blocks
1241	Printing from movable wooden type recorded in Korea
1250	Goose quill used for writing
1270	First paper mill in Italy established at Fabriano
1285	Eyeglasses made in Italy
1295	Marco Polo recounts his travels to Cathay
1305	Edward I standardizes foot, yard, and acre by decree
1307	Dante's *Divina commedia*
1353	Boccaccio's *Decameron*

The speed of communication may be limited not only by the technology of the time but also by the desire of the messenger to get going. This woodcut from Vecellio's *Compendium of World Costume* (Venice, 1598) is captioned: "Turkish rider in rainy weather." One presumes that he has delivered his message and is loping quietly homeward. Or is he bringing bad news? Vecellio doesn't say.

1370	Library of Merton College, Oxford, founded
1373	National Library, Paris, founded by Charles V
1380	John Wycliffe's English translation of the Bible
1380	Chaucer's *Canterbury Tales* begun
1385	University of Heidelberg founded
1390	Printing type made of bronze ordered by Korean emperor Tsai-Tsung
1391	Papermaking first mentioned in Germany
1400	Drawing in perspective starts to be developed
1415	*Très riches heures* (Book of Hours) for the Duc de Berry by Limbourg brothers
1418	First European example of xylography (block printing from wood engraving)
1422	Jan van Eyck uses oil-based paint
1431	Joan of Arc burned at the stake
1445	Chinese develop copper type
1446	First dated block print
1450	Johann Gutenberg in Mainz invents printing press and movable type matrices, from which type can be cast; the typeface, with its 300 letters, ligatures, and abbreviations, resembles the black-letter script of manuscripts.
1453	Constantinople falls to the Turks; scholars flee to Italy, bringing ancient texts to Rome
1455	Gutenberg's 42-line Bible is first book printed from movable type
1457	Johann Fust and Peter Schoeffer of Mainz use printer's mark for first time
1460	Bamberg printer Albrecht Pfister produces first book including woodcut illustrations with text
1465	Conrad Sweynheim and Arnold Pannartz of Mainz start press in Subiaco, Italy
1465	First printed music
1469	John de Spire produces first book in Venice
1470	Nicolas Jenson produces Jenson, the first roman typeface, in Venice
1470	First French printing press set up at the Sorbonne in Paris
1476	William Caxton sets up press in Westminster; produces first book in English printed in England next year (he had already produced one in Bruges in 1474)
1486	Berners of St. Albans, England, uses color inks for illustrations in *The Bokys of Hauking and Huntyng*
1489	Johann Widman's book on arithmetic shows symbols for plus and minus similar to the + and − signs
1494	John Tate establishes first English paper mill in Hertfordshire
1498	Albrecht Dürer's woodcuts of *The Apocalypse* published in Nuremberg
1500	First use of black lead pencils in England
1501	Aldus Manutius in Venice develops italic as most economical face for his pocket-size books; sponsors revival of type based on Roman capital letters; publishes Greek classics (the Aldines)
1502	Estienne, French printing dynasty, established
1508	Chepman and Myllar use paper for printing for first time in Scotland
1512	Michelangelo completes paintings in Sistine Chapel
1513	First English "newsbook": report on the battle of Flodden Field
1513	Machiavelli's *The Prince*

Wynkyn de Worde took over William Caxton's London press after the master died. His 1495 edition of *All the Proprytees of Thynges* (Bartholomeus Anglicus's *De Proprietatibus rerum*) contains a number of original illustrations such as this landscape.

Quills had to be cut and trimmed just right to write properly. This 1523 drawing is by the Italian writing master Ludovico Arrighi, who adapted the script used in the papal chancery to printing. The note at the top says: "The little knife for preparing the quill." The other one says: "This is the form of the prepared quill." The little knife is, of course, a *pen*-knife (from *penna*, the Italian for "quill").

Study this cartographer from *Methodus geometrica* (published by Paul Pfinzing of Nuremberg in 1598). It's a remarkably tidy art department. But why is he working in his own shadow? Is he a leftie, or did the wood engraver forget to flop the figure?

1517	Martin Luther posts 95 theses on church door in Wittenberg; start of Reformation
1519	Leonardo da Vinci dies
1519	Camera obscura invented
1522	Luther's New Testament, with woodcuts by Lucas Cranach
1523	First insurance policies issued in Florence
1525	Start of mathematical notation by Robert Recorde et al. (previously, mathematical ideas other than numbers were written out in words)
1525	Newsletters develop as an early form of newspapers and are widely used to keep trading houses informed
1527	Sack of Rome; center of culture shifts to Paris
1528	Albrecht Dürer dies
1529	Geofroy Tory's *Champfleury*
1535	Mexico's Estaban Martin and Juan Pablos print first piece in New World
1540	Claude Garamond, French printer and punchcutter, introduces Garamond typeface
1543	Copernicus's theory of the solar system
1543	Andreas Vesalius's illustrated study of human anatomy
1544	Michael Stifel's *Arithmetica integra* uses $+$ and $-$ symbols in today's form
1548	Christophe Plantin designs Plantin typeface; moves from Paris to Antwerp
1546	Etienne Dolet, French printer, burned as heretic at the stake together with his books
1556	London's Stationers' Company granted printing monopoly for England
1557	Robert Recorde's *Whetstone of Witte* uses first equal sign ($=$)
1564	Michelangelo dies
1568	Christophe Plantin's *Polyglot Bible* started in Antwerp; published in 1573
1568	Jost Amman's encyclopedic woodcuts and poems of craftsmen
1569	Gerardus Mercator's map of the world
1576	François Viète introduces decimal fractions
1582	Gregorian calendar proclaimed by Pope Gregory XIII
1583	Elzevir publishing company established in Leiden
1588	Shorthand manual published by Timothy Bright: *An Arte of Shorte, Swifte and Secrete Writing*
1591	François Viète uses letters for algebraic quantities in *In artem analyticam isagoge*
1592	Egenolff-Berner, Frankfurt, prints first known showing of type specimens
1599	William Shakespeare joins Globe Theater in London
1602	Shorthand recommended in treatise by John Willis
1605	Cervantes publishes first part of *Don Quixote*
1605	Biblioteca Anglica, public library, founded in Rome
1609	First regularly published weekly appears in Strasbourg: *Avisa Relation Oder Zeitung*
1610	Practice of sending one copy of every book printed in England to Bodleian Library, Oxford, begins
1611	King James version of the Bible
1611	Christoph Scheiner invents the pantograph
1614	John Napier introduces exponents and logarithms

Communication by courier was a royal privilege during the Middle Ages. Later, private letters could be carried for a fee, as with this sixteenth-century mail carrier. During the seventeenth century brigands became a deterrent to private postal systems in France. The British solution was to hire the brigands to carry the mails. Not until 1840 were stamps and the practice of charging by weight introduced.

There was little point in printing public information in seventeenth-century England—not enough people could read. It was more effective to draw a crowd by ringing a bell and then make the announcement by mouth. This is the Bellman of Holborn with a friend. The substance of his message? Evidently, some major meteorological disturbances in the near future.

1616	William Shakespeare dies
1620	Blaeu press in Holland improves on Gutenberg press
1620	*Nieuwe Tijdinghen,* first newsletter with illustrations, published in Belgium
1622	First graphite pencil
1626	Peter Minuit buys island of Manhattan for 60 guilders ($24)
1631	William Oughtred invents slide rule
1631	*La Gazette de France,* first major French periodical, started by Théophraste Renaudot
1631	William Oughtred proposes the " × " as symbol for multiplication
1635	Scheduled postal service between London and Edinburgh established
1637	René Descartes's *Discours de la méthode:* "Cogito, ergo sum"
1639	Stephen Daye of Cambridge, Massachusetts, founds first printing establishment in North America.
1640	Cardinal Richelieu founds Royal Printing Works in France
1641	*Diurnal occurrences,* London's weekly journal, started
1642	Blaise Pascal, at age 19, invents pocket calculator using stylus to advance gears
1642	Galileo dies
1644	John Milton's *Areopagitica,* a plea for freedom of expression
1646	Athanasius Kircher invents *lanterna magica*
1647	*Perfect Occurences of Every Daie Journall in Parliament* runs first advertisement
1653	Boston public library opens
1653	Mailboxes appear in Paris
1660	Staedtler pencil factory started in Nuremberg
1662	Census shows 60 publishers working in London
1667	Robert Hooke, English physicist, transmits sound on taut string
1669	Rembrandt dies
1672	*Le Mercure galant* (now *Le Mercure de France),* first feature periodical, founded
1682	*Acta eruditorum,* learned periodical in Latin, started in Leipzig
1685	William Bradford starts printing in Philadelphia
1690	*Publick Occurrences,* Boston's newspaper, suppressed by British after its first issue
1690	William Rittenhouse establishes first American paper mill near Philadelphia
1690	*Athenian Gazette* starts replying to readers' letters
1693	John Fell imports Dutch types of Christoffel van Dycke to England
1693	William Bradford of Philadelphia opens printing works in New York
1693	Philippe Grandjean designs Romain du Roi typeface with flat serifs on ascenders
1694	Leibniz constructs multiplying machine that uses repeated additions
1695	Partial freedom of the press results from Parliament's abolition of the Licensing Act
1702	*Daily Courant,* London's first daily newspaper, appears on March 1
1703	Énschedé type foundry established in Haarlem
1704	*The Boston News-Letter,* first regular news weekly in America
1706	*The Evening Post,* London's first afternoon daily
1709	Copyright Act, first modern copyright law in England
1709	Richard Steele, editor, publishes *The Tatler*

1710 Jakob Christoph Le Blon, German engraver, invents three-color engraving

1714 Queen Anne grants first patent for typewriter to Henry Mill

1716 William Caslon opens printing shop in London

1718 First banknotes printed and issued in England

1719 Daniel Defoe's *Robinson Crusoe*

1719 *The American Mercury* founded in Philadelphia

1723 Benjamin Franklin starts work as printer in Philadelphia

1725 *The New York Gazette,* first newspaper in New York

1725 William Ged of Scotland invents stereotypy: duplicating original printing surfaces by casting metal copies from a mold

1734 John Peter Zenger, New York's *Weekly Journal* publisher, proving that truth is a viable defense, is acquitted of libel charges—a major step in freedom of the press

1734 William Caslon's first type specimen sheet shows Caslon typefaces

1735 *Flora* becomes first opera to be presented in New World, in Charleston, South Carolina

1741 Benjamin Franklin founds *The General Magazine*

1748 Subscription library started in Charleston, South Carolina

1748 Excavation of Pompeii begins

1749 Sign language for the deaf invented by G. R. Pereire of Portugal

1750 John Baskerville, Birmingham printer, develops three major innovations: his typeface Baskerville, vellum (fine paper), and improved printing ink

1750 Johann Sebastian Bach dies

1751 *Halifax Gazette,* first English newspaper in Canada

1759 British Museum opens

1763 Benjamin West, American painter, moves to London

1764 George Cummings, in England, receives patent for coating paper

1764 Pierre-Simon Fournier invents point system; publishes *Manuel typographique*

1768 Giambattista Bodoni becomes printer to Duke of Parma

1770 Firmin Didot, French printer, designs his Didot typeface

1770 Visiting cards come into use in London

1776 Virginia Bill of Rights calls the press "the Bulwark of Liberty"

1780 First steel pen nib

1780 *Sunday Monitor,* first Sunday newspaper in London

1785 First issue of John Walter's London *Daily Universal Register* (renamed *The Times* three years later)

1788 Giambattista Bodoni, Italian printer and typefounder, publishes his Bodoni typeface

1791 First Amendment to U.S. Constitution guarantees freedom of press

1791 Wolfgang Amadeus Mozart dies

1794 Claude Chappe invents optical telegraph, a system of visual signals; series of stations links Paris and Lille

1795 France adopts the metric system

1796 Aloys Senefelder of Bavaria invents lithography (printing from stone with oily inks)

1798 Nicholas-Louis Robert of France invents papermaking machine

1800 Richard Trevithick invents high-pressure steam engine

1800 Conte Alessandro Volta produces steady electrical flow from chemical reaction in his battery

This polemical view of the printing press and its potential power is typical of early-nineteenth-century illustrations available to printers from the American Type Foundries as a ready-made cut, or printing block. It was the clip art of its day.

1801 Carl Friedrich Gauss presents symbolic notation of congruence in *Disquisitiones arithmeticae*

1806 Nicholas-Louis Robert's machine improved in England by Gamble and Donkin, financed by Fourdrinier Brothers, to manufacture paper in continuous sheets

1806 Elgin Marbles brought from Acropolis to British Museum

1808 Brazil's first print shop set up in Rio de Janeiro

1808 First war correspondent: *The Times* sends Henry C. Robinson to report on war in Spain

1814 London *Times* printed on steam-powered cylindrical press invented by Friedrich König of Germany at 1,100 copies per hour

1815 Robert Thorne designs Egyptian typeface

1816 William Caslon IV publishes Doric, the first uppercase sans serif face, based on lettering from Greek vases

1818 Giambattista Bodoni's *Manuale tipografico*

1819 Freedom of press announced in France

1821 *Saturday Evening Post* founded

1821 Jean François Champollion of France deciphers Egyptian hieroglyphics by use of Rosetta stone

1822 Joseph Nicéphore Niépce of France makes first photographic copy

1822 William Church makes first type-composing machine

1823 *The Lancet,* British medical journal, begins

1829 Louis Braille in Paris publishes his touch-reading system for the blind

1829 "The Typographer," first U.S. patent on typewriter, granted to W. B. Burt of Detroit

1830 Patent for steel-slit pen nib granted to James Perry

1832 Joseph Plateau invents phenakistoscope (moving-picture device on spinning disks)

1834 William Horner of England invents cylindrical, spinning moving-picture machine later called *zoetrope*

1835 *New York Herald* founded by James Gordon Bennett: four pages for a penny

1835 William Henry Fox Talbot makes earliest negative photograph, of Lacock Abbey in England

1836 Samuel F. B. Morse invents code for telegraph machine

1837 Isaac Pitman publishes *Stenographic Soundhand* in England

1837 Louis Jacques Daguerre invents system of developing images on metal plates coated with silver oxide

1839 First use of daguerreotypes (photographs) in European journals

1841 Calotype, a negative-positive photographic process, patented by William Henry Fox Talbot

1840 Paper made from wood pulp by Friedrich Keller in Germany

1844 500 stations of Claude Chappe's telegraph network connect 29 French cities

1844 Telegraph line joins Washington, D.C., and Baltimore, at cost of $30,000; first words transmitted: "What hath God wrought"

1846 Rotary press producing 2,000 newspapers an hour introduced in Philadelphia by Richard M. Hoe

1846 Charles Dickens named editor of London's *Daily News*

1848 New York News Agency, later to be called AP (Associated Press), founded by a group of New York newspapers

1849 Telegraphic message "Eureka" from Sutter's Mill in California sets off Gold Rush

1849 William H. Perkin creates mauve-colored synthetic dye from coal tar

1849 Earliest American photograph on paper by Langenheim brothers of Philadelphia

1850 Paper bags manufactured for first time

1850 First international telegraph cable laid between Dover and Calais

1851 *Daily Times* (renamed *New York Times* in 1857) founded

1851 Reuters News Service started

1852 Wells Fargo and Co. founded

1854 Pillars for posters erected in Berlin

1855 Vegetable parchment paper ("tracing paper") introduced

1857 *Atlantic Monthly* founded

1858 Transatlantic telegraph cable laid from Ireland to Newfoundland, but soon corrodes and breaks

1858 Start of aerial photography when Nadar ascends in balloon

1859 Charles Darwin's *On the Origin of Species by Natural Selection*

1860 Pony Express riders recruited with ads: "Young, skinny, wiry fellows… willing to risk death daily. Orphans preferred."

1861 Eastern and western sections of transcontinental telegraph linked in Salt Lake City on October 22

1861 *Daily Telegraph* in London begins English popular press

1862 Printed U.S. dollars (greenbacks) issued on August 1

1863 *Le Petit Journal* in Paris begins French popular press

1865 Electromagnetic theory of light put forward by James Clerk Maxwell

1866 New transatlantic cable successfully laid

1866 Lithographic printing on metal produces decorated tin cans

1867 First volume of Karl Marx's *Das Kapital* published

1868 Christopher Sholes invents typewriter that is as fast as handwriting

1868 Kineograph or flip-book patented, leading to coin-operated mutoscope peep-show machines

1869 Celluloid invented by J. W. Hyatt

1871 Toilet paper in roll form invented

1871 Cable to Australia laid

1872 Gillot the Younger of Paris invents photoengraving from line drawings

This typewriter, built by the Rev. Malling Hansen, was exhibited at the Copenhagen Exhibition of 1872. Writing was done by means of the pistons, and the machine was supposedly three to five times faster than handwriting. The paper placed under the central sphere could be moved vertically or sideways, giving a choice of the portrait or landscape mode. The inventor was awarded a gold medal by the King of Denmark.

1872 Duplex telegraph perfected by Thomas Alva Edison

1874 Cable to South America laid

1874 E. Remington's Sons start to manufacture Sholes's 1868 typewriter

1875 Karl Klietsch invents heliogravure, a photoengraving process

1875 First coated paper manufactured in America

1876 Didot measuring system adopted in countries using metric

1876 Alexander Graham Bell invents the telephone, transmitting the words: "Mr. Watson, come here; I want you!"

Samuel Clemens (Mark Twain) bought this typewriter in 1874. He saw it in a Boston window while on a lecture tour. The salesman's claim that it could produce 57 words a minute was borne out by the young woman called in to demonstrate. She repeated this feat several times, and it was only on Twain's return to his hotel that he discovered that she had typed the same well-practiced text over and over. He had, however, invested $125, so he learned to produce an astonishing 12 words a minute. In his autobiography he claims that *Tom Sawyer* was the first typewritten book manuscript. It was double-spaced, typed on one side of the paper, and appeared in 1876.

1877 Thomas Alva Edison invents the "sound writer," a cylindrical phonograph; first words: "Mary had a little lamb, its fleece was white as snow."

1879 Edison develops incandescent light bulb in Menlo Park, New Jersey

1879 Telephone exchange established in London

1879 Dr. Moses G. Parker persuades Lowell, Massachusetts, Bell Co. to change names to numbers on phone sockets: start of automation

1880 Stephen H. Horgan perfects halftone for use in newspapers

1883 Joseph Pulitzer becomes owner of the *New York World*

1884 George Eastman invents roll film and coated photographic paper

1885 William Randolph Hearst becomes owner of the *New York Journal*

1885 Ottmar Mergenthaler invents Linotype typesetting machine

1885 Karl Benz and Gottlieb Daimler attach an internal combustion engine to a vehicle, creating an automobile

1886 First International Copyright Convention signed

1886 Pica measuring system adopted in English-speaking countries

1886 Herman Hollerith develops prototype of punch-card computer

1886 Blower Linotype linecaster installed at the *New York Tribune*

1887 Tolbert Lanston invents Monotype typesetting machine

1887 *Esperanto,* artificial universal language, published by L. L. Zamenhof

1888 William Morris, in England, calls for craft revival of printing standards

1888 George Eastman invents Kodak box camera

1889 Hermann W. Vogel discovers chromatic sensitization for color film

1891 Tolbert Lanston's Monotype typesetting machinery introduced commercially

1892 D. P. Updike, Frederic W. Goudy, and Bruce Rogers start their presses

1892 Kurtz and Ives develop three-color process printing using halftones

1892 Emile Reynaud opens first moviehouse in Paris, using his Praxinoscope —combining a magic lantern with rotating mirrors and images on strips of translucent paper

1893 Kinetiscope, forerunner of movie projector, invented by Thomas Alva Edison

1894 Linn Boyd Benton and Theodore L. De Vinne design Century typeface

1895 Alexander Popoff operates wireless telegraph; Guglielmo Marconi sends radio signals one mile

1895 Lumière brothers invent cinematograph, a motion picture system

1895 Georges Méliès starts first motion picture production company

1895 Cathode ray tube invented by Sir William Crookes

1896 Bertram G. Goodhue designs Cheltenham typeface

1896 Lord Northcliffe starts London *Daily Mail*

1898 Danish engineer invents magnetic sound recording

1900 Sigmund Freud's *Interpretation of Dreams*

1900 R. A. Fessenden transmits speech by radio waves

1901 Guglielmo Marconi sends radio signals across the Atlantic

1902 Cable laid across Pacific

1902 Panchromatic plate invented by Adolf Miethe

1903 Arthur Korn transmits images by wire from Munich to Nuremberg

1903 Teddy Roosevelt sends telegram around the world in nine minutes

1904 Sir John Fleming invents electronic vacuum tube

1904 Corinna typeface developed at H. Berthold AG

1904 Offset printing invented

This graphophone (vintage 1902 from Sears Roebuck) is as close to CD recordings as handset type is to digitized electronic typesetting.

1905	Albert Einstein's Special Theory of Relativity
1905	Neon used in signs
1906	Ludlow typecasting machine for headlines introduced
1906	Radio broadcast of voice and music in the U.S. by R. A. Fessenden
1907	Lee De Forest invents improved vacuum tube, the basis of radio, TV, and radar
1907	First daily comic strip: "Mr. Mutt" (later "Mutt and Jeff") by Bud Fisher
1908	Morris Fuller Benton designs News Gothic typeface
1908	Fountain pens gain popularity
1909	Bakelite, first plastic, invented by L. H. Baekeland
1910	Aluminum foil invented
1910	24 million copies of 2,433 newspapers printed daily in U.S.
1911	Frederic W. Goudy designs Goudy Old Style typeface
1912	Cellophane invented by Edwin Bradenberger
1913	500,000 telephones in U.S.; 122,000 in Great Britain; 92,000 in Paris
1914	Bruce Rogers reworks Jenson as Centaur typeface
1915	Photographic silk-screening process developed
1915	*Birth of a Nation* by D. W. Griffith establishes motion picture as art
1915	Alexander Graham Bell speaks with Thomas A. Watson by transcontinental telephone
1918	Regular airmail service established between New York and Washington
1919	Bauhaus founded in Weimar
1920	Radio KDKA, in Pittsburgh, first to broadcast regular programs
1920	Jingle roadside signs by Burma Shave begin
1920	Morris Fuller Benton reworks Century type as Century Schoolbook
1922	Phonofilm containing both voice and picture invented by Lee De Forest
1922	Radiophotography invented by Arthur Korn
1923	Vladimir Zworykin invents iconoscope to transmit and kinescope to receive TV messages
1923	Charles F. Jenkins transmits TV pictures from Washington to Philadelphia
1923	*Time* magazine founded by Briton Hadden and Henry R. Luce
1924	First singing commercial broadcast
1925	Paris Exposition inaugurates Art Deco
1925	Herbert Bayer designs Bauhaus typeface
1926	Electrola recording technique developed
1926	Magnascope, a much enlarged motion picture screening process, developed
1926	Warner Brothers' Vitaphone Corporation releases *Don Juan*, first film with music (by New York Philharmonic) synchronized on disk
1927	Paul Renner designs Futura typeface
1927	Fox produces "Movietone" weekly news film with sound; first event to be seen and heard: Charles Lindbergh's departure
1927	Warner Brothers produces *The Jazz Singer,* with Al Jolson—a silent film with singing sequences
1927	Transatlantic telephone service inaugurated
1928	Eric Gill designs Gill Sans typeface
1928	Moving electric sign installed on *New York Times* Times Square building

1929	First true all-talking motion picture: *Lights of New York*
1929	Kodak introduces 16mm color movie film
1930	Four-color offset press
1930	Flashbulb comes into use for photography
1931	Stanley Morison designs Times Roman typeface for the *Times* of London
1931	Morris Fuller Benton designs Stymie typeface
1931	Spicer-Dufay introduces natural color photography process
1932	Brush lettering becomes popular; dies off in mid-1950s
1932	Typesetting by teletype tape introduced
1933	Bell Telephone Labs develop stereophonic sound reproduction system
1933	Phototypesetter invented
1933	Electronic television developed by Philo Farnsworth
1934	Muzak established
1935	Robert Watson Watt builds radar to detect airplanes
1936	First scheduled TV transmissions from BBC in London
1936	*Life* magazine started by Henry R. Luce in New York
1938	*Picture Post* magazine started by Edward Hulton in London
1938	Chester Carlson invents xerographic process
1938	Realism of Orson Welles's *War of the Worlds* Halloween broadcast terrifies listeners
1941	Television transmission from Empire State Building, New York
1941	Hans Haas shoots underwater photographs
1942	Magnetic recording tape invented
1944	Color TV invented by John Logie Baird in Great Britain
1945	Higonnet & Moyroud's Photon photographic typesetting machine introduced
1946	Intertype fotosetter introduced
1946	ENIAC, all-electronic digital computer, developed at University of Pennsylvania
1947	Edwin Land invents Polaroid camera
1948	Transistor invented by John Bardeen, Walter H. Brattain, and William Shockley at Bell Laboratories; replaces vacuum tubes
1948	Hermann Zapf designs Melior typeface
1948	Long-playing record invented by Peter Goldmark
1950	Hermann Zapf designs Palatino typeface
1950	Plastic films introduced
1950	Curta, the pocket mechanical calculator, goes into production
1951	Color television introduced to public
1952	Minoan script (Linear B) deciphered by Michael Ventris and John Chadwick
1954	Acrylic paints introduced
1954	Eurovision network established
1954	Monotype's Monophoto typesetting equipment introduced
1954	Mergenthaler-Linotype's Linofilm typesetting machine introduced
1954	Georg Trump designs Trump Mediaeval typeface
1955	Adrian Frutiger designs Univers typeface
1955	Universal Copyright Convention
1956	Bell Laboratories develop "visual telephone"
1956	TAT-1, first transatlantic cable capable of carrying telephone calls (52 at a time)

1957 Letraset dry transfer lettering introduced

1957 Max Miedinger of Switzerland designs Helvetica typeface

1958 Hermann Zapf designs Optima typeface

1958 Stereophonic recordings come into use

1958 MCR (Magnetic Character Recognition) alphabet invented

1959 U.S. astronomers establish radar contact with Venus

1960 Russians decipher Mayan writing using computers

1960 Lasers invented

1961 IBM Selectric (golf-ball) typewriter introduced

1962 182 million radio receivers in North America, 91 million in Europe, 3.5 million in Australasia; 92 million TV sets in North America, 26 million in Europe, 100,000 in Africa

1962 Telstar satellite links European telephone and television to U.S.

1962 First personal standalone computer assembled by Wes Clark

1962 London's *Sunday Times* publishes first color supplement

1962 First use of light pen as input device for computers; also first use of windows on screens

1962 Xerox, electrostatic printing device, introduced

1963 First application of mouse as pointing device

1963 Teletype "hotline" between White House and Kremlin

1963 OCR (Optical Character Recognition) faces designed

1964 AT&T introduces Picturephone at New York World's Fair; start of video conferencing

1964 First word processor: IBM Magnetic Tape Selectric Typewriter

1966 London *Times* replaces advertisements with news on the front page

1967 Berthold's Diatronic typesetting equipment introduced

1967 Optical reading machine introduced

1968 First touch tablet

1968 First digital typesetting machine: Linotron 1010

1969 Moon landings watched "live" on earth

1970 Scanner reproduction introduced

1970 Herb Lubalin and Tom Carnase design Avant Garde Gothic

1971 Video display-based word processor introduced by Lexitron

1971 First pocket-size electronic calculator: Bowmar 901B

1972 Personal computer concept and name comes into use

1972 Color xerography introduced

1973 Video word processor with floppy diskettes introduced by Vydec

1973 First calculator to use LCD (Liquid Crystal Display): Sharp EL-805

1974 Laser reproduction introduced

1977 Voyager spacecraft carries message beyond solar system

1977 Hewlett-Packard's HP-01, first wristwatch calculator

1977 Laser typesetting machine introduced

1978 First true "intelligent typewriter" produced by Qyx

1980 Laserwriter introduced

1981 Scitex introduced, first integrated type, photo, and layout system

1983 TAT-7, copper transatlantic cable, carries 9,000 telephone conversations

1983 First credit-card-size calculator: Casio SL-800 Film card

1986 Four-color laserwriter introduced

1988 AT&T's fiber-optic transatlantic cable carries 40,000 telephone calls

When books were the most precious of commodities, the idea of marking the owner's name and warning the borrower against any mishandling was even more logical than it is today. This hedgehog from 1450—probably the first bookplate ever made—reminds us that pictures are universal symbols, no matter what language the viewer speaks. The name of the owner of this book was Igler. *Igl* in German means "hedgehog." His image was universally understood. Words, alas, require translation.

Hexalingual nomenclator

All right, dictionary in six languages. What on earth for? Because nothing is as small and contained as it used to be. New technology is unifying the world, and communication is becoming increasingly international. Especially communication about communication. It has been my good fortune to have a number of clients outside the English-speaking countries. I have also had the privilege of teaching many seminars abroad. Though English is indeed the *lingua franca*, understood the world over, I have found it useful to prepare a translation of some of the technical jargon. It helps avoid misunderstanding. What follows, then, is my personal publication-making vernacular, which I have found advisable to translate.* It has no high-tech words in it, because it seems that those tend not to get translated. Instead, they are adapted into the other language in the form of Franglais, Espinglés, or a similar compromise. I find it is great fun trying to figure out what is being said, not merely in the more exotic translations, but even in British English compared with U.S. English. (The "English" column here is U.S. usage.) If you would like to render these terms into yet another language, nothing would delight me more. Send it to me care of Watson-Guptill. We'll get it into the next printing.

*Lest the reader be misled, understand that I could not possibly make the translations. I asked properly qualified friends to help me. My gratitude, then, to Gérard Lelièvre of Time, Inc., New York, for the French version; Patricia Burbano of Vistazo, Ecuador, for the Spanish; Odilo Licetti, Otto Vostoupal, and Thomáz Souto Corrêa of Editora Abril, São Paulo, for the Portuguese; Klaus Schmidt of Young & Rubicam, New York, for the German; Björn Karlsson of Populär Kommunikation, Göteborg, for the Swedish.

English	French	Spanish
Artwork	Image originale	Imagen original
Ascender	Ascendante	Rasgo ascendente
Bleed	À fond perdu	Ilustración al corte
Blow up	Agrandir	Ampliar
Body type	Caractère courant	Texto
Bold type	Gras	Negrita
Border	Marge	Marco
Boxed	Encadré	Recuardo
Bullet (round)	Point	Punto
Bullet (square)	Point carré	Quadrado
Byline	Nom de l'auteur	Nombre de autor, crédito
Capitals	Majuscules, haut de casse	Mayúsculas, altas
Caption	Légende	Pie, epígrafe
Color separation	Sélection quadrichrome	Separación de color
Column	Colonne	Columna
Condensed	Étroit, condensé	Condensada
Cover	Couverture de reliure	Cortada
Crop	Couper	Cortar, cropping
Deck	Chapeau	Introducción
Descender	Jambage inférieur	Trazo inferior
Display type	Caractères de titre	Tipos para titulares
Dropout type	Caractère en réserve	Escritura negativa, vaciado
Duotone	Deux tons	Simili-grabado duplo, duetone
Edit	Éditer, rediger	Redactar, editar
Editorial	Éditorial	Editorial
Editorial matter	Contenu éditorial	Contenudo editorial
Extended, expanded	Large	Anchas
Exclamation point	Point d'exclamation	Signo de exclamatión
Flush-left	Au fer à gauche	Justificado a la izquierda
Flush-right	Au fer à droite	Justificado a la derecha
Folio	Numéro de page, folio	Número de página
Footline, or footer	Nom et date de revue	Fecha
Format	Forme, gabavit	Formato
Frame	Cadre	Recuardo
Graph, chart	Diagramme	Gráfico
Grid	Gabavit	Reticulo, caja
Gutter	Pli	Lomo interior
Halftone	Demi-ton-simili	Medio tono, tono continuo
Headline	Titre	Título, línea principal
Hyphen	Trait d'union	Guión
Illustration	Illustration	Ilustración
Image	Image	Imagen
Indented	Renfoncé, alinéa	Escalonado
Initial	Grande capitale lettrine	Capitular, letra inicial
Italic	Italique	Itálica, cursiva, bastardilla

Portuguese	German	Swedish
Arte	Bild, Vorlage	Bild, bildoriginal, offsetoriginal
Ascendentes hastes das letras	Oberlänge	Uppstapel
Sangrar (foto)	Randanschnitt	Utfallande bild
Ampliar	vergrössern	Förstora
Texto	Brot-, Werkschrift	Brödstilar
Negrito	fette Schrift	Fet, halvfet
Margem	Randleiste	Ram
Box	eingerahmt	Ram
Bolas	Punkt	Bomb, kula (fet punkt)
Quadro	Quadrat	Fylld fyrkant
Credito	Verfasserangabe	Information om författare
Caixa alta	Versalie, Majuskel	Versaler
Legenda	Bildunterschrift, Legende	Bildtext
Separação de cor	Farbauszug	Färgseparation
Coluna	Schriftspalte	Spalt
Condensądo	schmale Schrift	Smal
Capa	Decke, Umschlag	Omslag
Cortar	beschneiden	Beskära
Subtitulo, ôlho	Untertitel	Ingress
Descendentes hastes das letras	Unterlänge	Nedstapel
Fonte para titulos	Auszeichnungsschrift	Rubrikstilar
Negativo	Negativschrift	Negativ text
Bicromia	Doppeltondruck	Duplex
Editar	redigieren	Redigera
Editorial	Leitartikel	Ledare
Conteúdo editorial	redaktioneller Teil	Redaktionellt material
Redondo	breite Schrift	Bred
Ponto de exclamação	Ausrufzeichen	Utropstecken
Alinhado à esquerda	linksbündig	Vänsterrak sättning
Alinhado à direita	rechtsbündig	Högerrak sättning
Numero da pagina	Seitenzahl	Sidsiffra
Pé	Publikationsname	Namn langst ned på sidan
Formato	Format	Grafisk form (rutnät, regler)
Quadro	Rahmen	Ram
Grafico	grafische Darstellung	Diagram
Reticula	Raster	Rutnät
Lombada	Steg	Innermarginal
Meio tom	Rasterbild, Autotypie	Rastrerat fotografi
Titulo	Rubrik, Schlagzeile	Rubrik
Traço de união, hifen	Bindestrich, Divis	Bindestreck
Ilustração	Abbildung	Teckning
Imagem	Bild	Bild
Indentado	einziehen	Indrag
Capitular	Anfangsbuchstabe, Initiale	Anfang
Grifo	kursiv, schräg	Kursiv

English	French	Spanish
Justified (type)	Justification	Justificación en bloque
Kerning	Crénage	Letras unidas, cortadura del cran
Leading	Interlignage	Interlineación, abrir texto
Legible	Lisible	Legible, descifrando
Letterspacing	Rectification des approches	Espaciado entre las letras
Light (type)	Maigre	Clara
Line cut	Cliché trait	Clisé de lineas, trazo, dibujo
Logo, nameplate	Logotype	Nombre, logo
Lowercase	Bas-de-casse, miniscule	Bajas, minúsculas
Margin	Marge	Margen interior, exterior, corte
Masthead	Générique	Staff
Mechanical	Maquette-montage	Arte final, pasteup
Medium (type)	Demi-gras	Mediana, medio grueso
Mugshot	Portrait	Retrato, primer plano
Outline (type)	Éclairé, forme du trait	Siluetiadas
Page	Page	Página
Paragraph	Paragraphe, alinéa	Párrafo
Pasteup	Original d'offset	Offset original, pasteup
Perfect binding	Reliure dos carré	Sistema perfecto, encolado
Proof of type	Épreuve typographique	Prueba de tipos, tirada de escritura
Question mark	Point d'interrogation	Signo de interrogación
Ragged-right	Lignes non justifiées à droite	Irregular por la derecha
Reduce	Réduire	Reducir
Rough, sketch	Esquisse, schema	Boseto
Roman	Romain	Letras normales, romanos
Rule, line	Filet	Raya, linia, filetaje
Running head	Titre courant	Pase, título corriente
Sans serif	Sans empattement	Llanas, sin bigotillos, sin remates
Shaded (type)	Haché, ombré	Sombreado, rayado
Screen	Trame	Trama (de puntos)
Size (of type)	Corps	Puntaje
Specify	Spécifier, déterminer	Especificar, ordinar
Spine	Dos	Lomo
Spread	Double page	Doble página
Stapled binding	Piqué à cheval	Engrapado
Styling	Style	Estilo
Subhead	Sous titre	Intertítulo
Transparency	Diapositive	Diapositivas, slides
Ultrabold	Large, extra-gras	Supernegrita
Uppercase	Majuscules	Altas, mayúsculas

Portuguese	German	Swedish
Blocado	ausschliessen, Rand ausgleichen	Sätta spalt med rak, vänster och höger
Supressão de espaço entre caracteres	Unterschneiden	Kerning, utjämning
Abrir texto	Durchschuss, Zeilenvorschub	Kägel
Legivel	lesbar	Läslig
Espacejar entre letras	Spationieren, Sperren, Schriftlaufweite	Spärrning
Claro	magere Schrift	Mager
Chapa de impressão em traço	Strichätzung, -klischee	Streckbild
Logotipo	Namenszug, Logo	Huvud på ett omslag
Caixa baixa	Kleinbuchstabe, Minuskel	Gemena
Margem	Seitenrand	Marginal
Expediente	Impressum	Redaktionsspalt
Arte final	Reinzeichnung, Klebemontage	Offsetoriginal
Medio	halbfette Schrift	Halvfet, normal
Boneco	Porträt	Porträtt av passfototyp
Letra com miolo branco	lichte Schrift	Outline
Página	Seite	Sida
Parágrafo	Absatz	Stycke
Pasteup	Reinzeichnung, Klebemontage	Offsetoriginal
Lombada quadrada	Klebebindung	Limbindning
Prova de tipos	Schriftabzug	Korrektur
Ponto de interrogação	Fragezeichen	Frågeteken
Irregular à direita	Flattersatz rechts	Ojämn höger
Reduzir	Verkleinern	Förminska
Rascunho	Skizze	Skiss
Romano	Antiqua	Normal
Fio	Linie	Linje
Cabeçalho de página	lebender Kolumnentitel	Kolumntitel, sidrubrik
Sem serife	endstrichlose Schrift, Groteskschrift	Grotesk
Sombreado	schattierte Schrift	Schatterad, skuggad
Reticula	Raster	Raster
Corpo	Schriftgrad	Grad
Especificar	vorschreiben	Typopgrafera
Lombada	Rücken	Rygg
Página dupla	Doppelseite	Uppslag
Grampeado	Heftbindung	Häftbindning
Estilo	entwerfen	Grafisk form (rutnät, regler)
Intertitulo	Untertitel	Mellanrubrik
Transparência	Diapositiv	Diapositiv, overheadbild
Super negrito	extrafette Schrift	Extra fet
Capitular, caixa alta	Versalie, Majuskel	Versaler

Index

Abbreviations, 67–68; see also Acronyms
Abstract, 115
Accents, 69–70
Acknowledgments, 156, 159; see also Credits
Acronyms, 32, 35, 67
Amman, Jost, xxi, 44, 124, 164, 170, 196
Ampersand, 59
Apostrophe, 58
Appendix, 160–161
Arrighi, Ludovico, 196
Ascender, 15, 182
Asterisk, 59, 138
Attavanti, Paolo, 37

Background, 39–41
Back matter, 156, 160–161, 183
Barberiis, 72
Baseline, 15, 183
Bede, Saint, 62
Bewick, Thomas, 2, 135
Bibliography, 161
Binder posts, 174
Binding, 78–79, 99, 170–174
Bio, 123
Blurb, 112
Body copy; see Text
Boldface, 38, 45, 183
 lead-in, 103, 134
Box head, 100
Brackets, 56, 57
Breaker head, 102
Breakout, 116–120
Byline, 121–122

Callouts, 133, 183
Capitals, 30–35, 44
 in heads, 95–96
Caption, 124–135, 183
 placement of, 127–133
 ragged setting and, 23, 130–131
 titling, 133–134
 type style of, 126–127
 writing, 125–126
Carroll, Lewis, 86
Caslon, William, iv, 13, 199
Catchline, 125, 133
Caxton, William, 195
Centered head, 100
Chapter, 160
Clemens, Samuel, 201
Colon, 56, 57
Colophon, 161
Column setup, 28, 83–85
 in tables, 143–144, 146–147
Comb binding, 79, 173
Comma, 56, 57

Comment card, 154
Common sense, type and, 1, 3, 5–9
Conclusion, 160
Condensed type, 45–46, 184
Copyright page, 158
Corio, Bernardino, 76
Counter, 15
Credits, 126, 135–136, 161; see also Acknowledgments
Crosshatch, 59
Crosshead, 102
Cut-in head, 103, 147, 149
Cutline, 125; see also Caption
Cyril, Saint, 71, 194
Cyrillic alphabet, 71

Dagger, 59
Dash, 56, 58, 184, 185
Data-processing characters, 50
Day, Richard, 191
Dearing, Octavius A., 30
Deck, 111–113, 184
Dedication, 158
Descartes, René, 64, 197
Descender, 15, 184
Diacritical marks, 69–70
Diderot, Denis, 51
Didot, François Ambroise, 175
Display type, 46–47, 184
Downstyle, 34–35, 96, 148, 184
Drop cap, 107, 108
Dropout type, 39, 40, 184
Dulaert, Johannes, 74
Dupré, Jean, 107
Dürer, Albrecht, 8, 9, 12, 69, 152, 195, 196
Dust jacket, 152–153

Elite type, 54
Ellipses, 56, 58
Em, 52–53, 184
 -dash, 58, 184
En, 52–53, 184
 -dash, 58, 185
Endnotes, 137, 138, 140, 161
Envelopes, 166–168
Epigraph, 158
Exclamation point, 56
Extended type, 45–46, 185
Eyebrow, 101

Folio, 156, 185
Font, 49–50, 185
Footnotes, 137–139
 in tables, 147–148
Foreign languages, 50, 69–71
Foreword, 156, 159
Fournier, Pierre Simon, 175, 198
Front matter, 156–159, 185

Gafurius, Franchinus, 39
Gauss, Carl Friedrich, 63, 199
Glossary, 161, 182–190
Gothic, 13
Greek alphabet, 70
Gutenberg, Johann, 22, 51, 195
Gutter, 78, 156, 185

Half-title, 157
Halftone, 125n, 185
Hammer, 102
Hanging-indent head, 100
Hansen, Rev. Malling, 200
Heads, 93–106, 185
 kinds of, 99–104
 placement of, 97–99
 table, 146–149
 type style of, 95–96
 writing, 94
Herodotus, 121
Hyphen, 57
Hyphenation, 21

Illustrations, 80
 captions and, 124–134
 credits and, 135–136
 tables as, 143
Index, 161
Initial letters, 107–110
Inset head, 103
International Standards Organization, 50, 165, 186
Introduction, 160
Italics, 36–38, 45, 59, 186

Jacket, 152–153
Jump head, 104
Justified type, 18–23, 91, 186

Kerning, 33, 52, 186
Kicker, 101

Landscape mode, 78, 166, 186
Leaders, 61, 105
Leading, 25, 26, 186
Legend, 125; see also Caption
Letterspacing, 19, 33, 51–52, 186
Ligatures, 22, 33, 186
Line art, 125n, 186
Line length, 24–29
Lining figures, 62, 63
Lists, 88–92
Live-matter area, 81, 82
Lowercase, 30–35, 44, 186

Magazine cover, 153–154
Mandeville, 193
Manutius, Aldus, 37
Margin, 81–82

Marginal head, 101
Mathematical symbols, 63–64
Measurements, 175–181
Mercator, Gerardus, 36, 196
Methodius, Saint, 71, 194
Metric system, 64–65
 conversion tables for, 177–179, 181
 envelope sizes, 168–169
 paper sizes, 165–166
Monospacing, 54

Napier, John, 64, 196
Noordzij, Gerrit, 13
Notes, 137–140, 147–148, 161
Numbers, 62–66
 page, 156
 table, 145

Old style figures, 62, 63
Oughtred, William, 63, 197
Over-head, 101–102
Overline, 127

Paper, 7, 77, 164–166
Paperback cover, 153
Paragraph sign, 59
Parentheses, 56, 57
Part, 160
Perfect binding, 78, 172, 173
Period, 56, 96, 127
Petrarch, ii
Pica (measure), 176, 187
Pica type, 54, 187
Pictures; see Illustrations
Pitch, 54, 187
Points, 176, 179–180, 188
Portrait mode, 78, 166, 188
Precede, 113
Preface, 156, 159
Proofreaders' marks, 72–73
Pull quotes, 116–120
Punctuation, 55–59, 91
 hanging, 22, 185

Quadding, 53–54
Question mark, 56, 57
Quotation marks, 56, 58, 117
Quotes, 116–120

Ragged setting, 18–23, 188
 captions and, 23, 130–131
 heads and, 96
 lists and, 91
Readability, 2, 13, 19, 25, 31
Recorde, Robert, 63, 196
References, 137, 161

Reversed type, 39, 40
Richel, 193
Richter, Ludwig, 5
Ring binding, 79, 173–174
Roman numerals, 66, 156
Roman type, 36–38, 45, 188
Rules, 61, 149
Runaround, 86–88, 188
Run-in head, 103
Running head, 103

Saddle stitching, 171
Sans serif, 12–17, 189
Section, 160
 sign, 59
Semicolon, 57
Serif, 12–17, 189
Sewing, 171
Side head, 101
Sidehead, 102
Side-wire stitching, 171, 172
Signature, 164, 171
Size, paper, 6, 77–78
Size, type, 6, 25, 46–47
 for decks, 112
 for heads, 95, 112
 for lists, 91
 for notes, 138, 140
 for pull quotes, 117
 for tables, 148
Small caps, 32–33, 189
Solidus, 58
Spacing; see Leading, Letterspacing
Span head, 147, 149
Spine, 153, 189
Staggered head, 100
Standing head, 103
Stapling, 78, 172
Straddle head, 100
Strike-through type, 50
Stub, 146
Stub head, 104, 146
Subhead, 102–103
Subtitle, 111–113
 of table, 146
Summary, 114, 160
Symbols, 60–61
 footnote, 138, 148
 mathematical, 63–64
 proofreaders', 72–73
Synopsis, 114

Table, 141–149
 horizontal tracking in, 143–145
 parts of, 145
 as picture, 143
Table of contents, 158

Terminology, 182–190, 205–209
Text, 76–92
 amount of, 79–80
 binding and, 78–79
 columns and, 28, 83–85
 folios, 156
 lists in, 88–92
 margins and, 81–82
 organization of, 159–160
 page size and, 77–78, 81–82
 runarounds in, 86–88
 type, 46, 189
 typeface for, 80–81
Timeline, 191–204
Title, 93
 page, 157
 of table, 146, 148
 see also Head
Tombstoning, 99, 110, 118
Turnovers, 91
Type, 1–73
 background and, 39–41
 common sense and, 1, 3, 5–9
 condensed or expanded, 44–45
 justified or ragged, 18–23
 line length and, 24–29
 message and, 2–4
 roman or italic, 36–38, 45
 serif or sans serif, 12–17
 size; see Size, type
 upper- or lowercase, 30–35, 44
 variety of, 44–50
Typeface, selection of, 47–49,
 80–81; see also Sans serif, Serif

Underscored type, 50
Underscoring, 38, 59, 96, 189
Up-and-Down Style, 34–35, 96, 148
Uppercase; see Capitals

Valla, Nicolaus, 116
Vecellio, 194
Verini, 175
Vesalius, Andreas, 150, 196
Viète, François, 64, 196
Vitruvius, 175

Wall-to-wall head, 99
Wallis, John, 64
Weight, of type, 45, 190
Widman, Johann, 63, 195
Wire-spiral binding, 173
Woffger, Georg, 18
Worde, Wynkyn de, 195

x-height, 15, 16, 26–27, 190

Frustration with technology was a recognizable
condition even in 1905, when the Inland Printer
Company offered this linecut to printers for 55
cents. Technological frustration is with us still.
Perhaps the best medicine for the condition is a
wayzgoose. First mentioned in 1683, it is a party
given by the printer for his craftsmen, marking the
beginning of the season of working by
candlelight.